Water Color

Winsor Red 2
Rose Madder 3
Light Red 3

Cerulean Blue 2
Cobalt green 3
Ospide Cromium 2

Ivory Black 2
Sepia 3

Yellow Cadmium
" Cadmium Pale 2
or Aureolin 2

Pencils Black
Brushes
Turps 6

S Stretchers

JOHN MARIN

by

JOHN MARIN

HOLT, RINEHART AND WINSTON New York Chicago San Francisco

JOHN MARIN

by

JOHN MARIN

Edited by Cleve Gray

PAINTINGS AND DRAWINGS
PHOTOGRAPHED BY OTTO E. NELSON

(Unless otherwise noted below)
Pages 43, 52, 106, 167 by Geoffrey Clemens; 65, 129,
145 by Victor Amato; 159 (color) by Henry Beville; three
etchings pgs. 81, 82, 91 by A. J. Wyatt; 50, 59, 93
The Metropolitan Museum of Art; 109 The Kennedy Galleries;
26 (Bulletin) The Museum of Modern Art, N. Y.

All rights reserved, including the right to reproduce
this book or portions thereof in any form.
Published simultaneously in Canada by Holt, Rinehart
and Winston of Canada, Limited.
Library of Congress Catalog Card Number: 77 - 102144
First Edition
SBN: 03-084151-8
Printed by Fabag in Zurich, Switzerland

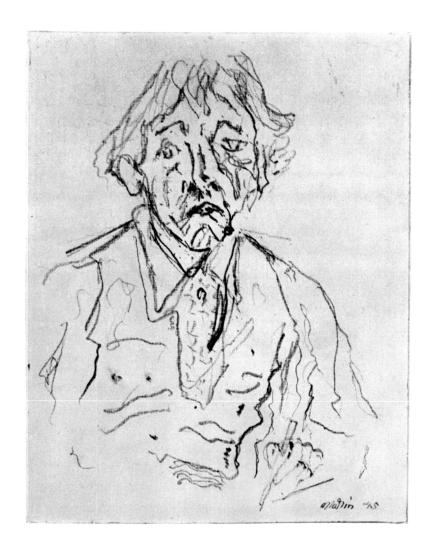

In my writings as in my pictures I make the Effort to give my thoughts shapes.

Those who accept my paintings seem to find in my writing a kinship—a being of the same woof.

Assuming (those who asked me to write) feel that I can give something to your public

why not not make a reasonable Effort to space as I have and use the—dash—in place of the orthodox punctuation.

On looking at and reading over what I have written I feel that you yourself will conclude that to—squeeze it up—will kill the Spirit of the writing (if any there Exist).

ACKNOWLEDGMENTS

In editing this volume I have had the invaluable help and friendly cooperation of John Marin, Jr. He answered my many questions and solved innumerable problems; he opened the John Marin Archives to me so that we were able to include an enormous amount of previously unpublished material; he made available works at the Lincoln Storage Warehouse which few have seen. I am deeply grateful for John's continuous encouragement.

Donald McKinney at the Marlborough Gerson Gallery, New York City, was tremendously helpful. Recently this gallery became the representative of the John Marin Estate; as a consequence I was able to see still more drawings and paintings from the Estate which had rarely been shown. The staff at the gallery was always kind.

My old friend and friend of John Marin, James E. Davis, permitted me to use those notebooks and letters of Marin's which Jim kept since 1940 when he first met Marin, through the time he was making films about Marin, until the time of Marin's death. This material and the photographs he took were tremendously useful.

Dorothy Norman was a champion and friend of Marin in her youth, and her work in his behalf is unequalled in the literary world. Her book, *The Selected Writings of John Marin* is a basic source; I have made extensive use of it as recorded in the Notes to the Text.

I express my thanks to Georgia O'Keeffe for her permission to reprint hitherto unpublished material from the Alfred Stieglitz Archive in Yale University's Collection of American Literature as well as for permission to use published material. I thank Doris Bry who so kindly helped me with these permissions from Georgia O'Keeffe and the Yale University Library for its additional permission. I am indebted to the Institute of Contemporary Arts, Boston, for permission to quote from *John Marin* by MacKinley Helm.

I owe thanks to Edith Halpert of The Downtown Gallery for letting us photograph and reproduce drawings and paintings in her collection and Marin texts in her files. Also the Metropolitan Museum of Art for permitting us to photograph and reproduce works in the Alfred Stieglitz Collection, 1949. I am grateful to Marjorie Phillips for giving me permission to reproduce some of the many Marins in her private collection and in the Phillips Collection. I thank the Philadelphia Museum for permitting me to reproduce three etchings by John Marin; also the Museum of Modern Art, New York City, for allowing me to reproduce the cover of their October, 1939, Bulletin; the American Federation of Arts for permission to reproduce the jacket of *John Marin* by E. M. Benson; and the Archives of American Art for its help.

Lastly, I thank those several persons and publications from whom I have taken brief excerpts of texts; these are acknowledged in detail in the Notes on the Text.

C. G.

CONTENTS

FOREWORD

John Marin looked like an aging Beatle. His face was all puckered up with smiles and frowns, bangs reached down his forehead to his wagging eyebrows and pixyish eyes, the rest of his carefully styled hair covered his ears. When he dressed himself for a special occasion he was a svelte dandy: tapered suits, high collars, elegant cravats and stickpins that might have come from Carnaby Street. He was dazzling. And after he dazzled, he mesmerized—if he chose to.

I was his ready victim when I met him. An undergraduate at Princeton, I believed, as I do now, that Marin was America's greatest artist. At first he had declined the invitation to speak at the university: "Two times in my life I have appeared in public and in both instances I felt that I was—a howling failure—the platform and the public in front baffle me and I come to dead stops."[1] But when he was reassured that there would only be conversation with a handful of students (he eventually called it a "POW WOW") and that no professors would be present (he hated "intellectuals"), he accepted and arrived on the train an afternoon in May, 1940. As he stepped onto the railroad platform, he commented about the passengers he had overheard: "I disapproved of everything they said." He seemed equally cautious and suspicious of us, and his answers to our banal questions were defensive: "I don't know"; "I don't know about such things"; "If someone asked Stradivarius about his violins, he'd say, 'Aw—I'm making fiddles, can't you leave me alone?'" But little by little after dinner he relaxed and started a folksy soliloquy: "I like to watch the way the elephant walks, the way it puts its foot down. It puts its foot down with respect for the earth; it doesn't fight the earth, it respects it and keeps its balance. And the tightrope performer, he swings this way, that way, but always keeps his balance." And he looked at a painting of his brought from the museum for the occasion and said, "Now that's the way one must paint a picture. There the sea pushes up, the boat pushes down, the sky pushes down; but they keep their balance. The artist when he paints a picture must find this balance between opposing forces; find a balanced reality." We talked with him until late that night.

A few weeks later, in answer to a letter telling how much his visit to Princeton had meant, Marin replied:

I will cherish the letter you sent me—it made me feel good—that you and the boys and I have that something in Common a Common love for the—neckties—of life than without which life is incomplete and often shortened for some people

and now for you and any of the boys who would care to—you must know that I would be mighty pleased to see you. So that if you can see it to do so— just drop me a line—I'll send directions—and we can have another little *POW WOW* to you and the boys greetings.[2]

Months later, when I saw Marin at Alfred Stieglitz's gallery, An American Place, or walking in New York City which he customarily visited weekly from his Cliffside, New Jersey studio, I was too much in awe of the great man to go up and speak to him, and so the night at Princeton remains my only direct contact.

In spite of the way he had opened up to us that night, there was something forbidding about John Marin. One sensed his defensiveness, he was what the French call *méfiant*. He immediately disliked

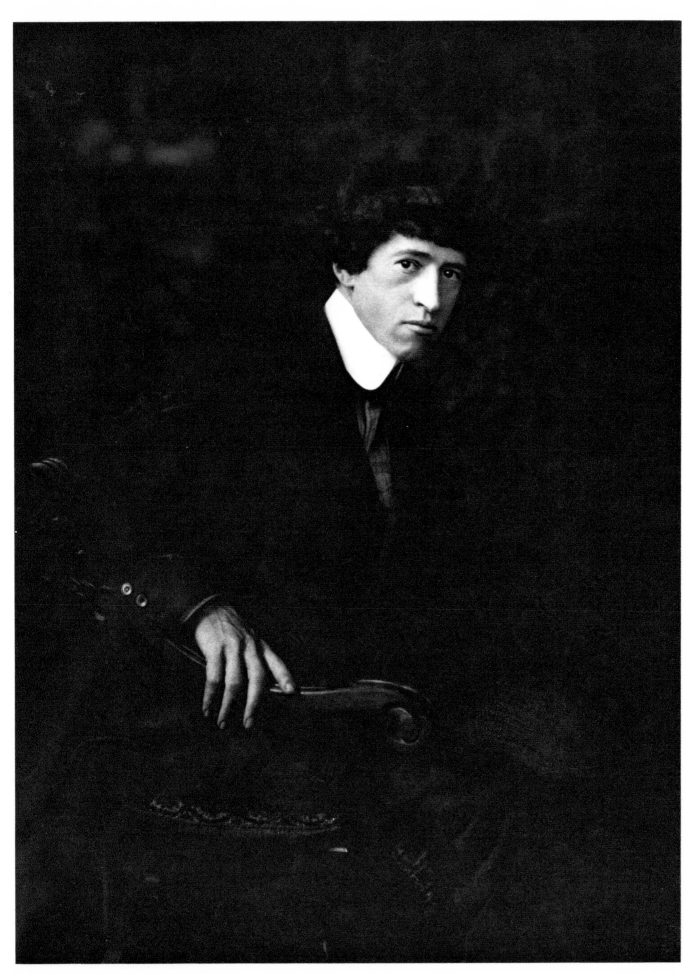

Paris, 1910. Photographer unknown

anyone he thought pretentious: intellectuals, sophisticates, critics, scholars. He was reportedly never more annoyed than the time when Alfred Barr asked him, "Mr. Marin, why do you paint? For, after all, painting is a perversion." Marin was furious: "Why don't those damned intellectuals leave one alone?" But those who grew to know Marin well found him warm, friendly and full of fun. His tastes were uncomplicated. Although he was always close to his associate, Alfred Stieglitz, and those of the Stieglitz circle, the majority of his friends were artists or country folk, neighbors in Maine or New Jersey, not "city critters." He frequently played billiards with Stieglitz and the photographer Paul Strand or the artist Marsden Hartley. He owned his own cue and used to keep it in a billiard academy in New York, somewhere around Broadway and Seventh Avenue. He saw Willie Hoppe, the champion, play several times. He devised a game of checkers which he played alone. Sometimes he would get dressed up and go with his son and a friend into the city to see a baseball game. He was a passionate fisherman and loved hunting. According to his son, John Marin, Jr., he read Shakespeare

Cliffside, New Jersey, 1921. *Photo by Alfred Stieglitz*

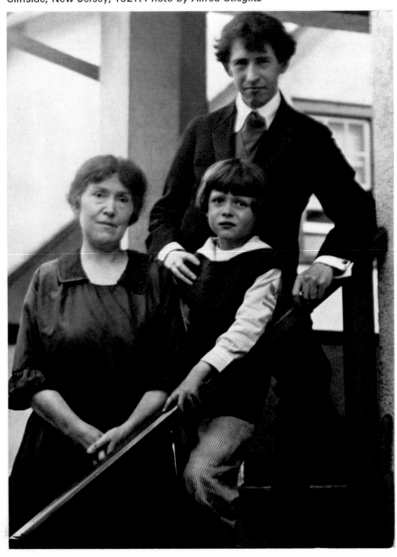

often, and occasionally Mark Twain, Dickens, Sherwood Anderson, the sea stories of Captain Marryot. D. H. Lawrence's *Etruscan Places* was one of his favorite books. At Christmas, about 1950, John Jr. gave him a set of Oscar Wilde's plays which he particularly enjoyed; there is a reference to this set and other novels in the draft of a letter to Mr. and Mrs. Duncan Phillips:

One of my Christmas presents this year was a set of Oscar Wilde's plays my— what an outpouring of bubbling sparkle—then I glanced through a couple of novels—a let's see what shall I have where shall I place so and so—and so forth and so forth—page after page—they tie themselves in knots winding up with a bevy of poor characters that get nowhere that are lost at the rushing finish— attached to which is a telling what a wonderful novelist what a wonderful book— the which above—from my outlook—can be said of most writing—most paint- ing—most music—a labor— which it shouldn't be.[3]

Marin's mother had died nine days after he was born in 1870, and his father had taken him over to Weehawken, New Jersey, then a pleasant country village, where the maternal grandparents lived with their two unmarried daughters. These two aunts, Jenny and Lelia Currey, brought him up; he lived with them for over thirty years. On his family's insistence he studied for business and then worked as an apprentice architect, but these ventures were not suitable to him, and the aunts realized it. They prevailed upon his father who consented to his going to art schools in the U.S. and then to Paris on a small allowance. After that everything seemed to go well. He had sold a few sketches before leaving for Europe and, in Paris, he found two dealers who sold the etchings he learned to make. The French government bought a painting and, most important of all, he was introduced by his friend, the painter Arthur B. Carles, to the photographer Edward Steichen, who in turn sent some Marin watercolors to Stieglitz in New York. By 1909, Marin had met Stieglitz who had come to Paris, and the great association, unparal- led between an artist and his representative, began. It lasted until Stieglitz's death about forty years later.

Marin's life was calm, happy and unadventurous. He loved his wife and was devoted to his son. He bought a home in Cliffside, New Jersey and eventually a summer cottage in Addison, Maine; he never went back to Europe after his return in 1910. He would complain now and then about lumbago or a bad stomach; at one time he thought he had stomach cancer; but these are complaints typical of most artists. Once the association with Stieglitz was made, he was exhibited almost annually and his paintings sold well. Within five or six years of his first show, critics, especially the perceptive Henry McBride, were praising his watercolors, and by the 1920's he was already regarded as the greatest watercolorist in the country. In 1930, E. M. Benson wrote a fine, small volume about his work. The following year, his friend and neighbor in Maine, the poet-critic Herbert J. Seligmann, published Marin's collected letters. Five years after that, the Museum of Modern Art gave him a large exhibition; by then museums all over the country were exhibiting his work. In 1948, MacKinley Helm's excellent critical biography appeared, and Marin was voted "America's greatest artist" in a poll of museum directors and art critics taken by *Look* magazine. The

following year, his friend, the art critic Dorothy Norman, continued Herbert Seligmann's work by bringing out *The Selected Writings of John Marin*.

But as the 1950's advanced, the sensational abstract canvases of the New York School began to dominate the contemporary art world; and Marin's comparatively small watercolors and oils, frankly based on reality, seemed to diminish in importance. By the time of his death on October 1, 1953 a real hiatus in his reputation had begun to set in. In the 1960's he so faded from public view that we are now in bad need of a reassessment of his art. It must be reassessed with a new comprehension of the work he did in the last years of his life—work which is insufficiently known, as is his writing.

The basis of all collections of Marin's writing is founded on the letters he sent in the summertime to Stieglitz. Undoubtedly, Stieglitz's sensitive appreciation of the artist's unique turn of phrase encouraged Marin and helped him to crystallize his literary style. He knew he was writing to someone who treasured his letters; indeed, Stieglitz kept

every one and eventually saw that they were published. It is curious and revealing of a certain egotism that Marin did not retain letters from Stieglitz. In going through the files of Marin's correspondence, I found only one inconsequential page from Stieglitz; but there were many drafts of his own letters and notes and drafts for later statements. This was also surprising. Marin's writing was so lively that it seemed spontaneous, and yet it was the result of painstaking drafts. They reveal how consciously Marin formed his writing style, how aware he was of his idiosyncrasies, even how he insisted on them. In 1928, for example, he had been asked by Lee Simonson, the editor of the magazine *Creative Arts,* to write an article on himself. Upon reading the article that Marin sent, Simonson telegrammed: "Glad to have your article want to allow you every necessary attitude towards expression but earnestly request you find substitute for at least fifty dashes please try to find some system punctuation less bewildering to average intelligent person of which I am one make changes on proofs."[4]

That same afternoon Marin sent back a furious answer:

. . . If my pictures cannot be understood by those of average intelligence how can you or anyone expect my writing to be—You can ask me to alter my pictures to the average intelligence as easily as you ask me to alter my writing to it.

Know you that much of the writings I read are un understandable to me. So that I may come under the head of—lesser—average intelligence.

I think my dear Simonson that you had better spare your clientele of—average intelligence—and not publish my article. For if you do I'll insist that it be published exactly as I have written it . . .[5]

And the angry letter continued on. Marin's comprehension that his writing and painting were of the same woof was absolutely correct. Moreover, his individualistic methods of punctuation, eliminating commas, using dashes and capitalization for emphasis, for pauses and adornment were necessary to the kind of shorthand, evocative, lyrical eloquence so characteristic of all his expressions.

The bridge between the two art forms, writing and painting, was Marin's drawing. "Drawing is the path of all movement Great and Small," he said. "Drawing is a form of symbolic writing." "Draw it carefully in your mind. Then write it down quickly . . . write it down quickly under the spell of seeing." This calligraphic quality began to appear in the drawings he made when he returned from Europe. The New York drawings that emerged from his hand after 1910 are increasingly excited and intuitive reactions to the city. The marvelous drawing qualities which he had from the start were retained and refined over the years. The drawing made in 1916, on page 87, if turned on its side, could easily be a late landscape or seashore. The volatility of Marin's line, the shorthand symbols he developed for movement, light and form are seen at their best in the notebooks he would fill during his yearly visits to the circus. Those who were lucky enough to accompany him to the circus were awed by the way he was possessed with drawing, the mad pace of his work, the way he used both hands at once. The artist Ernest Haskell reported finding him one day in the country perched high on the branch of a tree painting excitedly with both hands, totally oblivious of the extraordinary sight he presented.

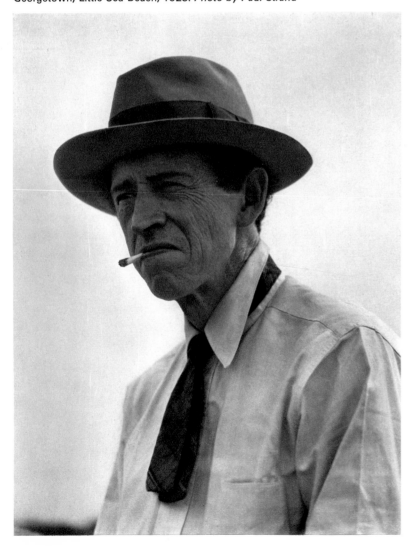

Georgetown, Little Sea Beach, 1928. *Photo by Paul Strand*

Maine Painting Outdoors. Photo by James E. Davis

"A sort of mad wonder dancing" is what he thought drawing and painting should be. The miracle of his small sheets of paper (most are just six or seven inches, few are the size of the fabulous sea drawing on page 60 and even that is no more than twelve inches across), the miracle is that they remain in the mind as huge works. Few of his late masterpieces in oil are more than thirty inches across. The water-colors are much smaller. Yet they loom in sight and memory as enormous.

In the last five or six years of his life, Marin was able to write down his paintings the same way he wrote down his drawings. This achievement at the end of his life fulfilled the calligraphic tendency that always existed in his work, even in the early Weehawken series of 1903–4. His kind of calligraphic brushwork had no precedent in Western art; the calligraphy of Van Gogh's drawn or brushed line comes nearest to it and perhaps that of a painter like Magnasco. ("Van Gogh felt paint. That man felt paint," he said to us at Princeton in an unusual tribute to another artist.) But Van Gogh's calligraphy was a kind of rhythmic reduction to a pervasive undulating movement— trees, skies and people all partook of the same *reductio ad serpentem.* And Magnasco's baroque brushwork was a palpitation joining form and space. Marin, however, moved and shaped his stroke with the direction, structure and tensions of the subjects he was depicting. It was a stroke that developed from Impressionism but that quickly became something different. "In painting water make the hand move the way the water moves—same with everything else." "The mountain was formed by weights pushing and pulling and it's as it were as if the weights were still pulling pushing—that the mountain is still fighting and being fought against—becoming conscious of all this / In your build up of mountain you have got to do just these things." Trees were to be painted the way trees grew, rocks the way they were formed, a wave the way it crashed against the ledge, a boat the way it worked, birds the way they flew; and the stroke of the brush, the character of the paint, the movement of the line were to be different for each different action in nature which one saw and felt. This kind of pantheistic sympathy with the natural world is typical of 19th century transcendentalism. Marin's philosophy was quite fuzzy, but it is in the personalistic, Romantic vein of Thoreau and Whitman. As it affected his art, however, it relates even more to the esthetics of Chinese and Japanese painting. Marin never codified his symbols or methods as did the Oriental academicians in their painting manuals, for this kind of an intellectual procedure would have been anathema to him. But similar to the Oriental artist, the basis of his painting process was always an insistence on natural growth principles. He called it "the Great Law," the Chinese called it "bones" or "natural order" or "spirit's resonance." Moreover, the increasing ability Marin achieved to *write* his paintings, to reproduce the felt vision by a personal calligraphy, is close to Oriental art, the basis of which we know is writing. And he was aware of exactly what he was doing, Marin was not naïve. He constantly referred to this writing process and even entitled one of his late masterpieces "The Written Sea" (see page 169). There is nothing in the Marin

Addison, Maine, 1951. *Photo by George Daniell*

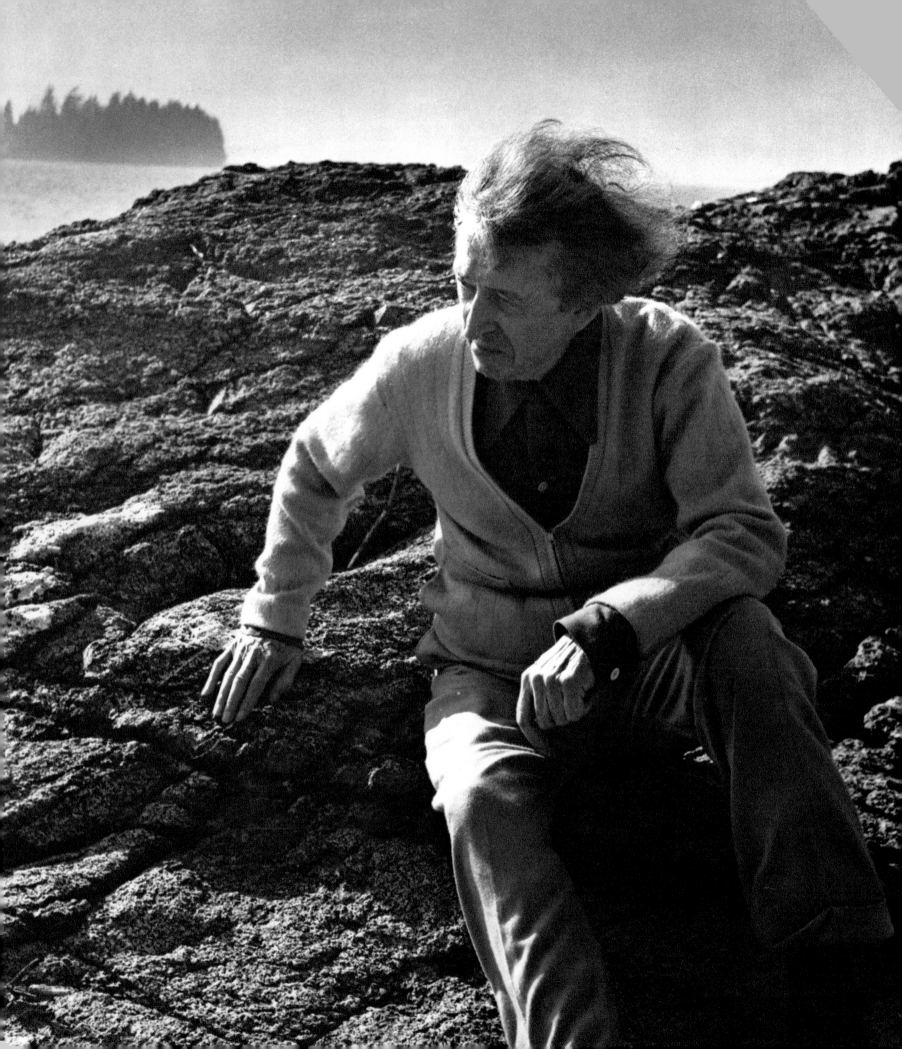

...icate how much he knew about Oriental calligraphy or ...; but his affinity with it is not superficial. It is more ... related to the East than, for example, to another great painter of the sea, the Westerner, Turner. Like Marin's seas, Turner's were grandiose, lyrical and forceful, but unlike them, Turner's were built on mass, form and void; he painted all of nature the same way, he did not paint natural structure.

In all of Marin's writing he invariably capitalized the E of Earth. If God existed for him, His manifestation was the Earth and its Growing Things. They were holy. An artist who did not know this was for Marin not a real artist. This is the basis of his objection to those he called abstractionists. They would not look at the Earth, their visions were inner revelations, hence egotistical, meaningless. His concept of a work of art is developed in the last chapters of this book. It is uncompromising even if liberal. It must be the result of love, of a delight in the seen, of observation of a divine equilibrium, of a felt reaction to vision. He believed that because abstract art did not come from natural reality, because it was intellectual, it was empty, diseased, "Nazi", the result of hate.

With all its affinities to the East, Marin's art was based on a purely Western axial composition. Cubism was the foundation of his overall design. Although in his later years the Cubist influence was loosened and, in the last paintings, broken through, his drawings and paintings were still axial, and he always insisted they remain within the format. Even in some of the late works there is a frame painted in the picture. Marin's repeated emphasis on the material quality of paint is also Western rather than Eastern; his conviction that "The paint is the thing;" "This is a tactile thing—to paint with paint and feel that paint." The flow of the paint, the drag of the brush, the plenty of paint—"Give paint a chance to show itself entirely as paint"—this emphasis was different from the spiritualization, the immaterialization of Oriental brush and ink.

Marin was a very Yankee personality, but the stress on the Americanism of his painting has been overexaggerated. He is characterized as an American provincial, often reduced to the role of "the painter of Maine and its boats." But his subject matter actually included all of the natural world. He painted the hectic movements of our biggest city, the calm of our small villages, the expanses of the Far West, sunsets, seas, mountains, trees, all growing things; he painted nudes along the shore. Perhaps a certain nervous vitality, a crepitatious movement in his work are more American than European; but, if Marin had found France sympathetic enough to remain there, his paintings would have developed in essentially the same way. He was by temperament a typical 19th century New Englander. He did dislike foreigners, especially the French—he never went back to Europe after his original stay there—but he did not simply paint a picturesque corner of his New England world. He painted elemental forces, he painted the movement of the earth. All of creation is in his last paintings of the sea.

Some of my conceptions of Marin's achievements require a new exposure to his work. His late oils are scarcely known yet they are his great masterpieces; they set in proper perspective everything he did. He drew and painted masterpieces from his early days, but there is no quantity to compare to the succession of breathtaking works that emerged in the late forties and early fifties. The reassessment I speak of is, I hope, beginning to occur. In the first quarter of 1969, the Philadelphia Museum exhibited his complete etchings; Carl Zigrosser, our outstanding scholar of graphic work, assembled the show and calls Marin's etchings the prints of "a virtuoso, a masterprinter." Later in the same year, the University of Utah assembled a comprehensive show of his drawings. Nineteen-seventy sees the opening in Los Angeles of a large retrospective exhibition that will travel nationally. Throughout his life he was justly acclaimed as a peerless watercolorist, but I am confident that his oils are his greatest achievement.

With all his objections to abstract art, Marin often came very near to abstraction. This is seen, for instance, in the early Weehawken sketches of 1903–4, in the "Tree Form" paintings of 1917–18 and in many later works, especially the landscapes and seascapes of his final years. It is sometimes said that his manner of abstracting, his distortions of form, are related to Cézanne. The similarity is superficial, for Cézanne's vision of form was architectural, rational, classic whereas Marin's was emotional, intuitive, lyric. Marin always denied a relationship to Cézanne. Opposites can converge. Laotze: "Supreme means going on / Going on means going far / Going far means returning".

Because a fresh look at Marin should be taken, I have mainly chosen for this volume works never before or rarely reproduced and in some cases never exhibited, those which emphasize the abstract direction of his art. A few well-known works such as the Woolworth or Brooklyn Bridge series or the Metropolitan's *Dance of the San Domingo Indians* were unavoidable because of their unique place in his production. As a result of my selection the Marin fan may miss many of his old favorites; so much the better. Marin is too much associated with his paintings of sailboats and tidy Maine villages. These were, of course, easy subjects for the public to like, and there are great paintings among them; but, because they pleased so many people, Marin's reputation became stereotyped. Even Stieglitz did not fully appreciate Marin's oils; it may be significant that it wasn't until after Stieglitz died that Marin's oils dominated his production.

Marin's conceptions were clearly situated in the stream of 19th century thought. He believed in the beauty of the earth, in the value of his own intuitions, in the existence of the "Great Law", in "a balanced reality" and in the importance of his own expressions of this faith. He was probably the last of the generations of artists who didn't question the significance of the work of art. He never doubted that he was involved in a matter of infinite importance to man.

JOHN MARIN

by

JOHN MARIN

I am in my boat—She's my boat—There's a yacht over there to windward but the owner can keep his blooming yacht—I've painted a good picture I think so anyway—I am not hungry though when I get home I can eat tolerably well—tolerably well—I am not worrying about the world not now I am not—How about the millions in Russia? Huh—where's Russia—How about Germany, France, England, the Irish?—Huh—who's dem people—Well there's people in Stonington hungry too—Now see here. Just now I am in my boat She's running tolerably well—I have my feet cocked up on the seat opposite— My pipe's in my mouth I am on the sea and I haven't an ache or a pain and I am tolerably well tolerably happy I know when I reach home I'll find the table set—or—and put to it I'll dig a mess of clams & get a few berries—But I am not home yet—am here—and if it weren't for the effort I'd pinch myself so that I might realize the good time I'm having. Would I have any of my friends here with me now? Well it would be a temptation for I might take the chance to pitch the parts of them I don't like overboard—As for my enemies well they're in the wake out there my boat is making—Do I want to be big or great or do I think I am big or great—Oh say now—look out around at this great tremendous fathomless Expanse—this wondrous ocean—and don't ask fool questions.

EVENTS IN A LIFE

My Ancestors were the best—English Ale—Dutch bitters—
French Vermouth and plain Scotch.

My Ancestors came over in a boat hired especially for the
occasion as the—Mayflower—oh we considered it overcrowded.

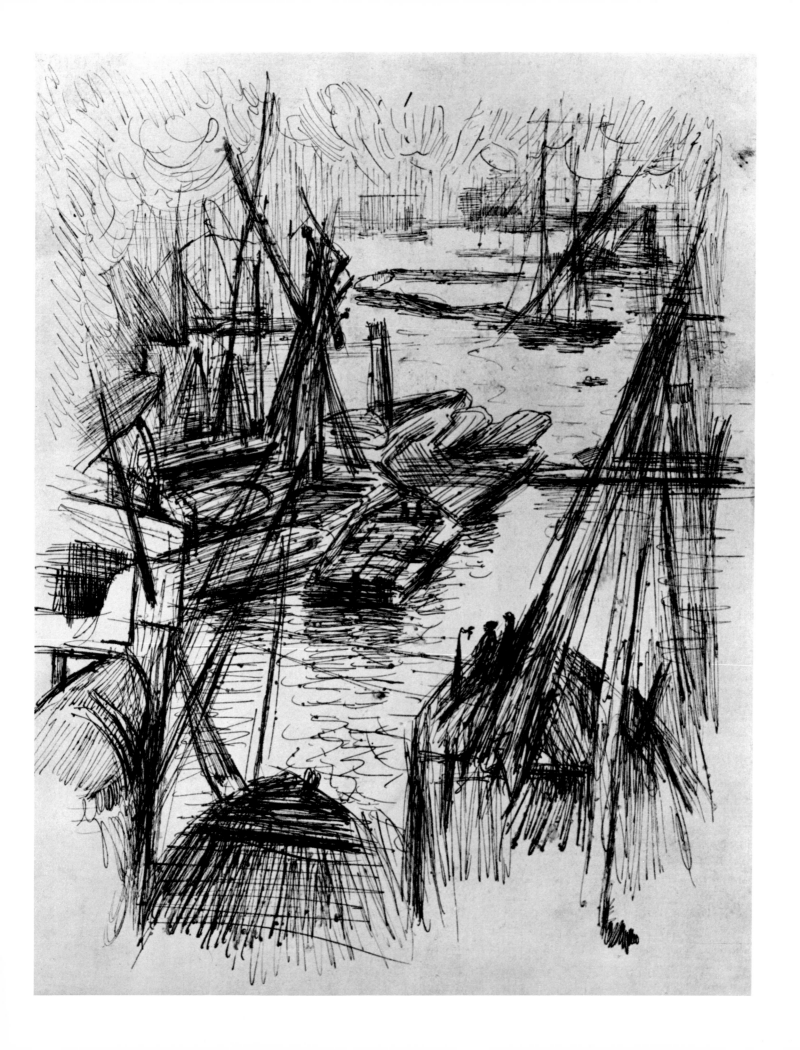

Editor's note: The editor has respected John Marin's often repeated wish to have his writing style preserved. His admittedly idiosyncratic punctuation, capitalization or its absence, sentence structure and paragraphing are reproduced as closely as possible. Spelling corrections have been made in the interest of comprehension. Astericked notes which mark a few needed editorial explanations can be found under notes to the Text in the Appendix where the reader will also find the provenance of the separate texts.

John Cheri Marin, III, c.1874

John Marin and aunts Lelia and Julia Currey, c.1888

A Small boy a very Small boy as I recall him as to what he looked like his manner of behaviour his seeings—yes he must have seen—he was given a pair of eyes to see—a pair of hands to touch and hold that seen and a couple of feet to take him places to see—as for those inner things that I know not much of, being that I who was this Small boy—have to go back years a plenty to get glimpses—yet they are unforgotten—vividly all through the years remembered—moments—and spots.

This Small boy whose mother had died giving birth* to him and who was then placed by his father with his mother's grandparents** was taken and placed by his grandparents and uncle with them on a peach farm in the state of Delaware—in short time—he made his acquaintances—three horses Cad, Dick and Nelly—3 hunting dogs—a beagle—a fox hound and a pointer—a few pigs—a few chickens and an untamable wild rabbit—and the woods not far away—yes he found himself looking at the earth and all growing and moving thereon—I guess he was too much occupied with his lookings to get into much trouble though as I remember there was a young negro girl who was supposed to follow him around—justincase—

Associated with his small wanderings and happenings—vividly—was his hero—his uncle Richard who by his family and intimates was called Dick—so to this small boy Uncle Dick pronounced by him Unle Dick—I recall one day his grandmother and two aunts took the carriage and went to town—he left with—Unle Dick—Unle Dick "Johnnie you dont want to look like a girl you're not a girl—you're a boy" No Unle Dick—Yes Unle Dick—Unle Dick—"Girls have curls"—Unle Dick—"Spose—now—I cut 'em off you'd feel better being a real boy"—Small boy—"Cut 'em off Unle Dick—Unle Dick did—too—Unle Dick got Hell when Grandmother and two Aunts got back—Unle Dick to him could do anything make anything say anything and that was—it—playmates of his age and kind he had none So he just had to look at things mostly by himself and wonder

and that pattern has to an extent prevailed through his life.

Two times each Summer the family would pile into the big wagon—hitched to Cad and Dick—go to Reheboth beach—that remains unforgotten—One Summer this Small boy was taken by his two Aunts Jennie and Lelia—who came down from upper Jersey on visit—to Lewis Delaware where we got on a boat destination New York—this boat belonged to the transition period it had paddle wheels and Sails and that was the first real sea journey.

Smells and tastes in my wanderings over the lands the woods and about the streams done mostly alone.

This Small boy must have found or been given a pencil or something to make marks which took on shapes—to him of things seen about him—Oh rabbits—dogs—horses—and maybe a bit of landscape I guess my elders thought if at all of them—as of children a making mud pies—I guess they were pretty crude. I cannot remember any of my folk a saying on looking at a certain picture—"why we have a Small boy at home who can do better than that"—At that time and place—children—male children surely were to eventually give forth to a useful creditable life—art, music, acting—as occupational was

frowned upon—maybe that is why in that early period so many gifted men made beautiful things of use—furniture—buildings—carriage and coach—and ships—a legitimate outlet to their feelings—But to get back to the Small boy—he was truly happy when his Uncle took him places—Especially the woods or over the farm—and there was the barn and stables—that held him many hours—and the smells of the barn and stables—I can even now relax and have those smells come to me—

MUSIC

It seems this Small boy without being aware of it loved music—I know that later on he could whistle about every tune he had ever heard.

Then why didn't he apply himself to it—well anything that he had to study was repellent to him—in all his schooling he would—could he—absent himself from it—Throughout his life he was never given music lessons other than to be shown the notes on the page by his Aunt but every time he heard music he quivered with joy I suppose at that young period he was not very discriminating as to music as to pictures—maybe he more or less ran with the herd—though he didn't belong—there must though have been that in him that balked—so that he took it out—that brought about his lone wanderings.

Bulls Ferry Road, West New York, N.J., pencil, 1887
Courtesy Marlborough-Gerson Gallery, N.Y.

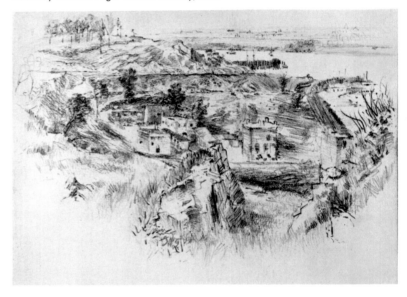

White Lake, Sullivan County No. 3, watercolor, 1888.
Marlborough-Gerson Gallery, N.Y.

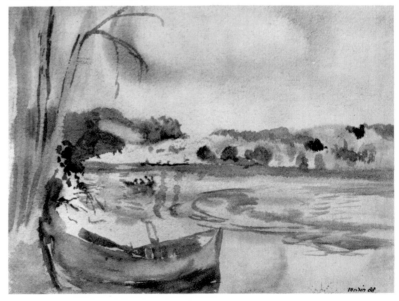

NOTES (autobiographical)

I John Marin was born some fifty years ago thereby placing Rutherford N. J. on the map—though the blooming burg hasn't acknowledged. Early childhood spent making scrawls of rabbits and things (my most industrious period) Then the usual public schooling where as is usual was soundly flogged for doing the unusual—drawing more rabbits on slate. After enough flogging one year at Hoboken Academy where the usual was the keeping in after hours. I qualified— a few more rabbits and a smattering of the now obsolete German language. Stevens High School discovered me next and the next the Stevens Institute. Went through the High School—went to not through—Institute—of course a few bunnies were added to my collection but the main thing I got there was mathematics for the which I am duly grateful as I am now an adept at subtraction.

1 year business—not much chance at the game bag—Believe I was fired.

4 years architects' offices—not much class otherwise they'd have discovered my Wondership.

2 years blank

2 years Philadelphia Academy*—could draw all the rabbits I wanted to therefore didn't draw any—While there shot at and captured prize for some sketches

1 year blank

1 year Art Students League N.Y. **

Saw KENYON COX

2 years blank

4 years abroad—Played some billiards—incidentally knocked out some batches of etchings which people rave over everywhere. At this period the French Government was going to give me the Legion d'Honor I refused—They then insisted on buying one of my oils *** — I ran away to Venice—They set up such a howl that there was no escaping—I let them have it. Since then I have taken up Fishing and Hunting and with some spare time knocked out a few water colors for which in former years I had had a leaning.

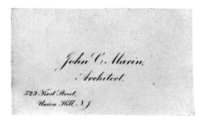

Calling Card and reverse side, c.1893. John Marin Archives

Atlantic Series, ink, 1904.
Estate of the artist

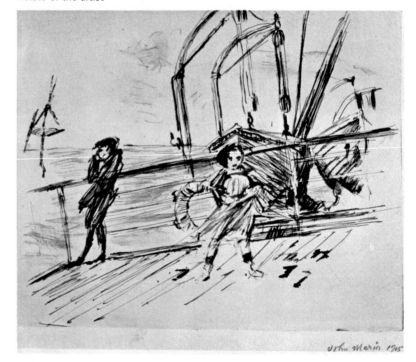

The doors have swung open* to me by my friend
Alfred Stieglitz and occasionally — with his say so — by Montross
and Daniel—** Alfred Stieglitz still persists in the Swung door
the only thing with this swinging business though is that others
creep in—There's those frenchy fellows Picasso and Matisse.
Then there's O'Keeffe Dove and Hartley—well we'll let these latter
stay but it will have to be seen to.

My greatest collection—The Dark Room Collection is in the Lincoln Storage.

Some few are scattered about among the violently happy possessors
being my friend Alfred Stieglitz ***—he has quite a few—I really
believe he thinks them good.

Then Mr Howald.**** of N.Y. & Columbus Ohio

Mr Phillips ***** of Washington D. C.

Mr Goodwin ****** seems to have a predilection for Lower N.Y.

One occupies a—Spot—in the Metropolitan given—as he had a
plenty by Mr Albert Gallatin ******* of N.Y.

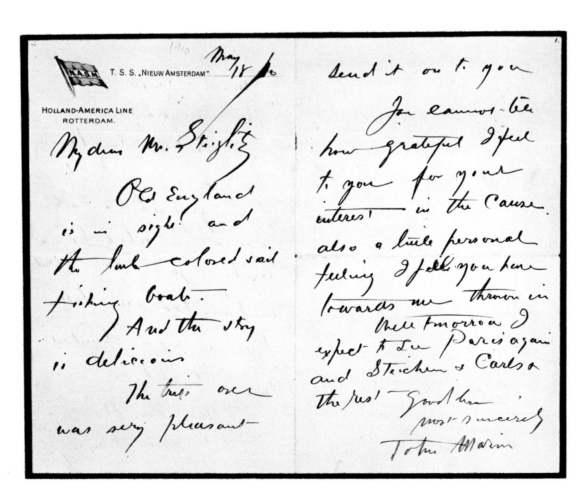

Portrait of Alfred Stieglitz,
pencil on paper mounted
date unknown. John Marin Archives

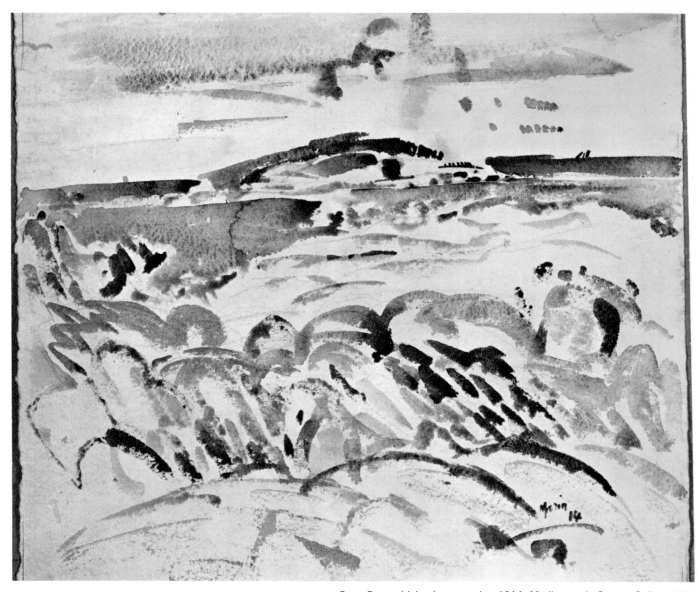

From Ragged Island, watercolor, 1914. Marlborough-Gerson Gallery, N.Y.

John and Billy in the Boat, watercolor, 1949.
Marlborough-Gerson Gallery, N.Y.

I well remember those first years in Maine—the very first year was difficult in that it was hard for us to get things—Your father [Ernest Haskell] straightway solved the—milk problem by letting us have a portion of his Cow's milk and I used to row over and we'd talk things over while he milked or if Mrs. Marin* was with me our visit was extended and your mother would join us and two or three times your father would make french pancakes—those were the days. Then we'd have picnics on the islands we'd go either in your father's Swampscot or power boat—quite often to Ragged island then we'd get busy your father with his etching needle I with my water Colors and somehow—we respected each others medium and respected one another's work.

... There is a certain spot discovered and it takes me 40 minutes hard pulling (rowing) to get there and 40 minutes back and this round trip 2 times a day.

But they make good apple pies up here you ought to come up and try them thats what one comes up here for to eat apple pies and of course if one looks out of ones bedroom window you are forced to view the lake.

Not a bad sort this lake but then you will know all about it when I get back for I will have made the lake famous ... I am afraid you would be shocked with the wildness the Northern feel of this region of lakes and trackless forests.

From the top of bear mountain—a climb of about 4 miles (that is when you keep to the trail and don't get off and go wandering) well from the top of this hill you get a vastness of country in every direction mountain back of mountain clusters of peaks forest covered—with lakes in succession as far as the eye can see.

This is the wilderness. This is the beginning of the great woods and when I come back I'll tell you more though the telling I know will be feeble in comparison to what I saw.

Our Kid** beats rubber in Elasticity—Where he puts it I don't know but there he is as broad as long and as thick. Good Lord how that Kid Eats—What am I to do?

My boy is brown and well—full of life—My wife is brown and well
 I am brown & well
 You!!!—Get away

I am seated just after breakfast with a cigarette in my mouth my feet cocked up on the window sill—thinking great thoughts?

My Kid is on the floor looking at the lantern—Daddy, what would you call this part of the lantern, would you call it the top? Yes, I guess so—You might call it the tower Daddy—Yes you might. Daddy? Well—what is this part of the lantern—No answer—Daddy you might call this part of the lantern the railing mightn't you Daddy—yes you might—Daddy what do you call the part that holds the oil—is that the oil well Daddy—No answer—Daddy—Could you make me an oil well—and so on so it goes the Kid with the lantern interrupting the Great Man with his thoughts.

Untitled (Tree), pencil, c.1900. Estate of the artist

There's that—Island*—that—Island of mine—beautiful little island—with all its trees the sense of its being mine.

I suppose there are now at least a thousand trees on it.

The other day—me—with my brood—went over to the Island I carrying an ax and I chopped down trees—I who love trees—but when you cannot see trees for trees—something has to be done about it—

and even though I never build a house on it—I can still see a house on it with—Groups of trees and vistas

and this is all right I guess it's all right

—a trifle sentimental—but then I wonder—am I not a trifle sentimental—and then a bit—

I have <u>bought the place</u>**

The place was to be bought so of course I had to buy it.

With the approval of Mr Harry Wass*** the man who seems to meet the approval of the better sort and too Our Mr Herbert Seligmann**** I am paying down 2500 and the other thousand in notes running a year with the privilege of paying that off at my convenience.

I could have paid in full but that would be running a bit too close to the wind.

Mr Harry Wass values my purchase at 7000—Seligmann at at least 10 000 well it's a pretty swell property.

and now to get down to work I have painted some and am now ready to pitch in and do something but to get this thing first off my chest & have an end to it.

They have gotten money and are improving the road down there and I should say it would be good enough for anybody in about a year.

I bought a boat 25 feet long with a Ford engine in her—put in first class shape for 175 dollars and as for a small boat as tender for the power boat—that went with the property.

The Seligmanns and we took quite a cruise in her yesterday and she went like a Sewing machine.

We went to an island which is most beautiful

—Last year's taxes on property 32 dollars for the year

also there is a big piano in the house <u>concert</u> <u>grand</u> Chickering make—beautiful tone

The woman from whom I bought it wants 100 for it That isn't settled yet I think I caught it for much less as it would cost big sum to move it and then she would have no place to put it . . . there are 281 panes of glass in this Shanty—

Yes we have the house and grounds and in front of us the bay and islands and smooth water and rough water and the porpoises a chasing after herring. The house is so close to the water I almost feel at times that I'm on a boat—Then there are those Sun Sets—we make 'em to order—the kind—No Artist can paint.

Well it's a damned good thing there's something <u>them</u> <u>damn</u> fool Artists can't tackle.

Map of Marin property and plan of house, Addison, Maine

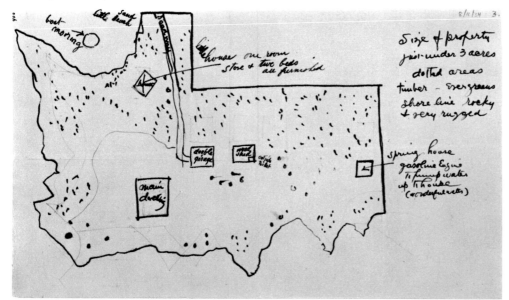

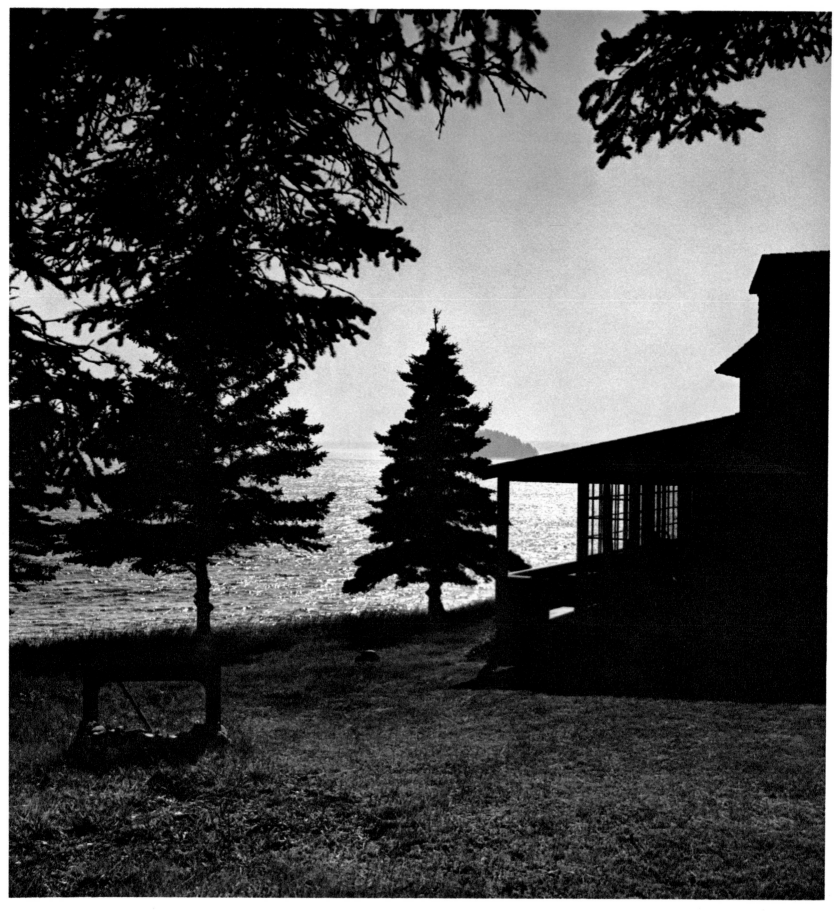

The Marin cottage, Addison, Maine.
Photo by George Daniell

Dear Stieglitz

The certain day is here—the day of the written word to you—Certain pictures have been painted—others to be painted—maybe—That word between—the meeting—the—that something which takes place—the undefinable—

—Art—

—the undefinable—

The scientist can bring two objects together—there's the explosion—all within a radius suffer—A rose can be brought in only those who are sensitive can smell it—only those who are sensitive can see a work of art—others round about who are insensitive do not suffer from their insensitivity.

Art that has to be advertised is mostly not art at all—

I was looking at some little Chinese figures about— four inches in height—at a friend's house beautiful little figures as important to me as—Great Works of Art—

So human they were. You'd find very little in the Art output of today has a whimsical curiously humorous aspect—No comedy at all (serious endeavor?)

For my part I think I'd walk as far to see those little Chinese figures as I would to see the frescoes of Michel Angelo in the Sistine Chapel at Rome—nay farther—

To the putting of it—that the art of the ancients is balanced by a good bit of comedy—The art of the present—barely a drop—

—To Hell with it—

To report

That I have just finished boiling a mess of lobsters in the sea water

That I went to Machias and pulled a porterhouse steak out ot the butcher shop

That I yanked me a mess of corn from the stalks and have it now a cooking

That the same for beets

 " " " for potatoes

Picked a mess of cranberries

 and

Those things I get from my friends the fishermen

Somewhat repay when I go to Machias a shopping and loading up with Cinnamon buns—bananas—oranges—peaches and a bit of meat now and then

 and

—No money passes hands—

Not so much as formerly is the squeak of the fiddle heard in the land—those—the fiddle squeakers—are getting older

and—the days are racing by—probably that's the reason I haven't written sooner—The days are racing by—

 and

There's the—wood fire am told I should burn gas—there are the Kerosene lamps—am told I should have Electricity

But a good douse in—Old Ocean quickly takes Care of all that.

The country is so beautiful now—the coloring so wonderful that—the thing to do is to—not look at it—to go about with an old board in front of one's face.

Well

 Be seeing you soon—and the others—

Still sailing a wee bit—

—Yer ancient Mariner be—

 —begosh—

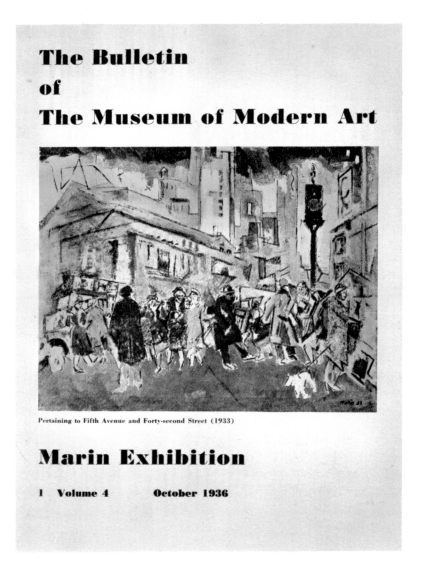

The Bulletin
of
The Museum of Modern Art

Pertaining to Fifth Avenue and Forty-second Street (1933)

Marin Exhibition

1 Volume 4 October 1936

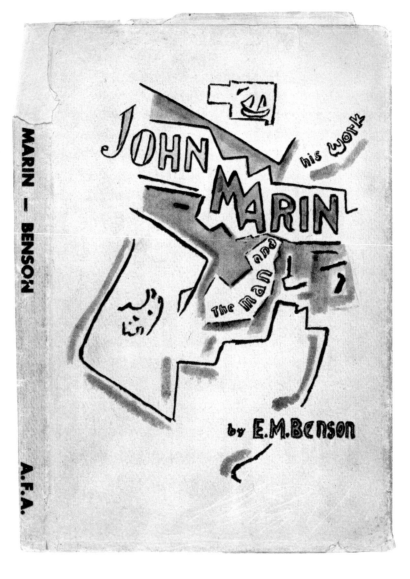

Now personally as I have had a one man show at the Modern Museum and that the heads—Mr Goodyear and Mr Barr—together with the several employees I came in contact with—showed a real interest and helped me to a feeling that I was in fact a part of the museum itself that I was not an outsider.

Marin's jacket design for E.M. Benson's book, *John Marin*

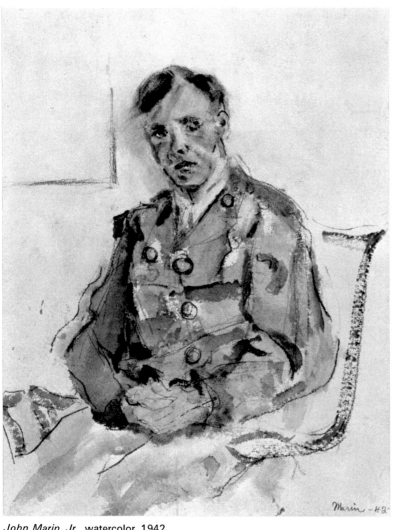

John Marin, Jr., watercolor, 1942.
Marlborough-Gerson Gallery, N.Y.

Office of Price Administration

Dear Sirs

It is a hot day and tomorrow fashions to be hotter—so that I don't propose to stand in line—taking up the time of those others standing in line—and also your time.

I do propose though to bring to your representative the slip I received last week as proof that the 4 tires are approved of—by Inspector at Michelson's garage.

I also propose to bring the car up and park it where your representative—by glancing out of the window can see it and see the old sticker thereon which—plainly seen—has never left the car.

Now we come to your Zealous traffic officer out there at Teaneck—for whereas one has oft heard that those who imbibe too freely are apt to see—double—It would seem that our officer has found something—the which if one had the receipt of—one might get and by just tilting the bottle—could erase from sight all objectionable objects—could be this man a teetotaler who just needed a drink. You know we in Cliffside Park also have our traffic men—I spoke to one the other day—about my boy—in the service—having done the dreadful thing in leaving his car parked in front of a—road house.

"First I have heard about that"—said he—"pity if the boys can't have a little fun"

Another thing we have been told "never talk back to those in authority"

That Concept I and other—Old line Americans utterly refuse to sanction.

For in my over 20 years of driving—without other than minor accidents—I have found that your—traffic man—is apt to be— if rightly approached—a pretty human fellow—the exceptions—well they you can never do anything with.

Too—I refuse to believe that your board is other than just human Americans who under difficulty are doing your best but I would if I were you try and find out what it is our traffic friend at Teaneck imbibes

Most Sincerely
John Marin

I have been much upset—my dear Wife passed on—Feby 12—45—
and she was failing quite rapidly some time before . . . am somewhat
pulling what's left of me together.

John and Marie Marin,
Cape Split, Maine, c.1940

To the Members of the Academy
First of all I want to thank you for the honor you bestow on me and I
hope I am in part deserving of that honor.*

 Then too must come an apology from me to you.

 For I have been lacking in courtesy toward the academy in that I
have not given correspondence to me proper consideration—as in
my case the older I get the more I am absorbed in my work so that
those other things I should do and which give pleasure are lumped
with negative things—then too I have to fight a growing absent
mindedness and forgetfulness.

 Asking your indulgence toward this rather old critter myself and
that my slippings are in no wise intended or calculated.

 I wish to remain in all friendship yours
 John Marin

John Marin; Arthur A. Hauck, President, University of Maine; and
Pierre Monteux, the symphony conductor;
receiving honorary degrees from the university, 1950

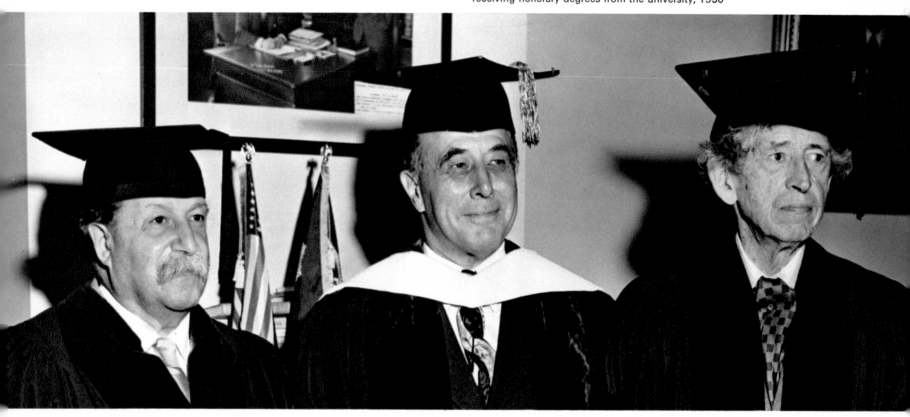

THE ANCIENT MARINER

I am a Small town Gink with a small town disposition
I'll insist on being an old Fashioned Critter
but the town must be of my choosing
the critters in this town of my choosing too
and since I cannot bring this about—I don't belong anywhere.

Untitled (Studies of the Artist), pencil, c.1940's.
Estate of the artist

Today I am in one "Hell of a mood"

I did something I rather like—a disorderly orderly sort of thing—

I am up on my haunches—I don't Know just what to do. I sort of want to raise Hell in my stuff and don't Know how to do it properly.

Feel like tearing things to pieces

Look at that Raphael photo on the wall and hate it for its perfection
 its smugness

in my present mood don't like anything much.

Want to be crazy.

Will be crazy

Like to paint some damn fool pictures—no you fool they may be foolish but damn foolish?

To paint disorder under a big order—

Smugness

When is one not smug
 is it

When one is tossed about and tosses—being played with and playing. Maybe That's a thrust—at it a stab at it.

Assuredness.

Cock-surity

Ter Hell with Honors
 ditto

Old masters Young masters all Kind of masters

Hurrary for all things that Come to grief—that Slobber that come a cropper

The Smugs roam the Earth—no they stay put

The Smugs start all the trouble

they Exasperate

It takes nerve not to be smug and no one has nerve enough

Nature just loves nerve.

Today I am an Apostle of the Crazy

but Damit it's got to be a caged crazy—otherwise it would butt into another crazy—Then you have destruction So

There you have the ideal humanity

Crazy humanity

Each in his little cage.

That would be a show

Maybe that's what God is waiting for—for all the world to become crazy—Then he'll crate them and put a label tag on each and ship them

So that's what each one should live for, look forward to—religiously—becoming with all one's heart soul and strength

CRAZY—CRAZY ALL

but it's a long way off.

The World is too full of the SMUGS

So

Weep for poor God.

Just to breathe the air—to sit around—to do nothing or what we call nothing for the World—or that part or parts of it—

—a stamping out individualism—and substituting their own damned diabolical individualism

—that's a funny one your high-exalted purified individual
a using all those dirty tricks—all those same old dirty tricks.

Damn it all I like this fellow Marin—can't help myself—But I tell you I cuss—him—a plenty—

So I've got to spoil more paper—I don't know anybody who loves their Visions more than I do—But not to absolutely get them down—that's what makes me speak—of Spoiling paper.

As I drive a good deal I am conscious of the road, the wonderful everlasting road a leading onward a dipping a rising a leading up over the hill to the sea beyond—to nail that— to express that—to find the means to clutch—so that there it is—that's what torments me—to show with startling conviction.

So I make the attempt.

Others may make and get but don't you see—it isn't my road—it isn't my—over to the sea.

And here it is

There are moments when I am unbelievably in love with myself. But

there are moments when I unbelievably hate myself—for being myself.

Curiously twisted creature

Prejudiced—as Hell.

Unprejudiced as Hell.

Narrow—as they make 'em

Broad minded next minute

Hating Everything Foreign—to a degree

With the opposite coming in time and time

A shouting Spread Eagled American.

A drooping wet winged sort of a nameless fowl the nest.

Poor Marin—he's a joke—He says his "Oh Hell" this place is no good and then he goes to work turns a somersault and straightway takes it all back and Says this is immense.

Lord how wonderful it is to be—alone—for then in imagination you can have any Companion you want and can get rid of when you want—My temperament cannot stand having a bunch around me wherever I go.

To produce this—work of art—you have to have the artist—to produce—This artist must be warm and comfortable must have his belly well filled must live in a state of comparative peace. When these conditions are not the work has not a sustained level of serenity and all works of art though full of life have this serenity . . .

So that is why I say that to produce one's best—one had better be comfortable with all the doors locked and the fire burning brightly—and to have a big watchdog to guard against the fanatics of the world.

Marin notes for a checkers game, c.1930's

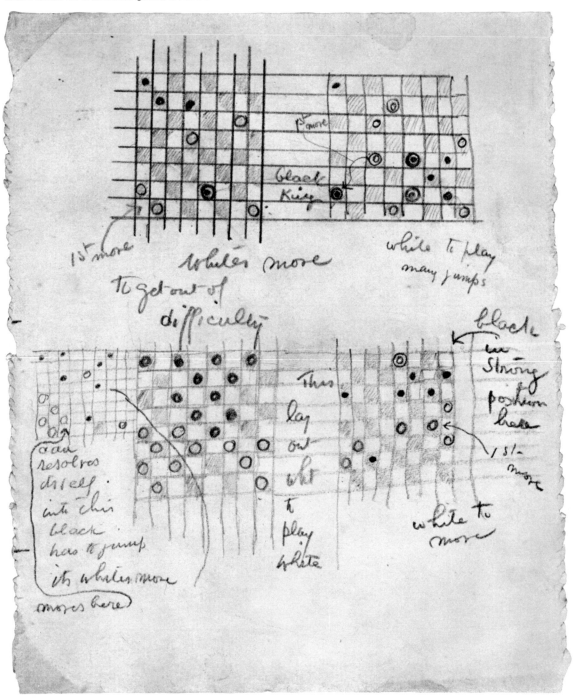

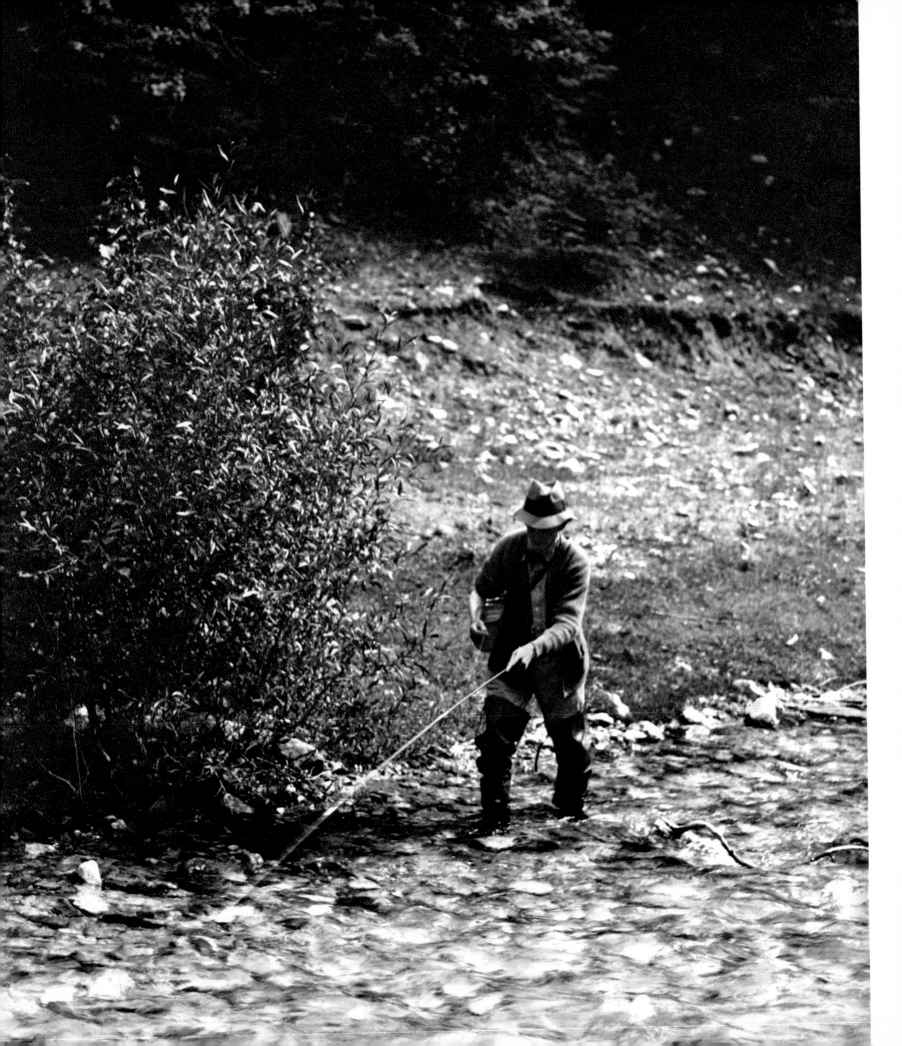

Took a long hike to a wonderful creek—mountain stream First it must be fished—afterwards painted.

Wouldn't think of disassociating Fishing from Art—one and the same thing with me.

Have caught some bass—finest sport there is—you first have to know his whereabouts—you have to dress to suit him—you have to so behave to get his acquaintance—to be wily—firm not too firm—fast yet not too fast—slow not too slow—sensitive—putting yours against his—You have to take a few years off to become a consummate—bass fisher. Yes sirree—they're the gamiest Ever
 —damn—'em—
but last time I came back with NOTHEN. So have started in to work painten picters—

I bought me a Gun this spring and I go out. Sometimes I get a partridge—have gotten some rabbits—have gotten some duck. Wonderful this roaming the woods—but then whilst on the land of dreams—up flies a partridge—and I have to come back with a jolt as I do when my kid starts throwing lantern questions at me.

The waves of the sea and the wind the birds of the sea are a soaring the wild duck in flock are beating their wings—swiftly in flight up there a flying—What right to fly Get me a gun—Bang—down one comes poor broken thing that was just before a beautiful life—Hurry up pluck him take out his entrails make quick the fire Cook him Eat him—Ah—Very good eating is wild duck—Stop, stop the memory of that was once a bird up there a flying—beating the air with its wings—
 Become hardened—more hardened still hardened more—Ah there's the trick—that's it—to shoot—shoot to kill—without a qualm—To stand the gaff—the world's bunkings Yes pluck—skin—take out their entrails cook—Eat—stern chase—stern chase—stern chase—till you overtake.

There must be an Element of bigness
 I am painting pictures
 landscapes
Trees—rocks—grass—water
 why not? It's nobody's business—and if I like to go a fishing—what then—
Does one have to set a pace
Does one have to be great
Does one have to try and jump farther or higher than someone else—

Mountains streams trees and rocks are so sympathetic—damned if I find most humans so—Of course I know why. That's within—it's because I make them so—so I can find no fault with the other fellow who sees differently—but—the tendency is that you can do as much and more than the other fellow—I'll show him—Damned if you can—strut amongst trees & mountains— They'd laugh at you—The human has the tendency not to laugh—but to start trying to Out-strut.

A little bird and its plumage—gives the heart a warmy warmy feeling—Huge waves sounding on a rock-ribbed shore makes the heart, liver, lungs everything the whole human critter expand "nigh to bustin' point". Then you live, live, live, and you "got to do somethin'" Yell, curse, something big, the bigness that is in you. Sink or swim there's the ocean handy and you mostly sink and most humans luckily sink and don't know they're sinking.

You if you make a better photograph than the other fellow—if you preach any gospel are a trouble maker. I if I should happen to paint a better picture than the other fellow am a trouble maker—Yep all creators are trouble makers for they change the condition of sublime take it Easyness. Why is it we've got to move about so and change things—if only the ladies and the gentlemen would stay away from one another—then there and only then would there be a dirth of books and their makers for there wouldn't be any such high Cock O'lorums to write about such as possibly yourself or myself or the Dick Wagners.

then wouldn't the birds of the air the beasts of the forest and the fishes of the sea Sing a glorious Song of joy and the little buttercups and the little daisies and the little violets would nod their heads most off in rapture and the trees would whisper to one another at last— it was about time God took a tumble to himself—that the last creation of his was a fade out.

I question—
Do I question another's rightness
 Will I question another's rightness
 I probably have and I probably will
 and you can cross out the probability
 Why—well it seems to be in the breed
 it makes for enemies it makes for friends
 One may have glimpses of such clearness that one cannot comprehend a like clearness in others
There is the right—There is the wrong
 But who with any degree of sanity would have the nerve to appoint The Judge.

If anyone does good work Give him a medal
So that the King pins of the racketeers
 a medal
a good shop lifter a medal
a good chair maker
a good second story man a medal
a good house builder
a good murderer a medal
a good painter " "
a good train robber " "
a good writer " "
in other words any one who shows quality in any walk of life politics or in a private way for what we now call good or evil Give 'em all medals
and let 'em scrap for them grab anything do anything so long as you make a good job of it—hurrah a premium on conceit deceit or rascality and the same goes for the good samaritan fellows.

So, there you are—Belong—if you don't belong get out—
There are whole bunches of—make believe belongs in this planet. They make believe they belong with the Deep ones.
 Human hogs let them wallow
 —in their depths—
I'd like to build a world just full of foolish
 people
Each one willing to give the other a lift
Wouldn't that be great—to—after traveling millions & millions of miles for one to suddenly come upon a world of foolish people—
 The deep Johnnie—Scat you're not wanted.
 The fresh Johnnie—Scat you're not wanted.
 The pseudo serious Johnnie—Scat—you're not wanted.
 Why not—didn't I build this world AIN'T it my world—
 Get out you boob.
 Yes, if I get rich—I am going to hire the biggest ever and when I come across a critter I don't like I'll say—Biff his nibs over there— Lord—wouldn't there be stacks of them—

I am sick and tired of of good? books—Good? people—good? everything—the middle man—
I'd rather have trash for at least trash is honest as trash it requires little effort and you do get a sort of kick—It's on that middle ground where the trouble begins—there's where we are fooled so often, on that middle ground.
 Yes
I am leaving soon in search of more trash, or rainbows, anything to get away from this local trash and these local well kept lawns, well kept trees, well kept houses and well kept people and presentable picture frames.
 We should have two selves, one held by the state (to conform and transact) the other to
 roam————

Blessed be the restricted herd. All of us who can be are fence jumpers.

Anyway may the man who invented barbed wire fences be eternally damned. That's my main occupation that of going through barbed wire fences. I believe you could find a part of my rainment stuck in every fence in this district. The people wondered at first now they say "Oh that's only a part of that Damn fool painter" When I stride forth with my kit I am taken for a peddler sure enough—To be more correct I was—now they kindly chain the dogs Damn fools are scarce?

Untitled (Self-portrait), pencil, *c.*1940's. Estate of the artist

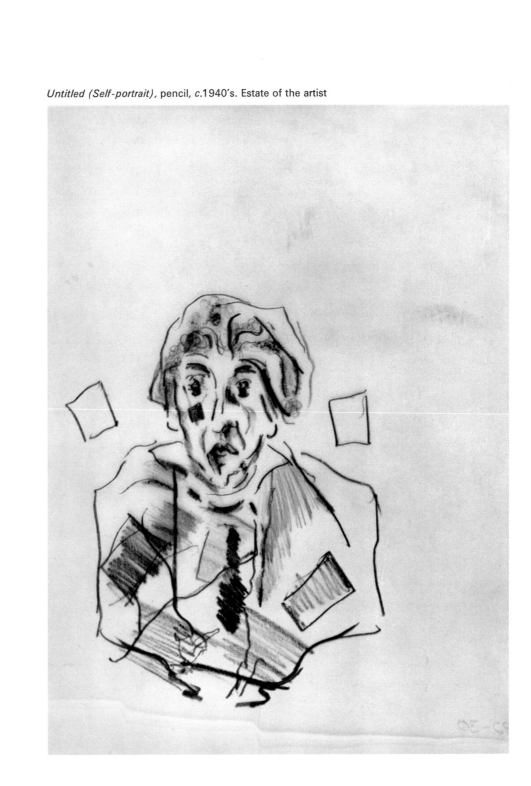

Old Jim Bassett is on his last legs, has to be wheeled over to his desk in a chair where he goes over his accounts or strictly speaking, goes over the same account to the last rent each day—Out of pure cussedness he may last a long time he's got his share of that and a little more added.

Being on his last legs accounts for the presence of Farmer Gutremuth. Farmer Gutremuth has acres, barns and stock of his own but when old Bassett, who is related on his wife's side, dies he expects to add more acres, barns and stock. That's why Farmer Gutremuth sits there and watches over old Bassett.

As Joe Thompson expressed it: "When Jim Bassett dies he h'aint a goin' ter be missed no more than that there Stick. He h'aint never did nor had a kindly word to say to nobody, he's nothin' more than plain hug—he'd stink up any burying ground."

Nothing escapes old man Lindstruth he's bent over double, creeps along with a cane, his hands shake but his little gimlet eyes under shaggy brows are glued to the ground He must have a raft of old knives, needles, pins, old rusty nails & the like.

The ladies say he is a nasty bad old fool. He's chuck full of cussedness too—Old Jim Bassett's brother died a while ago, he also was always primed full of cussedness as his own daughter who waited on him like a baby for 6 whole years, would tell you. When his brother died old Jim was told. Hemm! said old Jim and went back to his accounts.

Yes Sir! Mr Albert Lindstruth is a character, he shaves once every two weeks, his face is the color of his hat, his hat the color of his coat, his coat the color of his breeches and his shoes don't vary any. His wife left him.

Up on the hill live Joe Thompson and his wife alone Joe Thompson will look with longing eyes across the Valley to where the big woods lay Doc Kramer says, "He'll cash in afore Snow flies" They say he and his wife are very poor. But he will always talk of the big woods, is always going tomorrow, he really knows he can't, but he tries to make himself think he can—His old eyes will kindle as he talks about trout streams and deer runways he knows of—of trout cooked out of doors and of venison steaks that melt in your mouth and, "Say boy that be a livin'" "Yes sir you en I'll start off next week" "I know a place and all's we need be a bushel er pertaters and a few little things en we'll have a time you en I."

Half way down the village just beyond the "big elm" perched up saucily is Mike Bowman's. Mike took it into his head the other day he wanted his house painted he didn't do more than a few brush strokes himself somehow he got others interested—Mike does odd jobs to keep him in whiskey, though he don't drink "nothin' like what he useter"—He's little, like his house.

He's like a Bantam rooster Mike is. He's buried two wives Mike has—When his house was painted Some Village wag tagged a sign on it—Wife wanted, ten or a dozen kids no objection—Mike said— "It's a damn lie" Mike used to be quite a property man, but he sported it—Anyhow he's got the biggest and costliest Stone over his two wives out there in the cemetery—Maybe it's to keep them down.

Not far from Mike Bowman lives Mr. Merz he's a retired farmer raised children all his own stock. The Merz's had a picnic this summer only the Mr. side of the house. They all had their photograph taken he showed it to me I counted 60 and then stopped counting.

He's an "Anni Baptist" that's a great sect up here—Throw away everything interesting about a Quaker and you have an Anni Baptist— but the "Hook and Eye" baptists they are the real folk. They don't believe in buttons on their clothes hence "Hooks and Eyes"—

Jim Barker says that Werner he's our milkman waters our milk says he's "seen him at it"—He takes milk of Dixon, but that little scalawag awakens us a whistling in the morning a whistling a bar of some "Moody and Sanky" thing & that bar is all wrong—he has real milk and cream—but I suspect it is flavored with plain dirt and I'd rather have plain water if it must be.

There are two Stores in the place, Ormsby's with the Montross smile I prefer big George Hufcut the things he sells are the "Finest in the world" he's generally out of most of them anyway—My old box is on his porch where we sit & talk about who's putting in his corn today or something Down Lowville way or up to Watertown or Carthage.

Oh, well they are pretty fine people take them all together. I haven't mentioned the women much for they Keep generally "tu hum" do their work, have the wash all out by 8 in the morning always ask you to "step in and set" as a sort of conceit, challenging the always fiendish neatness of everything.

You will find here Subjoined a few attempts at my friends.

I go after milk Each night and sit and listen to an old man of the sea telling tales and this old man has a wonderful soft mellow oh so mellow a voice so that you could sit on and on and listen to it—
But like the rose and the thorn
An old Swede comes up to get milk and sits and interrupts with a pig like grunting sing song of nothings—to himself a Knowledge of everything The old man told him—one night—that his opinion wan't wuth anything but he keeps right on—that kind usually does—

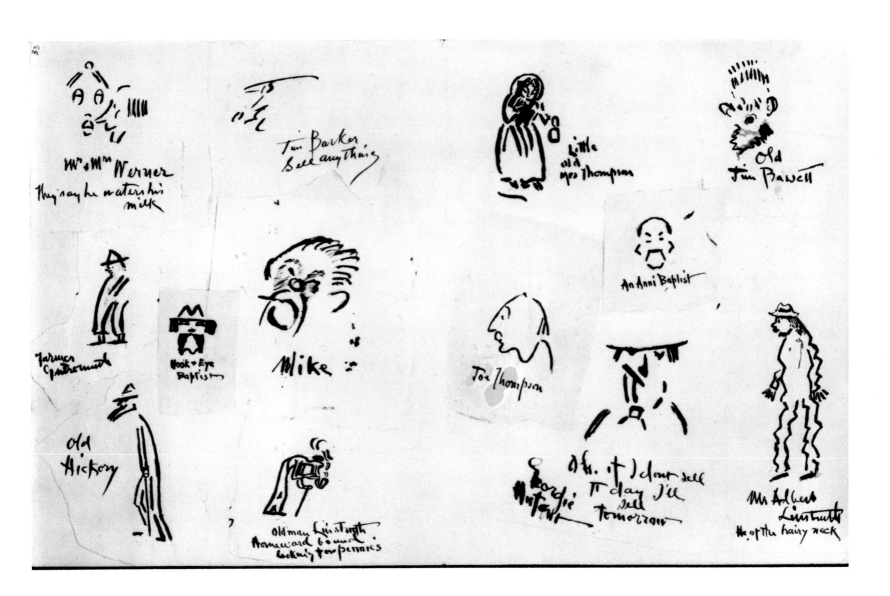

Mr & Mrs Werner

They say he waters his milk

Tim Barker
Sell anything

Little
old
Mrs Thompson

Old
Tim Bawell

Farmer Gutterman

Hook + Eye
Baptist

Mike

An Anni Baptist

Joe Thompson

Old
Hickory

Old man Linstruth
Homeward bound
looking for pennies

Georgie
Infant

Oh, if I don't sell
it day I'll
sell
tomorrow

Mr Albert
Linstruth
He of the hairy neck

39

A Maine Story

There was a family—and their collective name was Dudley—and many there were.

There came the time when the—old He—of the herd died— The family decided to place a Tombstone—an expensive swell tombstone—The order was placed and the tombstone in due course arrived—but lo and behold—the—letter—d—had been left out.

What to do—that damn stone cost money
they put their collective heads together
and now—their name is—Duley

Now then—

there was once a little Girl and a little boy who lived the one on one side of the Street the other opposite.

Said the little Girl to the little Boy "Tell me to come on over"
Little boy—"Come on over"
Little Girl—"I dasn't my Poppa won't let me"
after a bit—little Girl "Tell me to come on over again".

We were sitting—over to Bill Thompson's a joking and so forth and I remarked that I was a real good feller and did what I was told— (Little Bill Thompson) not yet six spoke up and said—"Mr. Marin if I told you to go jump off the head of the Cape would you do it?"— just like a shot out of a gun—well I was floored and started to beg off and said "now Billy you wouldn't tell me to do that would you"— Well he let me off—but he had the look on his face—like this— "don't let it happen again"—a close call—wasn't it—for I'd a had to make good—wouldn't I—and—to the World in general—do your bluffing before Grown ups—for—sure as Turkey—Infants will call your bluff—

Mr Shelton Pitney

You say my check will be deeply appreciated and I say "Oh Fudge" —You and your kind say—Oh the boys of America—I say can say Oh the boys of America just as loudly and as strongly as you and mean every word of it.

I am afraid you and your kind are Regimenters—In your accompanying circular you have a photograph of an hundred men or less boys with some confounded thing plastered over their—young tender ears—in another you have this little youngster—posed—and you have said to him Now look heroic little man—so there he is with the—trumpeted screamer alongside him—"We have not yet begun to fight" You say physically fit and mechanically fit. Nothing is mentioned of spiritually fit—no nothing is mentioned of a fine living—of the beautiful—but of a pseudo living born of and to be carried out by your kind—in other words—basically you would make of these boys the very thing we are supposed to be fighting against.

In other words you and your kind are all set to train them for a future war—which if it did not come you would have it was your and their hard luck—busybodies—busybodies bosybodies a plastered all over our beautiful country.

I get letters from busybodies every day of the week and I for one am getting pretty well fed up.

I am not so hard up that I couldn't give 10 or 25 dollars but who am I giving it to—to be used by you and your kind

I say—NO
 Sincerely
 John Marin

Oh what a grand sight it will be for me and my boy and the boys of others when they who are alive come back and see their young brothers all regimented—with their corporals their lieutenants majors colonels & what not—How they will praise you and your kind—will they—Well maybe not.

When man walks nature is with him
When men walk nature forsakes them.

In order for man to get about easily he must pitch overboard all his art
Straighten out all his roads—cut down all the trees—level the mountains and fill up the streams.

The only leadership I'll recognize if you can call it leadership Is by the man who by his good works gives courage to those about him.

To sensitive people Statistics mean very little—they question statistics—
We must make it so that every human on this Earth owns just so much and no more—for one man to own 50 acres—and another two acres—Oh no—
I own 6 acres in Maine
at least 5¾ acres should be taken from me—
To be modern I have no right to love the Peach Orchard—
All seen objects I should abhor—the old basics must have no place in the modern world.
all sympathies all feelings should have no belonging except communistic—all old basics must be killed—yes your old basic brother—must be killed—you not willing to kill him should be killed yourself—Ancient art should be all destroyed—you—you have no right to love your old father your old mother.

I make here another statement—To do away with Capitalism the human race will have to be done away with—for every one of us would be a Capitalist and is within his or her personal limits. Now then a man has 10 thousand dollars in the bank—a good pair of shoes cost 16 dollars—therefore he must buy 625 pair of shoes—give away 624 pair—then only maybe he's entitled to the one pair left—
The good man has the right to live—he will not do harm to his good neighbor but he must not allow the bad neighbor to do his will which is to destroy the good.
All must think alike and have like beliefs?
Those who have—if strong enough—must destroy all others?
A truly terrible idea—how it persists—but all good men where'er located do think and feel basically alike—may they multiply—the healthy minded—all the good people a saying our destiny whatever it may be is the same.

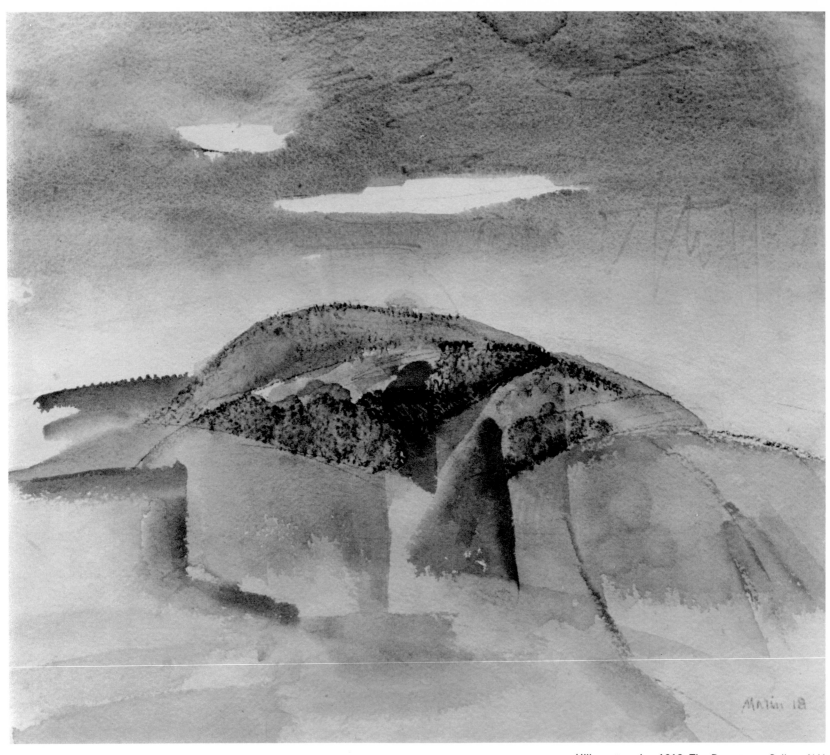

Hills, watercolor, 1918. The Downtown Gallery, N.Y.

To be warned in advance—

That we the Human Cuss—must of our very nature—Raise a bit of Hell—with quite a bit of Heaven—right here on this—Old Earth—

With this awareness—one might Enjoy quite a bit—This life—and if the feller beside You takes a tumble—you are to pick him up—that is required of you—

Good—go thou and do

me—go me and do—

Yep—but—mister—I am still going to kick and growl—and then—kick and growl some more—the which if I couldn't do once in a while—or more often—why I wouldn't want to live.

Yup—we'd cease to live

So that after you have picked yer brother up—yer to cuss him for a falling down.

Have been going out into the Country quite a bit of late—I spoiling more Canvas with paint—mostly I skirted the region between Rockland lake and Suffern the country—SWELL—the only draw back—the Old stock who inhabited the region—well—for the most part they have passed out and in their place you find bunches of those—city critters—who don't seem to belong—critters you'd dub—INTELLIGENCIA—whatever that may mean Farther South around Ramsey it's somewhat better for there you feel that the young people derive more from the old stock—therefore go better with the landscape.

THE SEEING EYE

To close one's eyes to the seeings on this Earth—
to specialize in a limited seeing—that one is not for me
and that limited seeing full of distortion—nothing
recognizable—that you've never really seen with love.
If you are really a lover—you don't escape—you just love
and have to do about it—

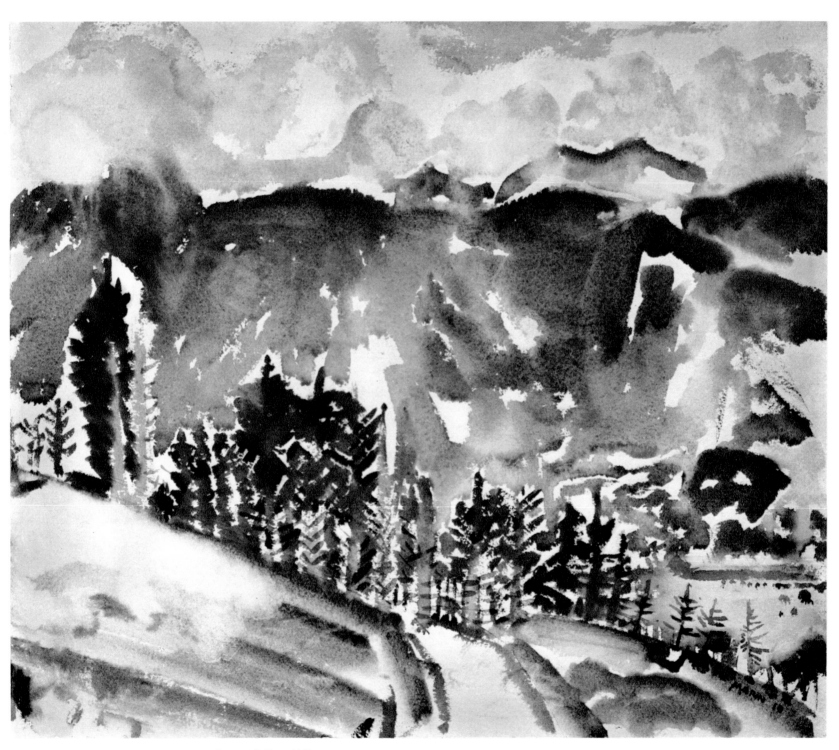

The Tyrol, watercolor, 1910. Marlborough-Gerson Gallery, N.Y.

Over the winding Ever ahead road—the dipping rising—white road—
Seeking—finding swiftly its cleavage between—on either side—
bay and woodland
 fields and ledges
 fields with berry bushes
 ledges with moss and juniper
 Over all
 the moist cool—lifegiving—northern
 salty air
 Away over yonder
 across the waters across the waters of the bay—in creeping—
 the white—white fog—in Separate disconnected Swirl
 forms—lost and found—
So that now a headland is taken up now an Island lost found and
lost again by this silent creeping mystery of the day.
 —The Car moves on—
 and whilst these still slow moving white members ever approaching
closing up their gaps to become one vast close veil of mysterious
nearness.
 Near yet not so near but that the nearness of what is seen is felt in
forms of enchanting beauty never before so disclosed.
 In this white walled chamber of the road ahead—of copices—
of bush—and ledge of mosses—greymosses of lichen—black
lichen—of turf greenest turf of firs stately little firs of flowers yellow
and red blue and white flowers are veiling and unveiling.
 A feeling of mad joy possesses me down jams the foot leaps the
Car ahead Over the road he bounds swift swifter over the road laps
up the road
 He hums
 the long glad swell of his humming Over the road the under road
the winding road the stretching road—pick up—left—pick up
 The white road—the white sand road
 The grey road
 The gray gravel road
 The brown road.
 The—warm—brown—EARTHY—road creeping in stealthily
creeping in
 closer closer
 Now—fewer the forms
 smaller the Chamber
 —intimacy—
 the foot stops pressure
 the car—idles
 alone with a form
 now—it's a quivering little fir tree
 now—a ledge jutting a dripping moisture jewel drops.
 now—a little flower bunch beautiful in chaste clear
color loveliness.
 roves the eye
 comes in closer the fog
 Now he's a mass in one creeping in shutting in

down drops the foot forward on its way over the road
slowly feeling its way over the road moves the Car
 on in the silence
 on in the stillness
 in this yet stillness—
 Sounds are clear
 clear as bells—as tinkling silver bells strung on ribbons of thread
 feeling its way into the now ghostly shroud of obliterating
whiteness
 groping its way. Sounding its way with Siren blast and blast
Moves the Car
 Stealthily out there somewhere Stalk the—fog witches—
 dimmer yet more dim
 becomes the road
 a house looms up
 the car
 —stops—
 The rain is pelting on the roof—the rain is swishing wind blown
about the house
 The clouds are emptying out their pockets
 and—its' all pure water.
 The human family is too Emptying its pockets and it's—
 not—all pure gold.
 Out in the grass and weedy stretch—out there perched atop
slender stalks—cling two little birds afeeding—Yellow birds black
band on wing their little heads black topped—feeding—sleeping—
flying—frisking—mating—nesting—talking—pruning covered in their
little garbs of life—that's all

Old mistress—Maine—

 She makes you to—lug—lug—lug—

 She makes you to—pull—pull—pull—

 She makes you to—haul—haul—haul—

 and when she's thrashed you a plenty—between those thrashings

 She's lovely

 She smiles

 She's beautiful

 with an unforgettable loveliness

 an unforgettable beauty—

 Turns masculine—borders big and mighty—against—the big and mighty—Atlantic—

 Tremendous shoulders to brace against his furious brother.

 Spread over these shoulders most beautiful intimate carpetings—spread on shore between these shoulders Enchanting fine sand beaches

 Maine—makes or breaks

 Maine demands and rivets

 —A painter man—here—if—of—her breed or her adoption—must needs conform—

We up here get but few glimpses of the outer world—as to objects on the water a fish boat looks big a sail boat looms up the eagles soaring overhead are big or is not their bigness a something of the imagination as—if in the wilderness lost—what a little light would mean as—in a city one light means little or nothing as—in a world harbor the insignificance of one little boat.

Such—to sit and behold—is the—painter man's dream—

 movement Expressing itself

 weight Expressing itself

 its play boys are frolicking

 its seamen its seawomen

 are toiling are sporting

 Sea boats—sea fishes—seabirds

 look—look once again

 they're there

 Ah now—What a swell—picture—

Under the lea of this island a floating on the waves were two little sea pigeons (a kind of miniature duck) and oh so beautiful one's heart went out to them—there they floated—the pair, with nature's caring, with the mating season once a year—the rest of the time perfectly happy & content to be near one another—no complicated depressions. When the storm approached they had their wings to take them to some sheltered place under the lea of the storm.

The water delicious, the sands to the touch of the feet. Big shelving wonderful rocks, hoary with enormous hanging beards of sea weed, carrying forests of evergreen on their backs. The big tides come in, swift, go out swift.

And the winds bring in big waves, they pound the beaches and rocks.

 Wonderful days.

 Wonderful sunset closings

 Good to have eyes to see

 Ears to hear the roar of the waters.

 Nostrils to take in the odors of the salt—sea and the firs.

 Fish fresh—caught some myself.

 Berries to pick

 picked many

 wild delicious strawberries

 The blueberries are coming on.

 On the verge of the wilderness—big flopping lazy still-flying cranes.

 Big flying eagles.

 The solemn restful beautiful firs.

 The border of the sea.

A FEW NOTES

Go look at the bird's flight—the man's walk—the sea's movement

 They have a way—to keep their motion—nature's laws of motion have to be obeyed—and you have to follow along

 The good picture embraces these laws—the best of the old did—that's what gives them their life

 The bird soon senses when it's done the wrong thing—the flight is disturbed—and it immediately counterbalances this disturbance to keep in flight

 The sensitive workman soon is aware of the wrong layout

 The bird is (right away) aware of the broken wing

 The artist of the lifeless line

 The Earth revolves around the Sun so fast—you'd think it would be smashed to bits

 but no—the Sun's pull is just right

 Just look up—the Sun is shining

 The Earth is here and all is well—the basic law is being obeyed

Watch those animals put their feet down—they have a respect for the Earth.

The woods are wonderful
The WOODS—Can one think of them without picturing wild beasts
and wild men—The Element of fear—and is it not that which makes
them alluring and can one thoroughly Enjoy without this mixture of
fear and don't they always run hand in hand
 So that
To those who see and feel
 There is this
unquenchable longing
 for those places
 where
lurk the Demons and
the Lovely ones—

Wonderful evergreens the more beautiful in their last throes when
that wonderful parasite moss begins creeping upwards and along
the branches—here & there a green piece holding out and then lo
they are in their death clothes beautiful wonderful death wraps.

In a little glade back in my woods I discovered a straight growing
little poplar tree—I cleaned up all around it—Now it is my Shrine—
where I can go and pray Each Day—How's that—Marin says his
prayers?
 anyhow I have gotten those quivering little leaves so that they
talk to and sing to me (Honest to goodness).

Castorland, oil, 1913. Marlborough-Gerson Gallery, N.Y.

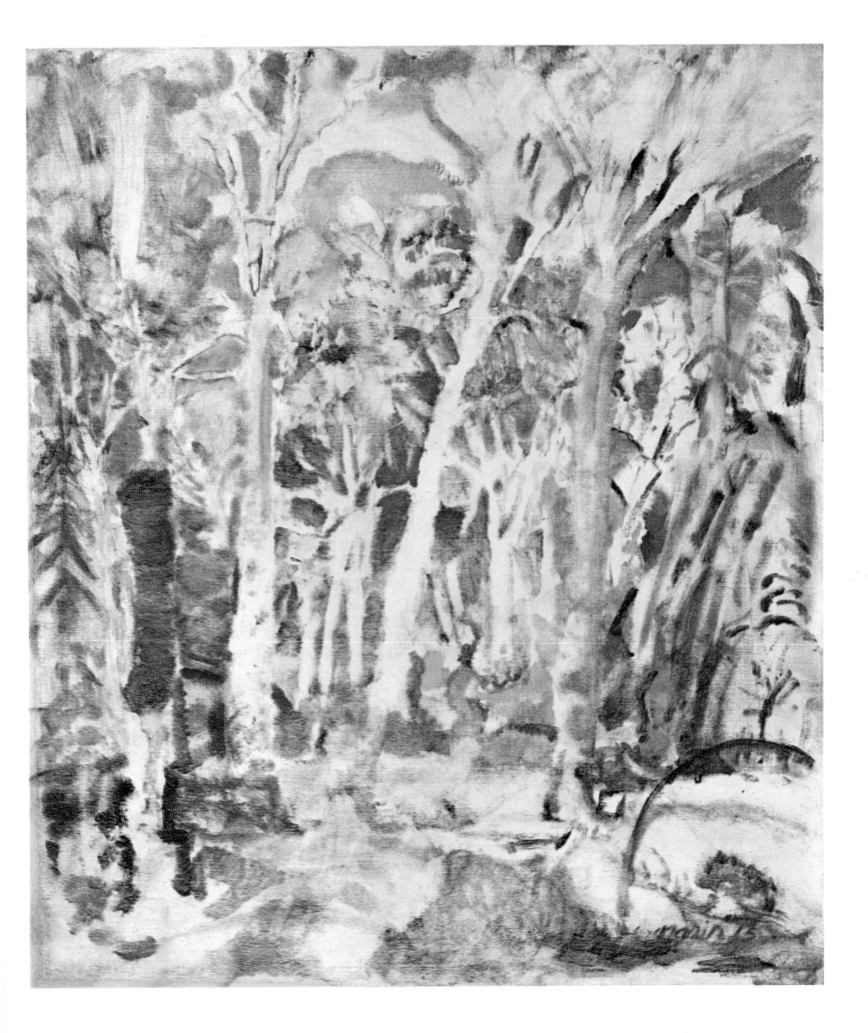

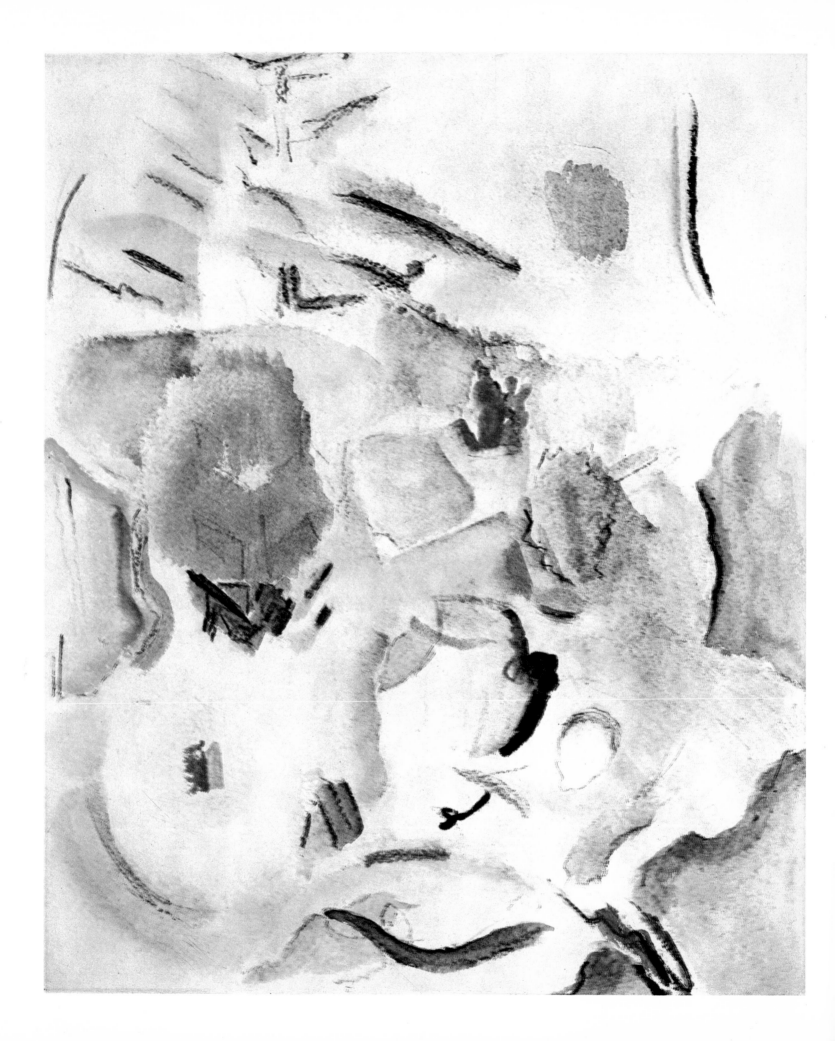

Tree Forms, Maine, watercolor, 1917.
The Metropolitan Museum of Art,
The Alfred Stieglitz Collection, 1949

REVELATION
a wonder word

There is a veil in front of the Artist
he's got to pierce that veil

For most—when they come upon the Strange—they are lost—

After or during the looking at the artist's work
 one says Oh I'd like to go to that country and see—
the artist has the right to say—Ah but you won't see that—I have
produced a world that you cannot see if you go there.

Note—When one says they like that one best—they are apt to like
the easiest for them to like—they are afraid of the unknown Ay—
they hate the unknown—But to the few—they will say Ah—you
have made me see things as they really would show themselves and
we didn't know it—You have given us the great adventure—of
seeing the beautiful unknown—You have brought the unknown to us
—You have gone into its Vitals—so that—that seen by the many be-
comes the unknown
 That seen by the few the Known—

All ancient art in its best periods was made to conform to the artist
a seeing as he wanted to see—he too had eyes and saw as all others
see—then he transposed to the great seeing in other words his was
a revelation in seeing

Juxtapositions in pictures can be startling
The revealing can be something that one would swear could not exist
These revealing sparks go back to the base of things for they are
revealed only to the receptive
From whence do they come—they come from the base source—
that gave out to the bird the building of the nest.

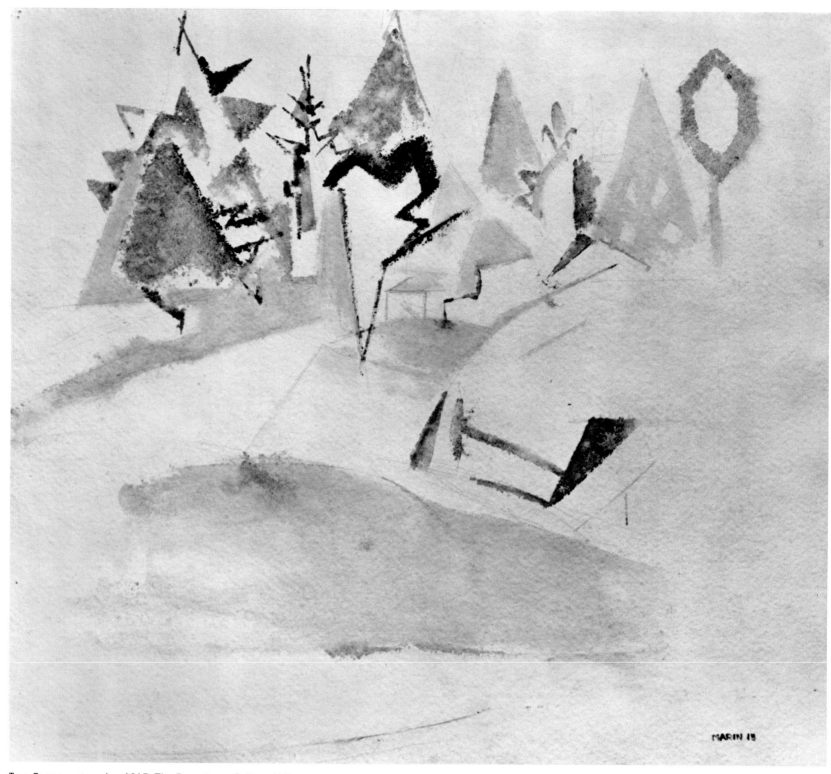

Tree Forms, watercolor, 1915. The Downtown Gallery, N.Y.

In nature
You see things objects back of one another
in painting they are all on one plane
therefore the great transposition
but there is no way out
You make things in paint as they are made in nature
things are built in nature things are built in paint

Abstractions are a self indulgence
Painting a universal indulgence

In nature no relationship
Everything asserts itself irrespective of relationship

An artist has to construct shapes seen—to his own shapes
the triangles and squares & circles which he creates he would never
have created if he hadnt seen triangles circles or squares in nature
all his life
so that's the source of his gettings—he being a natural object himself
he can never get away from this (his seeings his hearings) and they
register within himself and he uses them.

These—the artists of the world—are akin to the scientists only in that their effort is to bring things near but even there they part for the scientist must need use the telescope or the microscope whereas the artist brings them near in sympathy their far awayness is an inducement—an all worthwhile inducement—such that cannot be laid aside so that from his very nature he brings the far away up close in loving embrace. The minute you say beautiful evening star—You have done just that—brought its far awayness right up to you. To the one without imagination the far away remains—the near remains. The one with a full imagination loses the far away and he immediately begins peopling it with his imaginings. Those things near too he pushes into the far away & brings them back with an added seeing.

In nature there is distance. That this tree is here that tree a distance— the mountain off yonder—
But on canvas what distance have you—therefore all things are brought up to canvas focal surface.
 And in a sense there are no distances in nature. For the distant star becomes near too—the minute we look at it we bring it to ourselves in loving intimacy—so the distant mountains—loving them dissolves distance—the trouble with most painters is that they will never recognize this. Nothing to them gets intimate nothing near—They want to see the bare recognizable object but there is so much to the intimate things we love that they everlastingly recede and come forward and sway from side to side.

The Earth is flat
So the old ones—the ancients—were right after all—The Earth is flat
The Earth to man is what man can see of it—is a flat
and into that flatness there will be gouges—they will be the places for Oceans and the Seas the rivers the lakes the valleys
and onto that flatness there will be bumps—they will be the hills the mountains—and onto this the relative flats the bumps—hills and mountains there will be growth—trees—bushes—plants and grasses roaming about all over this movable life—

I would say that no two forms born are alike no two identical—a form based upon the idea of leaving out the Emotional will not raise that Stir for it is not sexual that all endeavour has to be sexual to be vital to give birth to any old COCK O ROBIN
and that's the trouble with most art endeavour it is not sexual— has no sex—that everything that lives was born of SEX

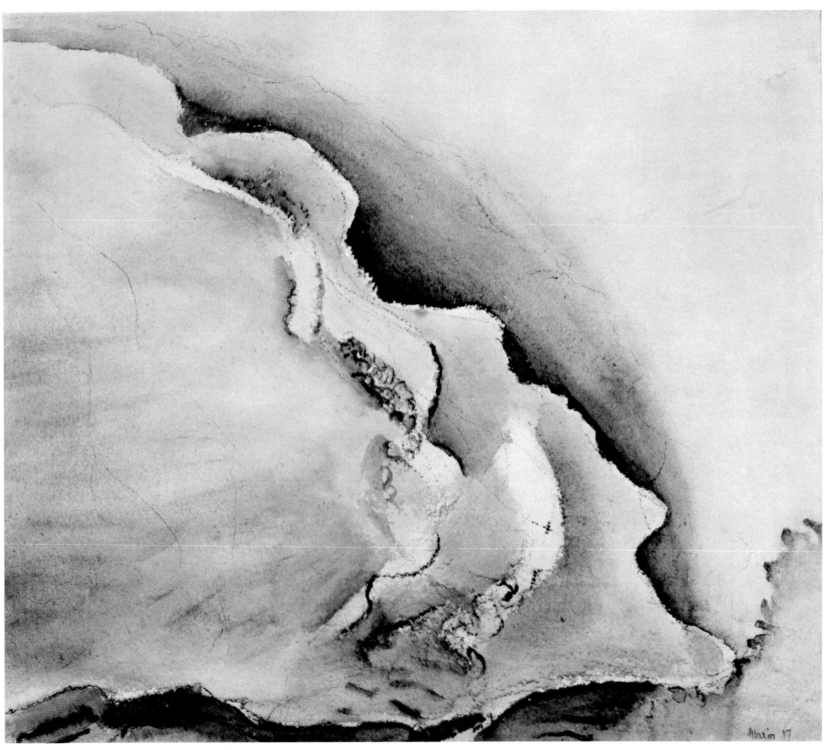

White Waves on Sand, Maine, watercolor, 1917,
Norma and John C. Marin Foundation

The East looks screened in
The West is a memory that we are constantly talking about.

Miles upon miles of level stretches covered with sage brush—with here and there a drop of a few hundred feet that would be a canyon— After that you proceed with the levelness again.

Hills & mountains of every color—some with little trees stuck in by the feller who made them.

The One who made this country this big level seeming desert table land cut out slices. They are the canyons. Then here and there he put mountains atop. A standing here you can see six or seven thunder storms going on at the same time.

A sunset seems to embrace the Earth
Big sun heat
Big storm
Big everything
A leaving out of that thing called Man
With his a moving about
 " " talk
 " " scribbling.

Blue Mountains, New Mexico, watercolor, 1929. Private collection

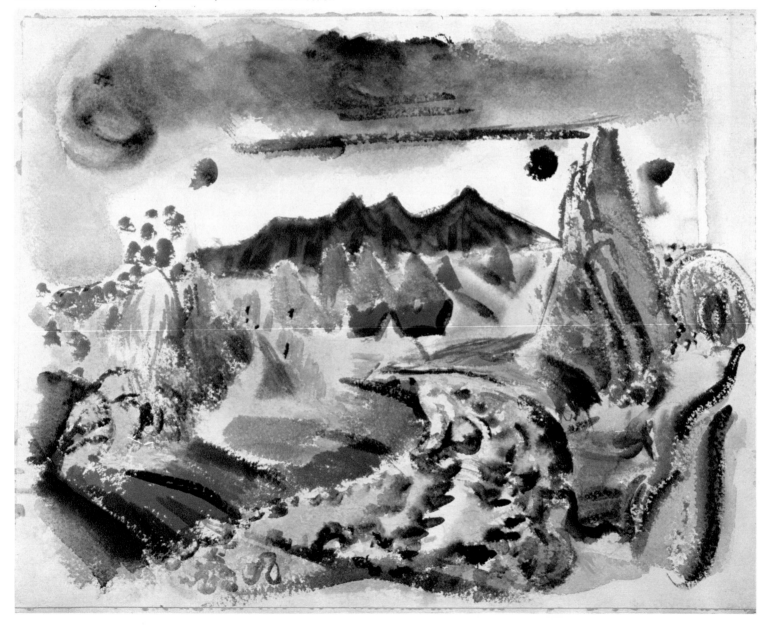

The Indians had a rabbit hunt a couple of weeks ago. <u>Yours</u> <u>truly</u> stumbled luckily right into the midst of it almost taken for a rabbit. The rest of the bunch here not so fortunate. So that I am at work on a rabbit hunt picture of immense proportions—size 8 inches by 10 inches. I am doing a bunch of sketches—the rest are painting pictures—As usual my studio is the big out-of-doors in the car when too hot.

The Taos Indian Rabbit Hunt, watercolor, 1929,
Norma and John C. Marin Foundation

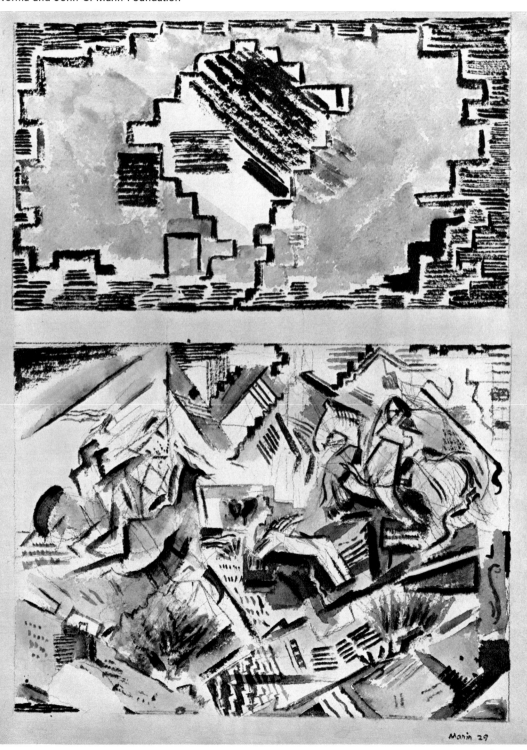

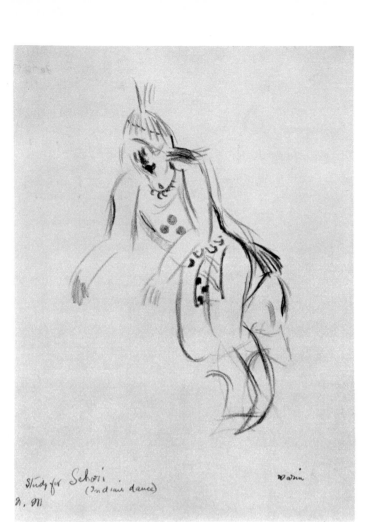

Study for Schori (Indian dance)
я, ЧП

Warin

Study for Schori (Indian Dance) N.M., pencil, 1929-30.
John Marin Archives

A big Indian dance I attended—I feel my greatest human Experience—the barbaric Splendor of it was magnificent.

The movements within movements are swell—and it kept up for hours.

I drove an hundred miles to this dance—but that's nothing here—the country is so damn big—So that if you succed in Expressing a little—one ought to be satisfied and proceed to pat oneself.

Tomorrow morning I expect to go the great San Domingo dance—I wonder if I'll get the Kick out of it that I got last year whether I'll feel like tearing up my picture made last year.

Later

I have been to the dance and since I do not feel like painting from having seen just now—I'll wait a while before tearing up the old—in fact fortunately or otherwise—cannot as it is in the Lincoln Storage.

Certain passages in the dance are so beautiful that to produce a something having seen it—becomes well nigh worthless it's like grafting on to perfection

it's like rewriting Bach.

To out brilliance the diamond—To out red the ruby

But man will always Continue it seems to try and do just that—

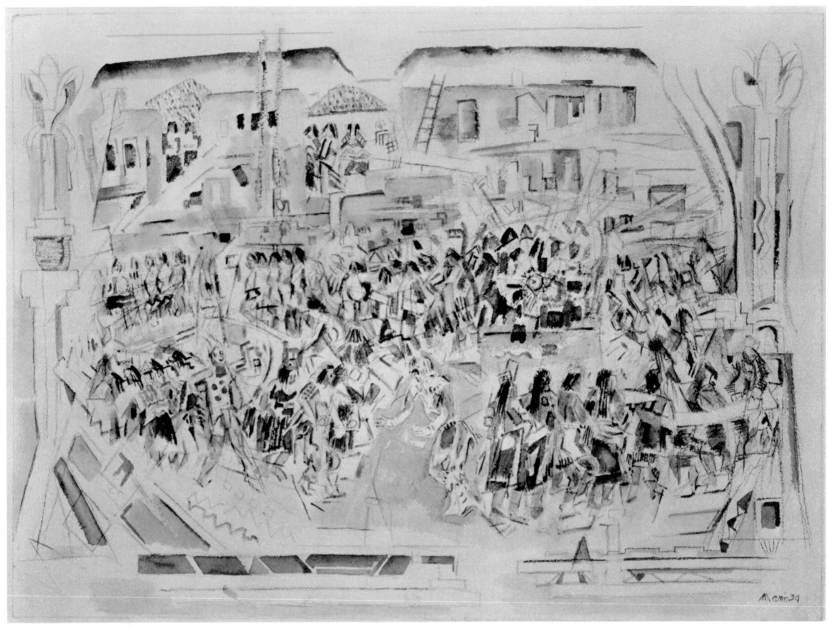

Dance of the San Domingo Indians, watercolor, 1929.
The Metropolitan Museum of Art, The Alfred Stieglitz Collection, 1949

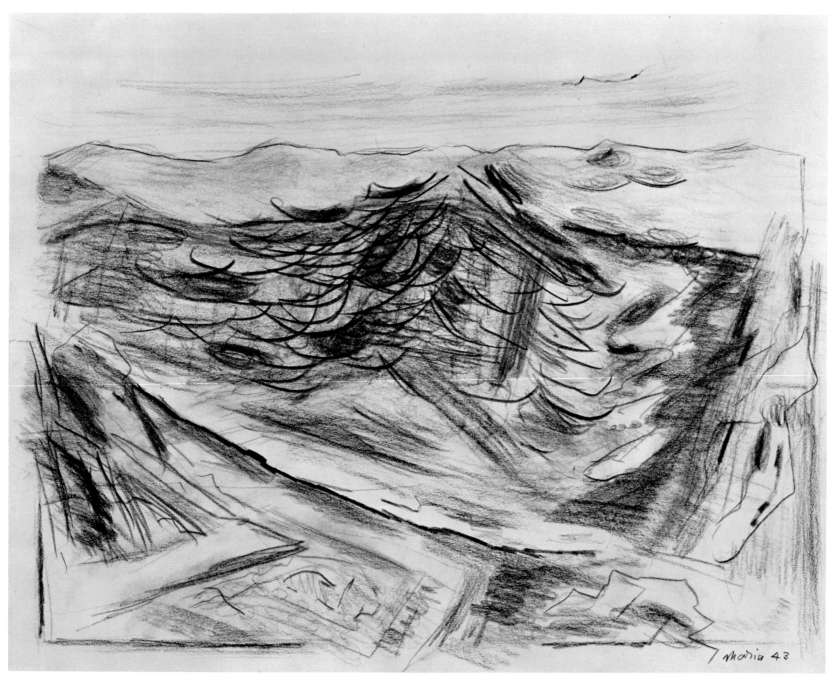

Waves, pencil, 1943. Private collection

Day before yesterday there were warning signals all along the Coast—telling—to pull in all small craft to safe places—Yesterday it broke loose and the wind she did blow a full gale and those long heavy seas do come a rolling up and a smashing on the ledges—all ledges sunken ledges ledges miles out—Well you see something.

as many as could piled into my car and went to the head of the Cape—to see—the Grand Sight— and with it all the air was so CLEAN. Those seas out there could take all the inhabitants of the Earth and SPEW them about.

Don't lok the tyrants up—make them look at this make them look from tops of mountains but alas you cannot get them there they cannot strut and do their stuff—but man's upheavals must take place too and maybe they cleanse the man atmosphere—too—there are those men who can look at this great—sea manifestation taking place—and there are those who upon looking can only think what it is doing to their own little tiny boat—The man who can look at this Glorious wonderful sea and too will take care of his tiny little boat —he's the fellow—

It's a blowing out there—The seas are piling in—

It's breaking over a sunken ledge out there—ordinarily one is not aware of—what does one see—one gets glimpses—a repetition of glimpses—and that—I would say is a multiple that we—critters— call seeing—which has—nothing to do with Mr. Camera—The nerve of them with their Mr. Cameras—Well—maybe—the nerve of me with my paint pots—

How some ever—we will—do what?—Why paint—Damn it—

The fog has come back. I am beginning to Enjoy fogs they are so tantalizing—they tease—they're so—now you do—now you dont't— sort of things—I'd advise one not to get into one in a tight place though—They're like a raging sea—better to see—than to hook up to—unless you belong.

Today it is a gale of wind from the North West.
 and
 There is a great Clarity

You go out to sea when it is running high and then you come back and say to yourself "How can I do anything with paint and canvas"

The sea—it's the sea—
The rock ledge—it's the rock ledge
The sea weed—it's the seaweed
The beaches—they're sand beaches
The fishes—they're sea fishes
The birds—they're sea birds
Trees—bushes—all—all of themselves—of their belonging—

"The Hurricane has just hit. The Seas are Glorious—Magnificent— Tremendous—God be praised that I have yet the Vision to see these things.

61

At present it is high water and the giant boulder just down below is fully covered by two feet of water—at low water—its twelve feet of bigness will be all revealed

—this is our tide measure—

The Ocean looks swell and big—there is much of it—

It is now a green grey and the rain clouds are a racing a top it—a spilling their showers on it—it can take it—it can take heaps and not notice it.

All the writings of man about it—all the ravings of poets about it—don't bother it a particle. It looks at its best in broad day light when it's all revealed in all its big—Saltiness—You Can Smell it afar off—when you are on it you are enveloped in its—Big Smell—

To bring something of this back—I for one—hope that I may—just a little—that my paint too shall Smell—a little smell—as a minute equivalent to that great—salty smell—out there. That it shall give forth an honest healthy Stench that shall—a bit—counterbalance unholy vulgarity . . .

The Wind is blowing a half gale from the north west. Three men in a small boat—they Crowd the boat—they are a going to one of the islands—her small sail makes for her to hum through the water.

I have stopped everything to paint that little boat—to surround it with the Sea and Still keep boat that's my job . . .

You Can't go modern—(up here you Can't—)

You can't go past—present or future—you stay put—this Confounded Big Ocean Sees to that.

Once in a great while it lets you—let out a little peep—and that's about all.

Isn't it funny that Dictators never never never live by the Sea—

The Sea looks Swell—There is a driving Easterly gale and the Sea Caps are a showing and the House is so perched atop the ledge that I seem to be right in it all.

Two days ago a seal seemingly stuck his nose right up to meet mine.

And a quiet evening not so long ago there were porpoises out there showing their black backs—a chasing a large school of herring—through the glasses you could see countless thousands (later—Mr Harry Wass says they were not herring)

And the Loons out there diving into the bottom after fish—and almost standing up in the water a flapping their wings.

Oh this is the life of a dozen Rileys and I don't have to stray farther than my sun porch to see it all—

Sea, pencil, 1943. Private collection

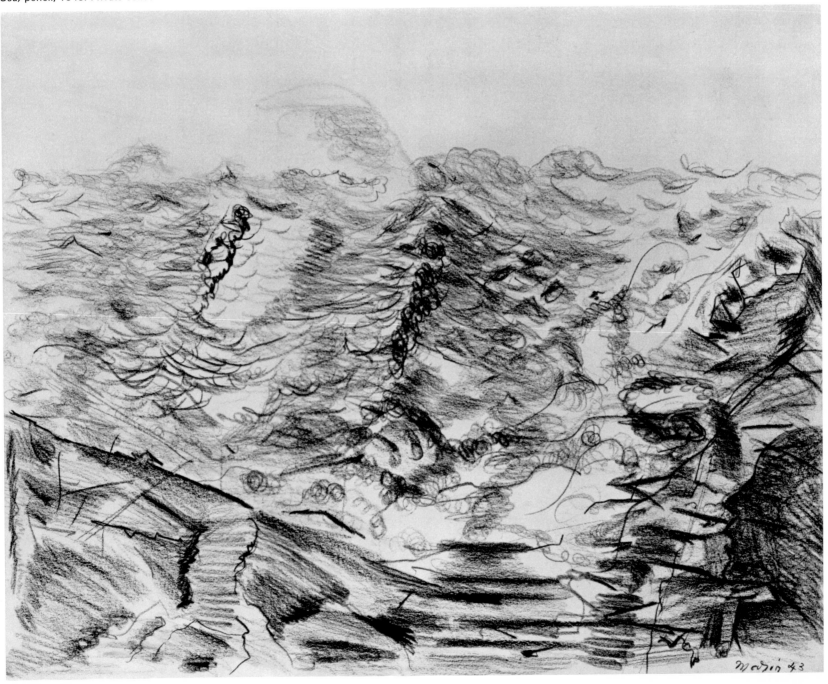

It is raining—Grey skies—Grey sea—scurrying clouds wind this way blowing that way blowing weather vane says Eastward and Eastward it is I guess—and the wind whistles that mournful sound and I like it for this time of the year for every year that I can remember other winds of other yearns have had this same tune—Every boat of every description has its nose pointed into the wind and it seems as if all the houses of the village are likewise pointed windward.

I am noticing these village houses more and more this year.

Maybe as I grow older I will look with more interest at houses.

Maybe having purchased a house I am kidding myself into an interest in houses

Yes my chief interest in life—I am strong on houses and islands— the Ocean can nuts—but houses & islands will have my help—Oh I forgot boats—so

John Marin { houses
islands
boats

Therefore

I don't need to paint masterpieces and be conceited.

Heavy Sea, oil, 1938. Collection Mrs. Duncan Phillips

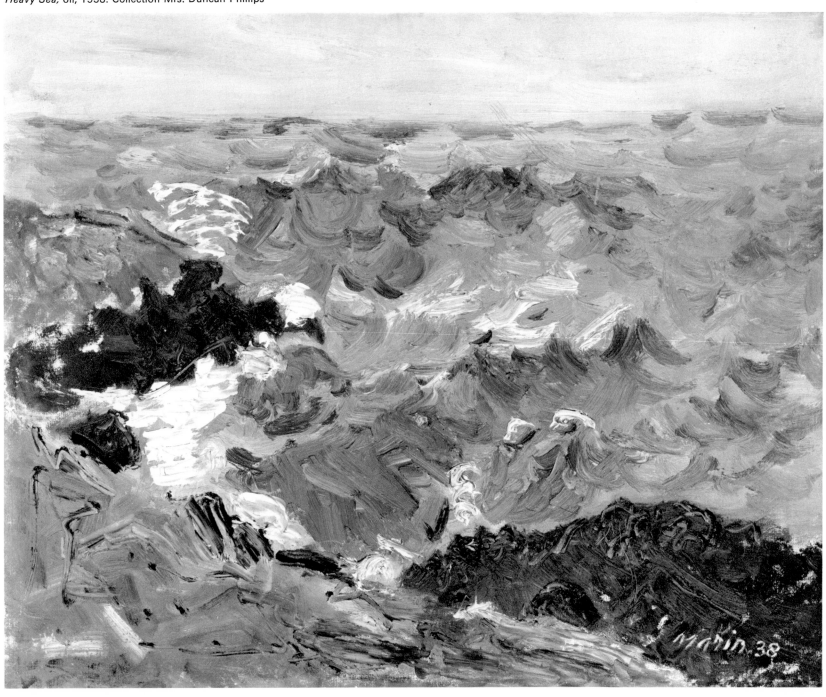

Discovered for myself a new island—a little place of enchantment. Safely moored the boat went ashore & painted a picture—I happened to be feeling just right

That boat of mine she takes the seas bully without much wash. In the afternoon it was quite choppy but I put her nose right up into them & said well if you want to go—go—if you don't—don't—Lord—

I lie in bed and about 4 o'c in the morning they start—Starting out—and I can detect Engine troubles in the different boats—I didn't notice it before—Then I laugh in glee & go back to sleep content.

Out in our little rocky jutting cove tosses our boat and how much it means for we could not do without it. Yes sir that little Object out there bobbing about on the waves bears us here, there & everywhere—you can never know what a boat means until you are stranded on an island—But it is a beautiful island and is constantly offering—Surprises. How tame an Estate seems as compared with it but then I don't like tame places.

The Little House, Stonington, Maine, watercolor, 1920.
Private collection

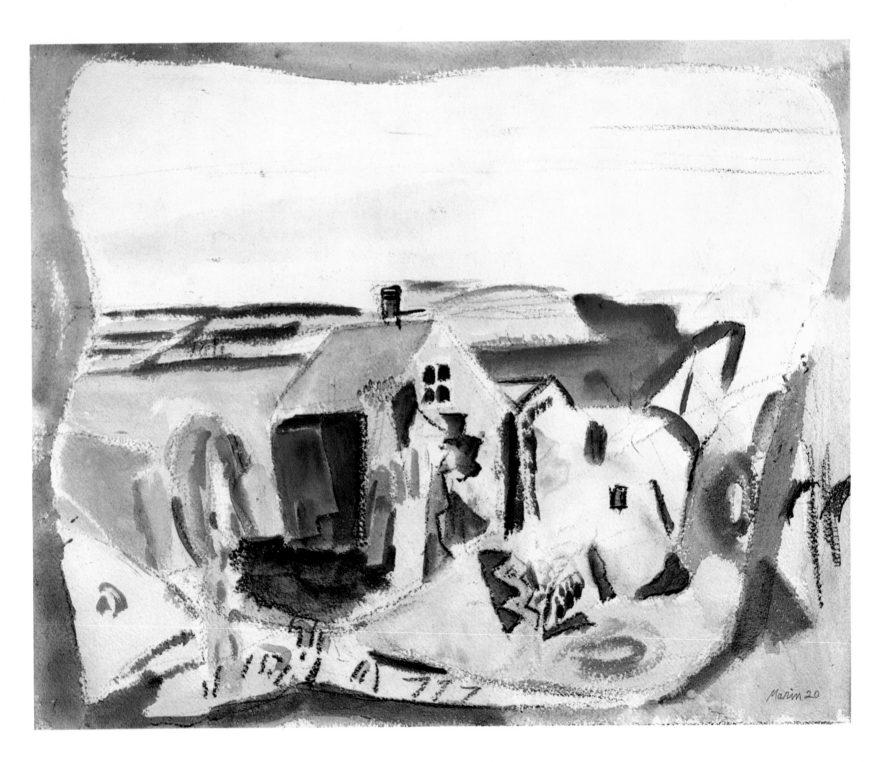

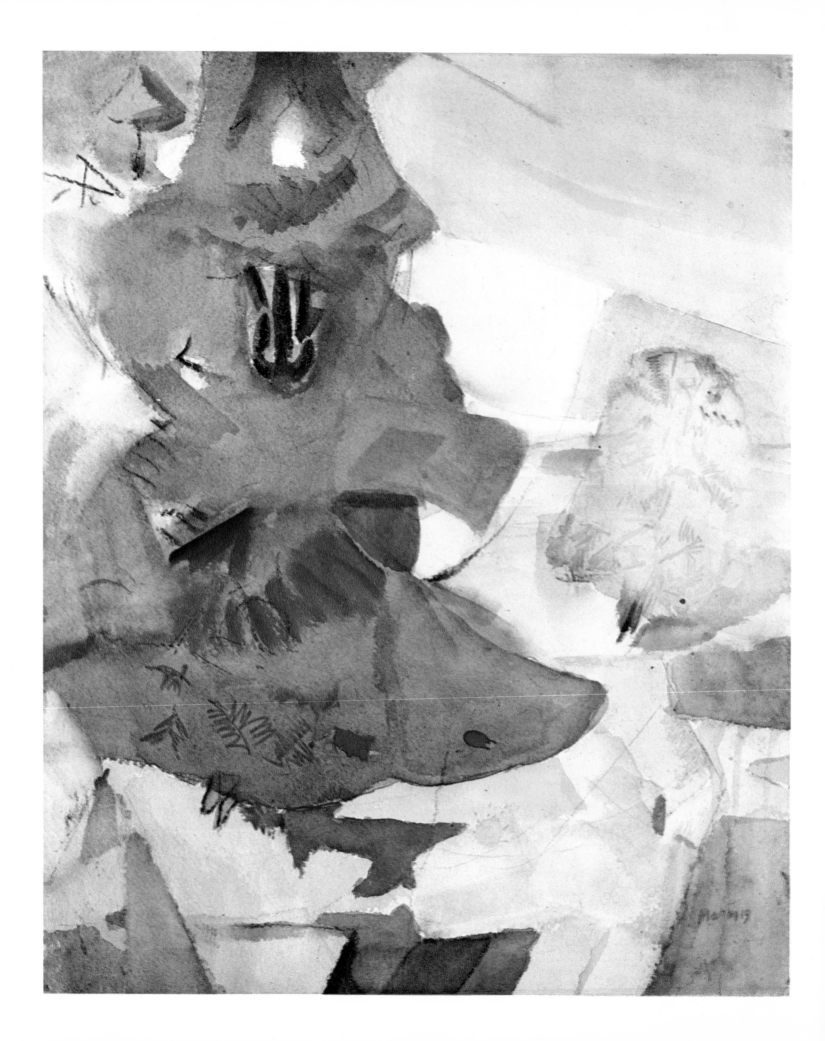

That my nakedness is for me alone not for them
That nobody can see as I see or what I see that nobody can move or
be where I am
That the daisy is seen by my eye alone
You my brother have too seen the daisy—well I am glad you did
that you too got pleasure but you saw your daisy I saw mine—

If you hold to the concept of seeing a human figure it will not look
good
If you hold to the concept of a something that has its own right of
existence then it will look good.

Supposing a man from another planet who had never seen a flower
and he was shown a flower—he could say—"I don't know what it is—
but OH I LIKE IT"—

What a wonder thing—seeing
What a life—seeing

THE SOUNDS OF INSTRUMENTS

It isn't that we are so wonderful
that our concepts are so wonderful
 Give the canvas a chance
 Give the paint a chance
 Give the brush a chance
 Give the pencil a chance
As in music
 Give the instruments a chance—their sounds
are quite beautiful

Weehawken Sequence, #3, oil, 1903-4.
Marlborough-Gerson Gallery, N.Y.

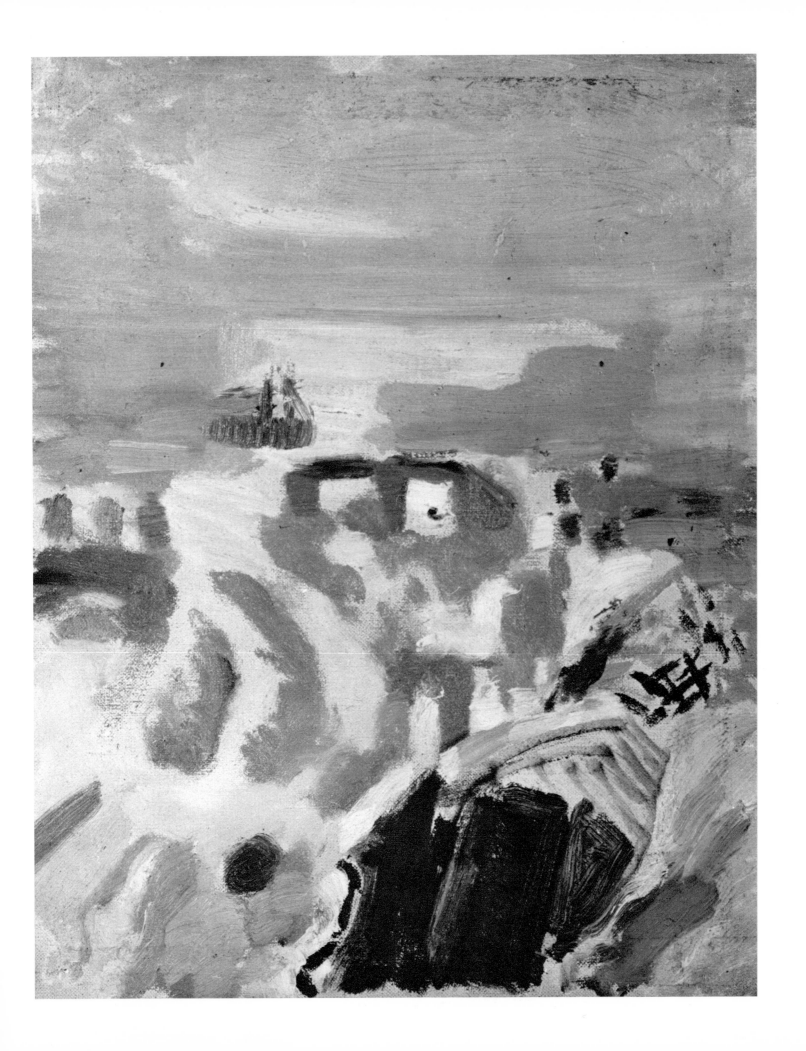

1

— The drawing —

 To begin

 When one speaks
of drawing — what does one mean to
Convey. Does it not derive from
motion gestures

 As an instance — a
story instance — we might read —

 The man draws a bucket
of water — for the horse to drink — whi
in turn draws him and his produce
to the village — where the buyer in
turn draws money out of his pocket
to pay — Then again — your attention
is drawn to something.

 . Quite a word — quite
embracing — quite alive — and cannot one
say — all alive gestures pertain to
drawing This image of a gesture
 — motion —
and it's these motion gestures that liven the artist

2

The direction movement of a wave — or what not — that impelled the first Artist man to pick up a piece of soft stone and go to a flat rock — and there start making gestures — and he — being an artist — felt movement in all nature — Even in — so called — still life — for nothing was Ever really still to him — and — since he was born the artist — Reverence — was in his nature — and — that being the Case — he Chose his flat rock to work on — not any old rock would do — and there was about that he did — That intangible something — that inner vital spirit — that wouldn't allow him to Copy his factual seeings — but his seeings were processed through his being into his own way of wanting to see — so he proceeded and what was revealed was —

3 the rock – with those lines –
his drawing – the rock Taking
on a new life – with its drawing
on it – Thats what he did –
Thats what he wanted – for them
to live together and – The man
who made this unity – looked –
and was – happy –

and
What if those drawings
he made – making the lines and surface
a oneness – were seen centuries later
by the archiologists – the historians
and interpreted by Them (The story
of a Time) – He who made Them
took his seeings of his Time and made
his Creations with – no thought
of interpretation – or – as helps to
an understanding of his people
and
One Cannot say he – dedicated – his
life to this – no –

4 he had no say in the matter .
 — he just had to — as one just
has to breath — eat — and sleep —
to live His outpourings resulting
from the pleasure given him on seeing
the great and the small movements
— seeing the wonder of Ballance
— hidden to the unseeing — He
— a Canny observer — of the inner
— the outer — the under — the above
 So — of course the story.
of his. time was told — living his time
abundently he most naturally ex
pressed his time and it was not
difficult for him — no more than it
was difficult for Shakespeare to
write his plays — for if it had been
difficult — those plays would never
— have been written — repeating
— that which is within the Creator
has to come out
 Back to the drawing
most drawings are unworthy of the paper
whereon they appear

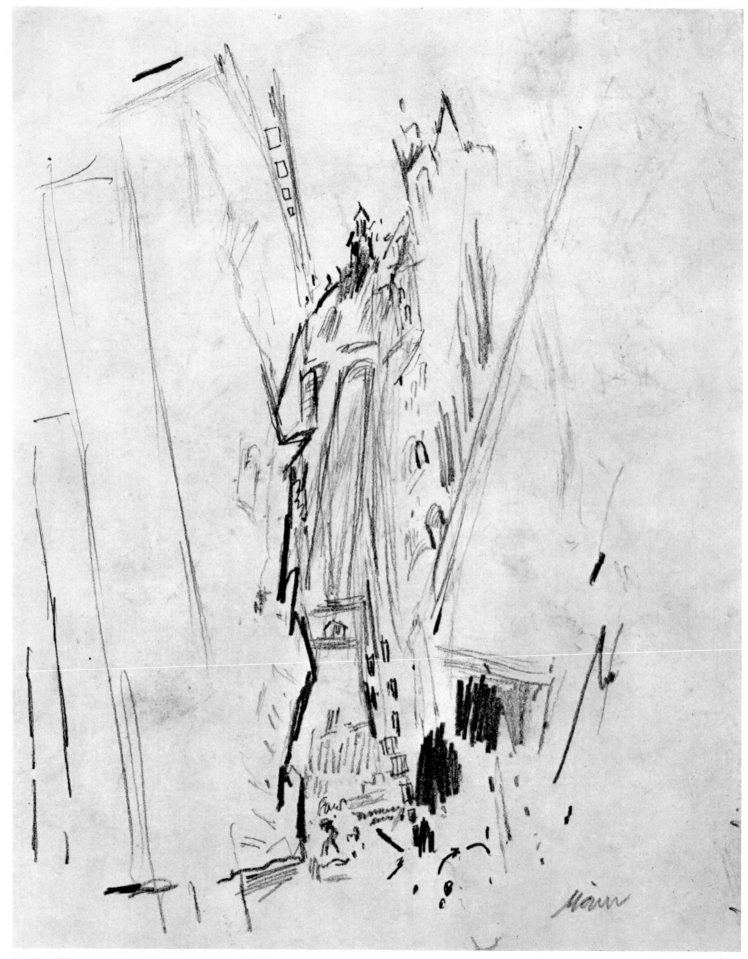

Untitled (Movement, Singer Building), pencil, *c.*1916.
Marlborough-Gerson Gallery, N.Y.

5 (if so happen that its good paper)
and if good — the Crime — of placing
bad on good — "Look at that Beautiful
sheet of paper" — What a desecration
To place an ugly drawing on it.
 — To be unworthy — who
can Tell? Who? — it will be Told
Eventually — it Tells itself —
 this unworthiness
whether relating to my work
 your work
 any ones work
we are each and Every one of us more or less
unworthy — There is This Though
Those of this world whom we respect —
who have given delight — who have given
Their all for better or worse — They —
Those whom we Term — Artists —
they have this in Common
 — respect and reverence —
and — I will Tell you This
 the True Clown should
Command This respect & reverence — as Too
The Kitten at play — as Too all whimsy

6 — all delightful — cut up — for coming
back to Shakespeare again — he —
you know — wrote Comedy as well
as Tragedy — These Two preserve
lifes balance —
it would almost
seem an axiom that there is no one worthy
to Train the gifted one — if not quite an
axiom it certainly Takes a gifted one
to help — for — Take the horse of spirit
— you can train that horse to the degree
that there will be no spirit left.
Train the — Hermit Thrush — might
not the lovable note be lost —
— Back to the drawing —
All the advertising in the world cannot make
a bad drawing good
Now — What is
good drawing? What makes for it?
— is it not This —
the line that lives of
its own right — a nervous Tension in
all its length — that Travels livingly on
its surface — and all these lines
living Together and so placed that there
is formed in unison with that surface —
— A composing —

— Again The line —

Its often said —
" that has good lines " — but its
not just the outer line — its The inner
line that preserves the ballance
— that Ever changing line — a Constantly
Changing with the movements of the object
seen — Even the mountain looked at
in its many attitudes —
 Comes the Artist — he sees
— he plays round about — never losing
its magical existence
 and as The beauty
of the flower is intangible and since you
Cannot Copy the intangible — so it follows
— this drawing we speak of is
intangible Then The — paradox —

is not The Artist — he — who makes the
intangible to — blossom forth — into a
— seeings — which for — seeing ones —
is about as Tangible as is any thing on
This Earth for what its worth
 John Marin

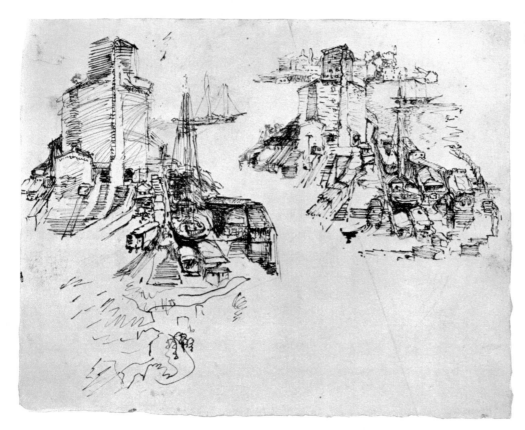

West Shore, Riverfront, Weehawken, N.J., pen and ink, 1903.
Marlborough-Gerson Gallery, N.Y.

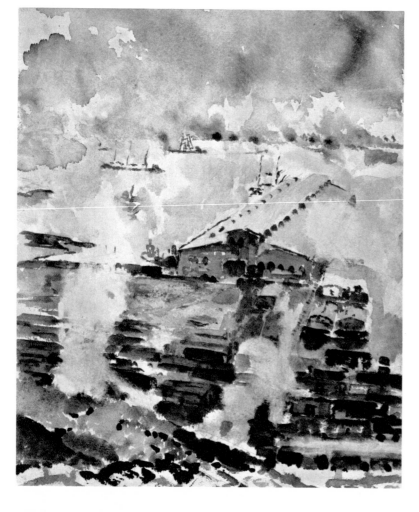

A curious thing is why should a man allow himself to paint in oils before he has made drawings and wash drawings.

Drawing is the path of all movement Great and Small—
Drawing is the path made visible—
Yes—the each separate line—the each separate spacing—to live and play with Each other
 and this symbol of flatness—the sheet—
and that that occurs thereon—the line—is no small matter
for does it not embrace Our Earth and all that occurs thereon.

Untitled (Railroad Yard and Pier, Weehawken, N.J.), watercolor, c.1910.
Marlborough-Gerson Gallery, N.Y.

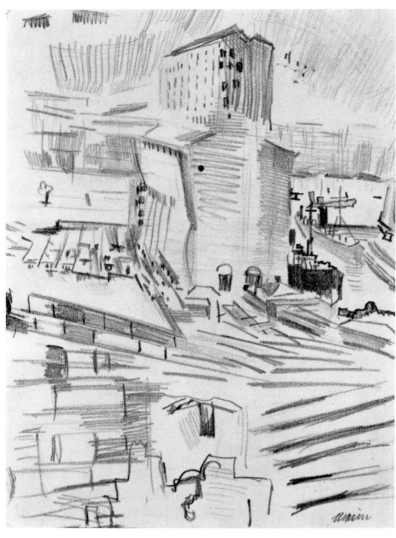

Untitled (West Shore Railroad Yard and Grain Elevators at Weehawken, N.J.), pencil, 1915. Marlborough-Gerson Gallery, N.Y.

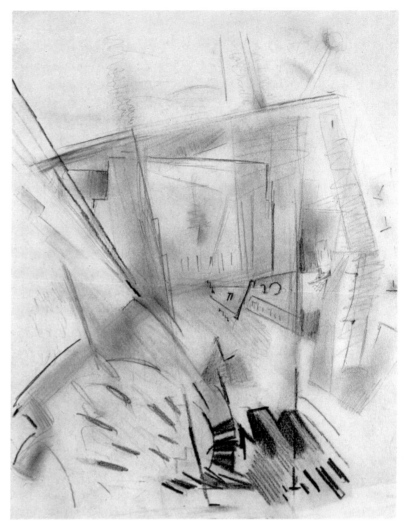

Untitled (Grain Elevators, Weehawken, N.J.), pencil, c.1915. Marlborough-Gerson Gallery, N.Y.

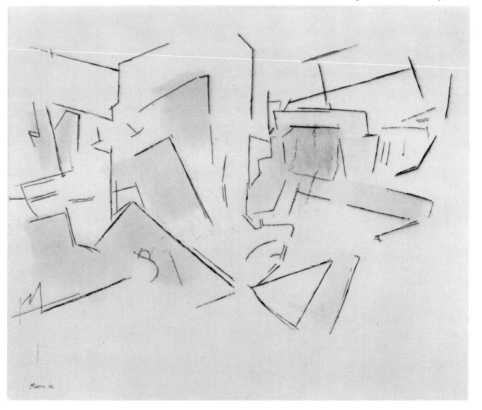

Movement, Grain Elevators, No. 2, engraving with offset areas, 1916 (Zigrosser #128). The Philadelphia Museum of Art

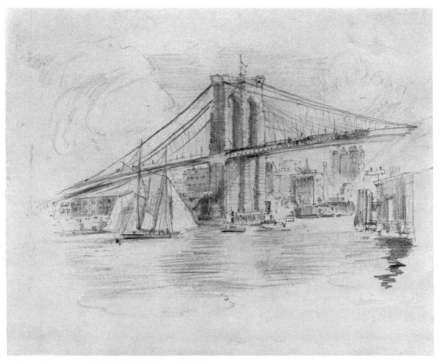

Untitled (East River and Brooklyn Bridge), pencil, 1910
Marlborough-Gerson Gallery, N.Y.

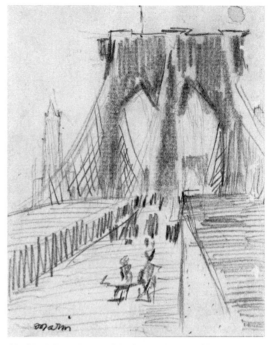

Untitled (Brooklyn Bridge), pencil, *c.*1915.
Marlborough-Gerson Gallery, N.Y.

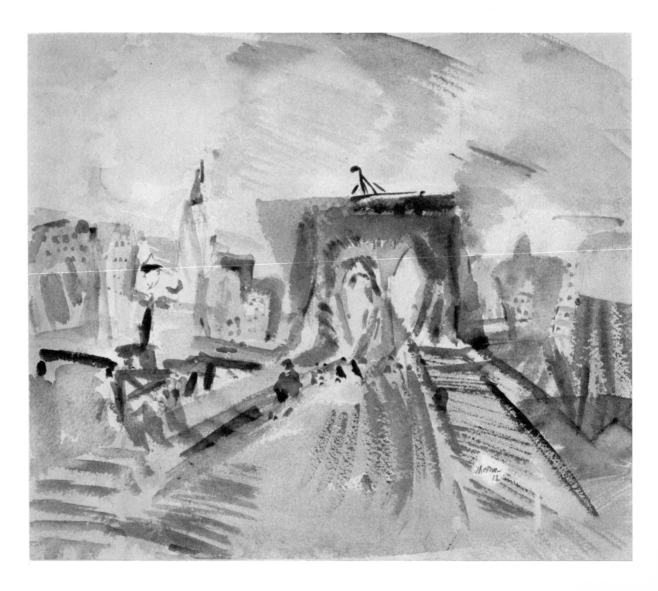

Brooklyn Bridge Series,
No. 12, watercolor, 1912.

Marlborough-Gerson Gallery, N.Y.

Untitled (Bridge), pencil, c.1913.
Marlborough-Gerson Gallery, N.Y.

My line pulls that weight down—my line pushes that weight—
my line can swing a thing in any direction—
truly <u>wonderful</u>—it can hold it can release.

Search for the back bone—as it were—of each object then it becomes
easy to draw the object.

All these movements of the hand—obeying—the inner urgings of man.

 taut taut
 loose and taut
 electric
 staccato

Brooklyn Bridge No. 2, (Song of the Bridge), etching, 1913.
(Zigrosser #109) The Philadelphia Museum of Art

In spite of their shortcomings these drawings of mine gave me certain pleasures to do then to look at

That they give pleasure—that they give Something of the Great City—together with the feel of other wanderings—circus—mountains —and seas—to others—is my hope—

Let's try now try to illustrate a point

this is the prow of a ship I draw abstractly it's cut up yet not cut up it does things it assumes directions and leanings yet is not really cut up—In all its movements it remains a whole it doesn't lose track. Mr Fisherman, he don't maybe understand yet he's made to feel something like he feels as he knows prows of ships—

I make a second drawing like this—

abstract—Why of course

Superior intelligence—why of course

—Mr Fisherman—

"Oh Hell man your prow is digging down into the waves it's— too—being bent aside—"

he's really worried now he's cause to be You've made a fool concrete thing unworkable—when you assumed in your wonderful intelligence that it was a felt abstraction.

They—the drawings—were mostly made in a series of wanderings around about my City—New York—with pencil and paper in—sort of—Short hand—writings—as it were—Swiftly put down—obeying impulses of a wilful intoxicating mustness—of the nearness—nay— of the being in it—of being a part of it—of that—which to my Eye went on—of the rhythmic movements of people on Streets—of buildings a rearing up from sidewalk—of a sort of mad wonder dancing to away up there aloft—
for

 Everything became alive each a playing with and into each other like a series of wonder music instruments

City Hall—World & Tribune, N.Y.C.,
pencil and crayon, *c.*1924.
Marlborough-Gerson Gallery, N.Y

Untitled (Lobster Boat),
pencil and crayon, *c.*1940.
Marlborough-Gerson Gallery, N.Y.

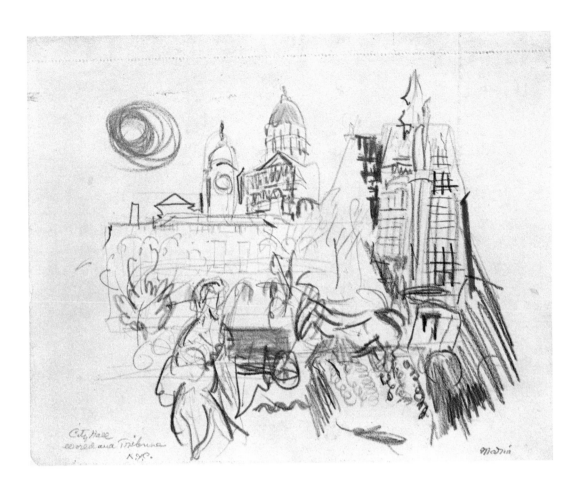

City Hall
World and Tribune
N.Y.

Marin

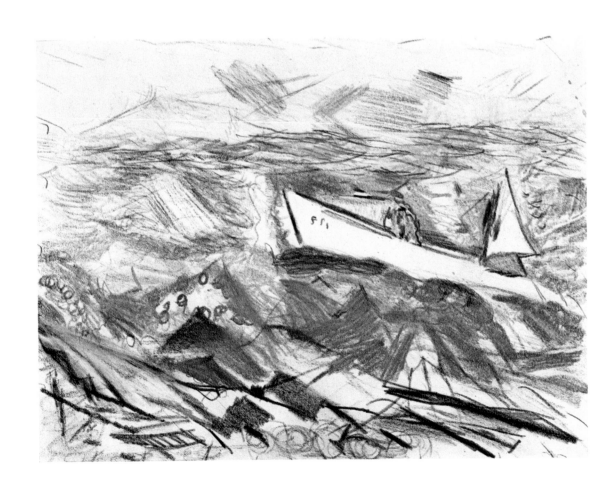

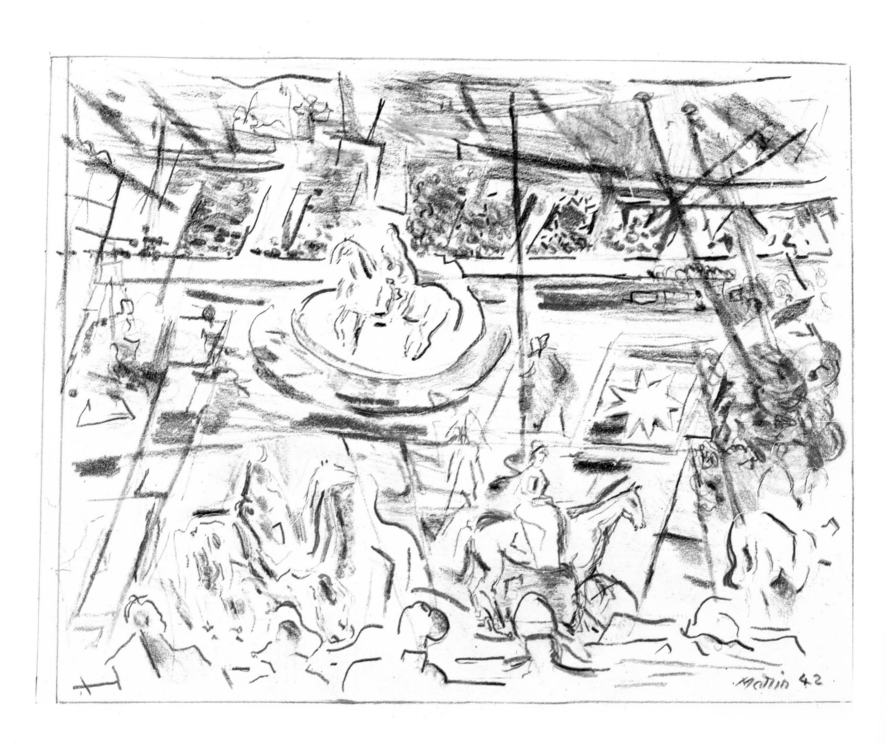

I guess I am getting too old and critical—The man in the Lion cage left me angry—in the cage with the Lions they had a couple of mongrel dogs a couple of bears and some rabbits cats rats and mice for all I know—then his nibs—the lion tamer—first of all he was a foreigner—the showing off brand—(Me greata da big a da man stuff)—a cracking his whip with every breath he took.

Now we Americans can and do put on the show off stunt quite often but we have just a little bit of that saving grace call it our humorous streak or something like that.

Yes I sort of felt I wouldn't have minded too much if one of those lions had made a real pass at him.

Then the Elephant show—it seems to me that the Elephant is too fine a beast in his own right to be taught a damn bunch of fool tricks and to be dressed up in pettycoats and didoos.

Oh yes—I still love the Circus . . .

Untitled (Circus Elephants), pencil, 1941.
Marlborough-Gerson Gallery, N.Y.

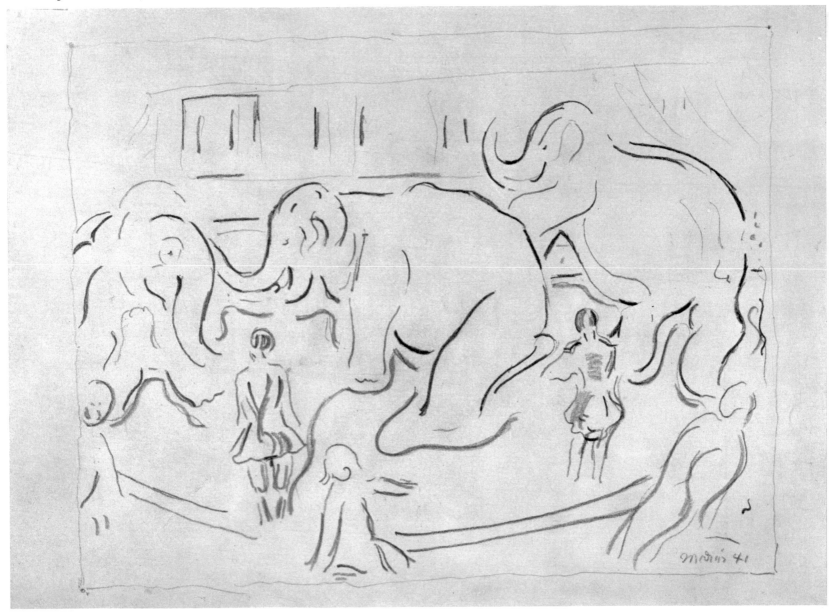

The drawing is a form of symbolic writing

Draw it carefully in your mind
Then write it down quickly
in other words to draw a hand you see it before putting it down then
write it down quickly under the spell of seeing Everything is to be
rhythmic

When you have to use conviction
you haven't got it

Untitled (Circus), pencil and watercolor, 1940's sketchbook. John Marin Archives

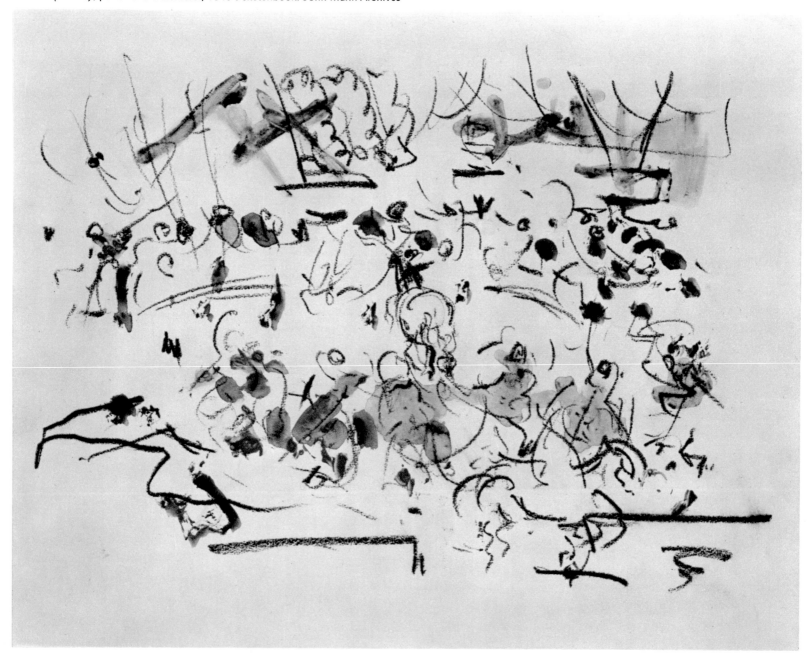

Untitled (Circus), pencil and watercolor,
1940's sketchbook. John Marin Archives

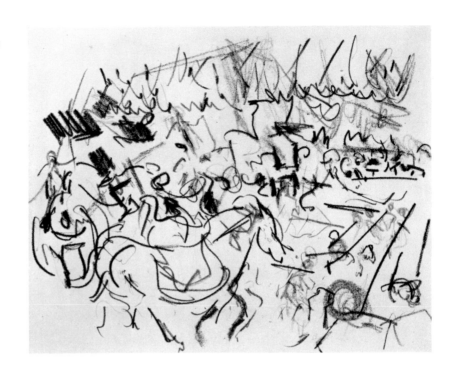

Untitled (Circus), pencil and watercolor, 1940's sketchbook. John Marin Archives

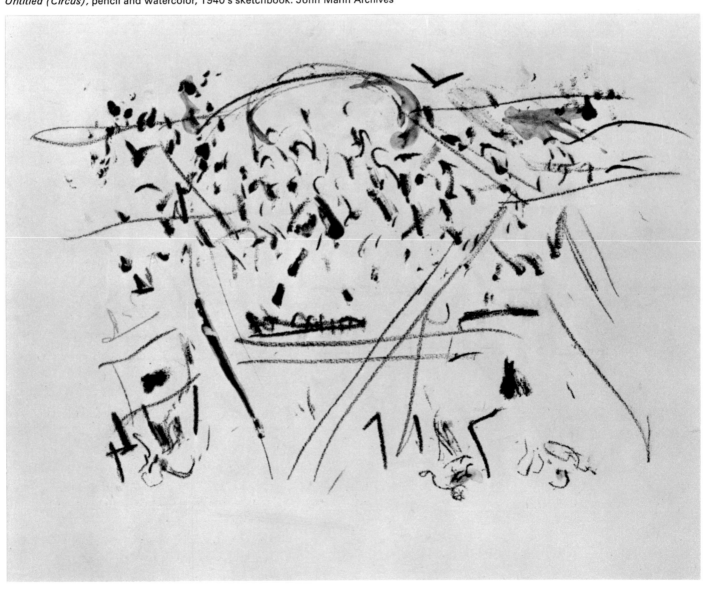

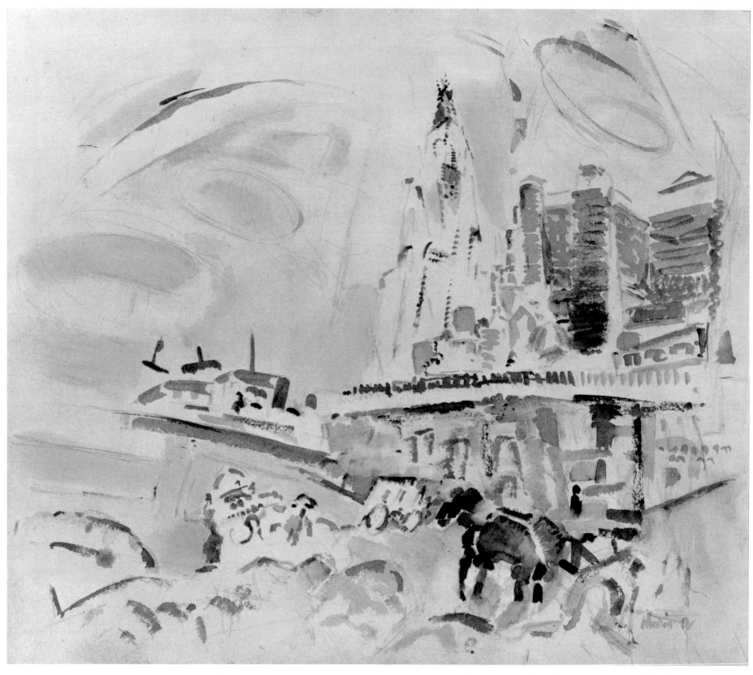

Downtown, New York, watercolor, 1912. Private collection

Woolworth Building, pencil, *c.*1913.
Private collection

I have just started Some Downtown stuff and to pile these great houses one upon another with paint as they do pile themselves up there so beautiful, so fantastic—

at times one is afraid to look at them but feels like running away.

Do you want to know what I think about etchings and what they should be? Well, little letters of places. You don't want to write a volume to give tersely, clearly, with a few lines, each individual line to mean something, and there should be a running connection existing throughout. There you have it—lines, letters; letters, words; words, a thought; a few thoughts and you have your line-impression of a something seen and felt.

Woolworth Building No. 1, etching and monotype, 1913 (Zigrosser #113).
The Philadelphia Museum of Art

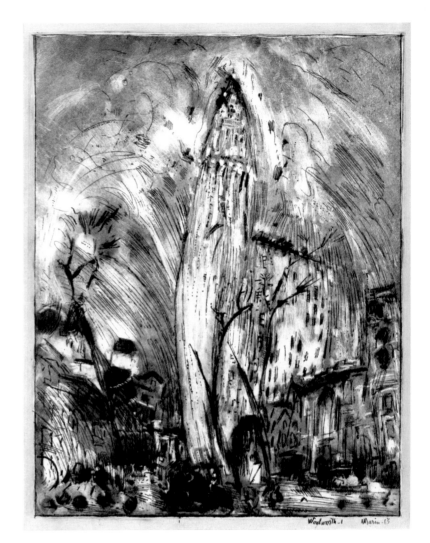

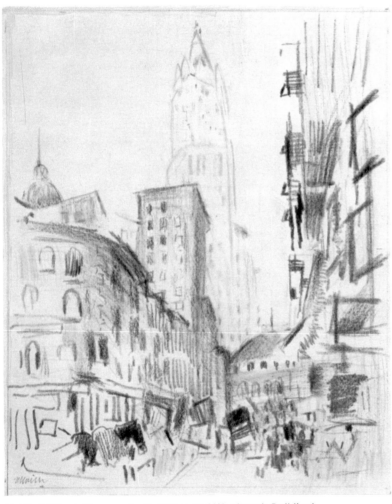

Untitled (Street Movement—Buildings and Woolworth Building),
pencil, *c.*1914-21. Marlborough-Gerson Gallery

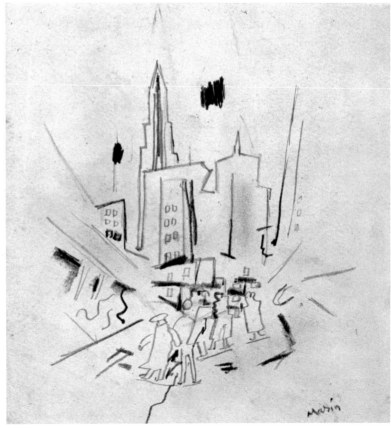

Untitled (Street Movement—Woolworth Building, N.Y.C.),
pencil, *c.*1928. Marlborough-Gerson Gallery, N.Y.

Paint until you feel you are down to the surface
Example (as the ocean)
then work on that surface

In painting water make the hand move the way the water moves—
same thing with everything else—

My passion now seems to be to recognize paint. The old masters'
seemed to be to use paint to recognize.

If the musician could say I will write music to recognize my instru-
ment—if that could be uppermost—and not I will use the instrument
to express my own recognitions . . .

The wave a breaking on the shore—that starts something in the
artist—makes for him to hum—that's the story—it's for the artist to
make paint wave a breaking on paint shore
 That takes nothing away from nor adds to the—wave a breaking
on the shore for that exists in itself as a beautiful thing—therefore to
assume to copy—is vile—
That wave a breaking on the shore can as I said—start—the start of a
wonderful thing by the artist.

So maybe I'll start painting—if I do—I shouldn't wonder but what
I'd paint Rocks—Sea—Sky—and Earth—
 and I'll probably use plenty of Paint
 like the feller up here said about baking beans—Plenty of Pork—
Plenty of Pork—Plenty of Pork—

As to my doings—my makings—on canvas and on paper—of oil
paint—of waterpaint—of a quiet realized recognition of—of a
difference between—of a stretched canvas—as a burden bearer for
to tenaciously grip and to hold and to bind its expressing oil paint—
of a white paper—of itself—of a quality intrinsic—for to hold—for
to show—of itself and its water paint talk.
 There seems now to be a benefit found in the working of these
two—in the working of others than these two—
 Of one offsetting another—of a greater understanding of each—
thereby of a seeing of each thereby.

There are some things we know—like—we are going to have baked
beans for dinner—and—I know—that—I am going to eat too many—
baked beans—that I know pos-i-tively.
 Also I know that when I quit this Expression in Water Colors—
the which I am now playin with—and get to the dignified—the high
muck a muck medium Oils—I know that my clothes'l a 'gin to have
paint spots on 'em and that my wife'l a'gin to say things.

Popham Beach, Small Point, Maine Series No. 1, watercolor, 1928.
The Metropolitan Museum of Art, The Alfred Stieglitz Collection, 1949

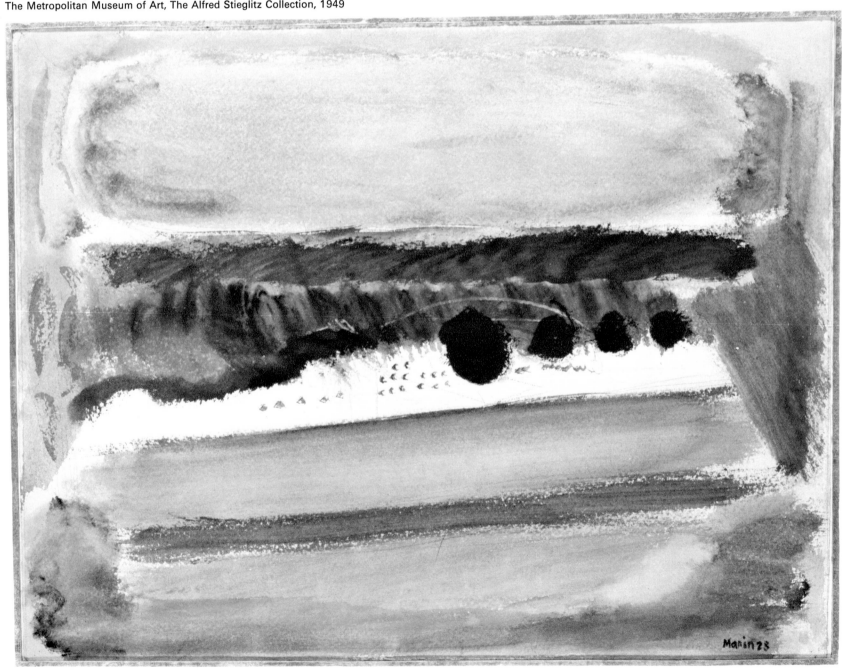

The picture—straight forward honest to goodness painting—never forget the paint—watch it—look at it going on

Art is produced by the wedding of man and material—When man uses material to the glorification of self he's—damned—

 When man loves material and will not under any circumstances—to the best of his abilities—destroy its own inherent beauty

 <u>then</u> and then only can that wonderful thing we call art be created

Paint should never lose its flow—it will lose that inevitably if you copy—that's—the life of the painting—its flow.

And all forms in the hands of the artist take on a related familiarity to nature familiarity—they are forms in paint welded together so that it exists as beautiful paint and nothing else

The piano has a sound of its own

 " flute " " " " " "

 " violin " " " " " "

When man uses these instruments to the very killing of themselves and when man uses paint to the very killing of its own paint life one must feel a vital miscarriage.

White Mountain Landscape, watercolor, 1927.
Marlborough-Gerson Gallery, N.Y.

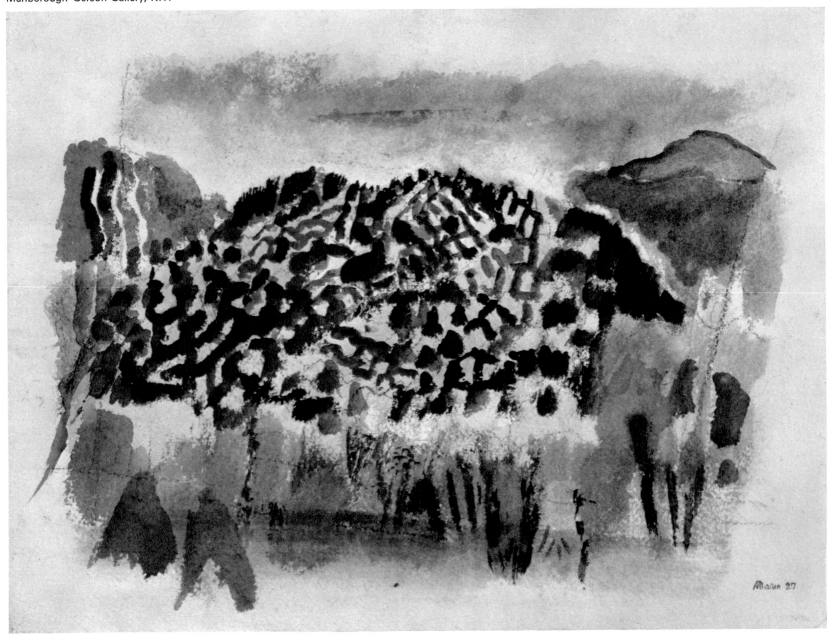

This Sea—makes me to get out the paper and start to work—
I did start—I went ahead—I finished—I slapped a boat in there—
plenty of wind—so I heeled her over—there now she moves a
painted boat in a painted sea—

her grey green paint Sea a sea curling white about the boat a sea
curling white about the ledges and if you put on the paint right it
will find its own depth and if you paint the boat right it will tell its
own story—if story there is—to be told

but again paint the boat right and forget the story

paint the sea right and forget the story

an afterthought—(forget the story—quite impossible)

This is a tactile thing—to paint with paint and feel that paint

What did you paint it on (on paper)—Well then why in the Hell
didn't you give the paper a chance to show itself?
—ditto with Canvas—

Give paint a chance to show itself entirely as paint

My dory needs painting—I may suppose it is Easy to paint a boat—
but—it isn't Easy to paint anything—to really put it on so that one
Knows it is painted—

Using paint as paint is different from using paint to paint a picture.
I'm calling my pictures this year "Movements in Paint" and not
Movements of Boat, Sea or Sky, because in these new paintings—
although I use objects—I am representing paint first of all and not
the motif primarily.

What do the objects sit on—they sit on the paint therefore the paint
must be strong enough to hold them.

Anyone who paints is a damn fool—unless he be a born damn fool
then he has a right to paint.

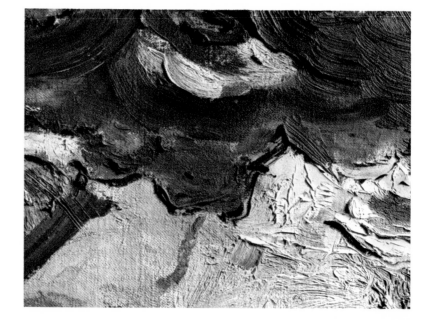

Detail of *Vicinity of Cape Split, Maine,*
oil, 1937

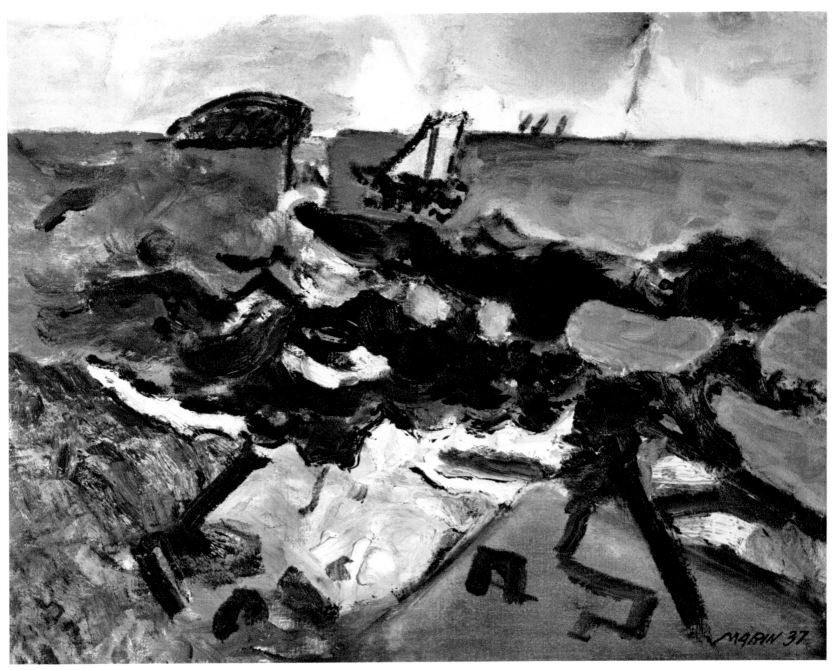

Vicinity of Cape Split, oil, 1937. Marlborough-Gerson Gallery

Every Artist draws the object and through his Existence the objects he places on paper or canvas will have his Stamp—If he's warm blooded his objects will show it—If cold blooded—will show it— If generous will show it. If mean will show it. If normal will show it. If a pervert will show it. All objects will show his disposition no matter which way he turns no matter how he shows—he cannot Escape that—his tell tale disposition. A Guillotine is strongly made but its purpose is seen.

. . . that they have the music of themselves—so that they do stand of themselves as beautiful—forms—lines—and paint on beautiful paper or canvas—

Shadows are the bugbear of painting. The recognition of them leads to all the copying of nature. The thing is to place planes of flatness next to [the] object then nail that object with drawing.

As one sees not a line in nature
 lest it be such as a hair—a cobweb—a grape vine—so that a line
in pictures becomes all the more wonderful
in other words
 drawing and paint side by side make for the Splendid

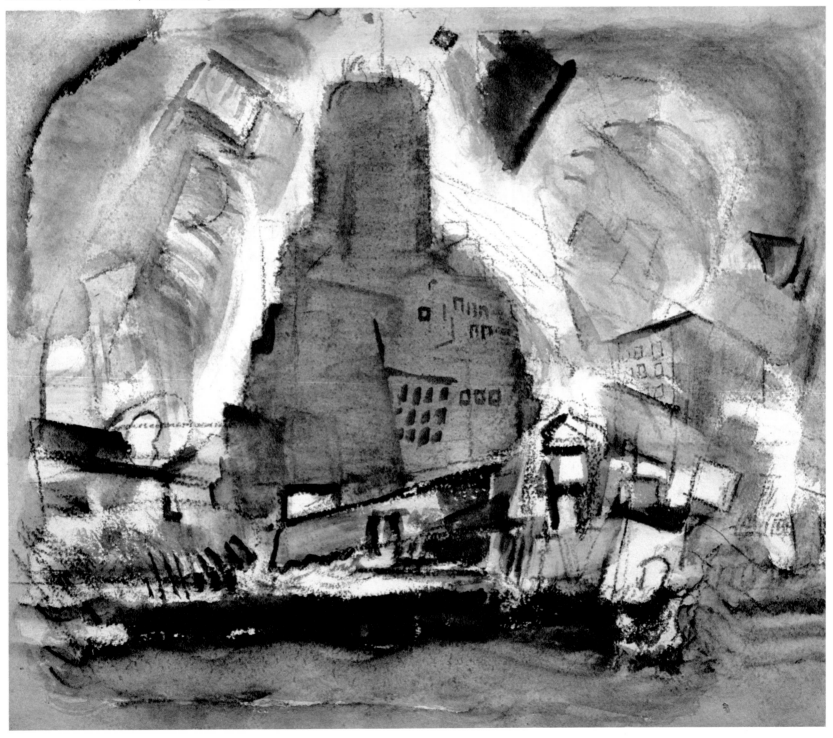

Downtown, New York, Telephone Building, watercolor, *c.*1925. Private collection

THE PICTURE CONCEPT

The good picture—
No one wonders at more than the one who Created it—
 Made—with a inborn instinct—which in time begets
an awareness—and these periods of awareness are—
The—red letter—days in the Creator's life.
 Made—by an instinctive recognition of the—Basic—
 The great Horizontal—the Culmination of rest
 The great Upright—the Culmination of activity—for all
things Sway away from or towards these two—
 A recognition of the back bones—as it were—of
movement—all objects within the picture obeying the
magnetic pull of these backbones—
 Having not—these back bones of movement—in the
mind's eye—there can be no real creation
 Having—one goes not far astray—pulled back by an
awareness of these—

Movement, Lower Manhattan, watercolor, 1932.
Marlborough-Gerson Gallery, N.Y.

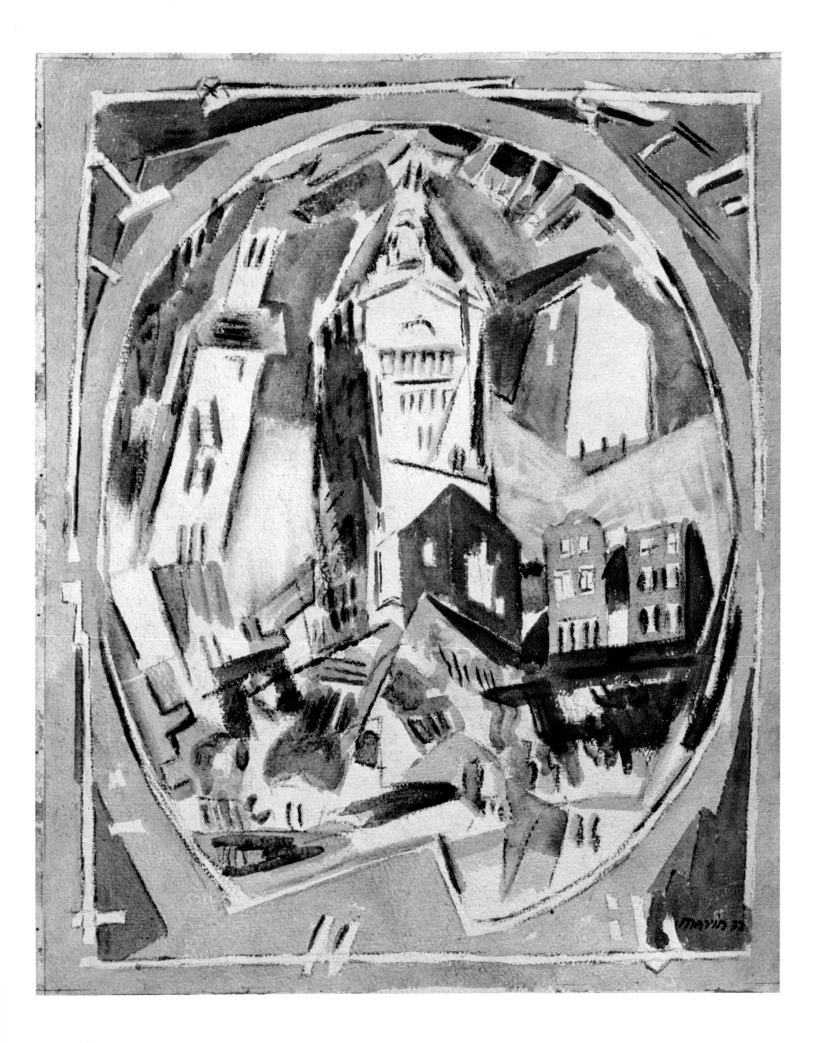

The three primary hues ... Nature has given them to us—how can we get rid of them? None of them is absent from nature except when nature is sick.

Color should have a setting—objects should have a setting.

If you are showing a fine stone you dont surround it with tonalities but with something that has a decision within itself—so with this painting

Tonalities are apt to kill color

There is not much quiet in tonalities as there is no quiet in the spectrum where one color at its edge blends with its neighbor each killing the identity of the other

Sun Spots, watercolor, 1920. The Metropolitan Museum of Art, The Alfred Stieglitz Collection, 1949

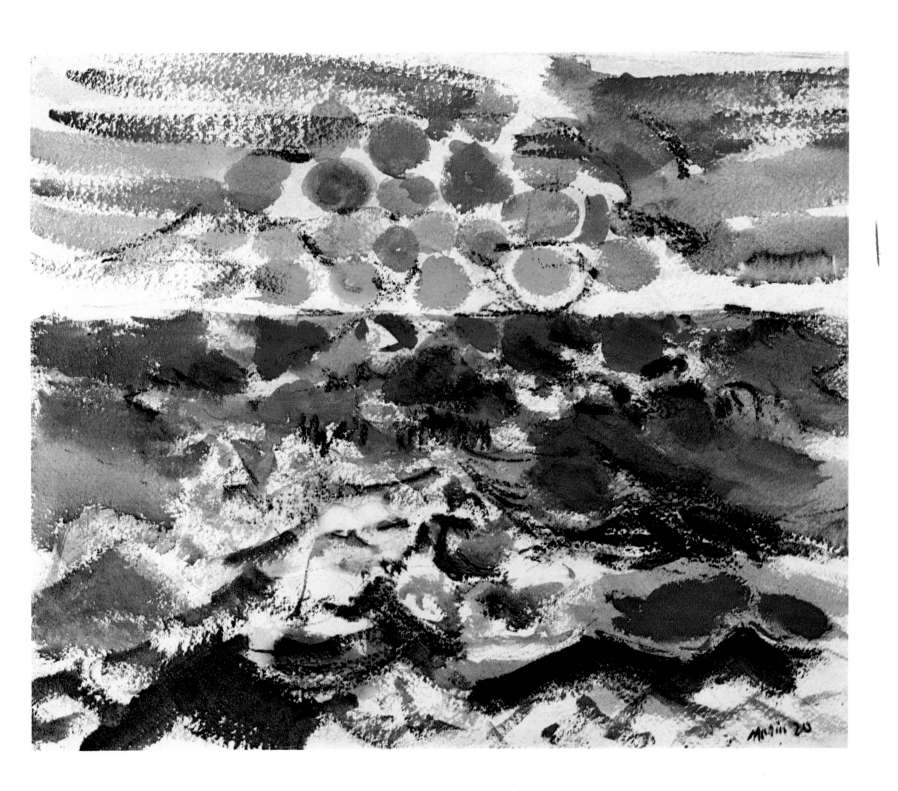

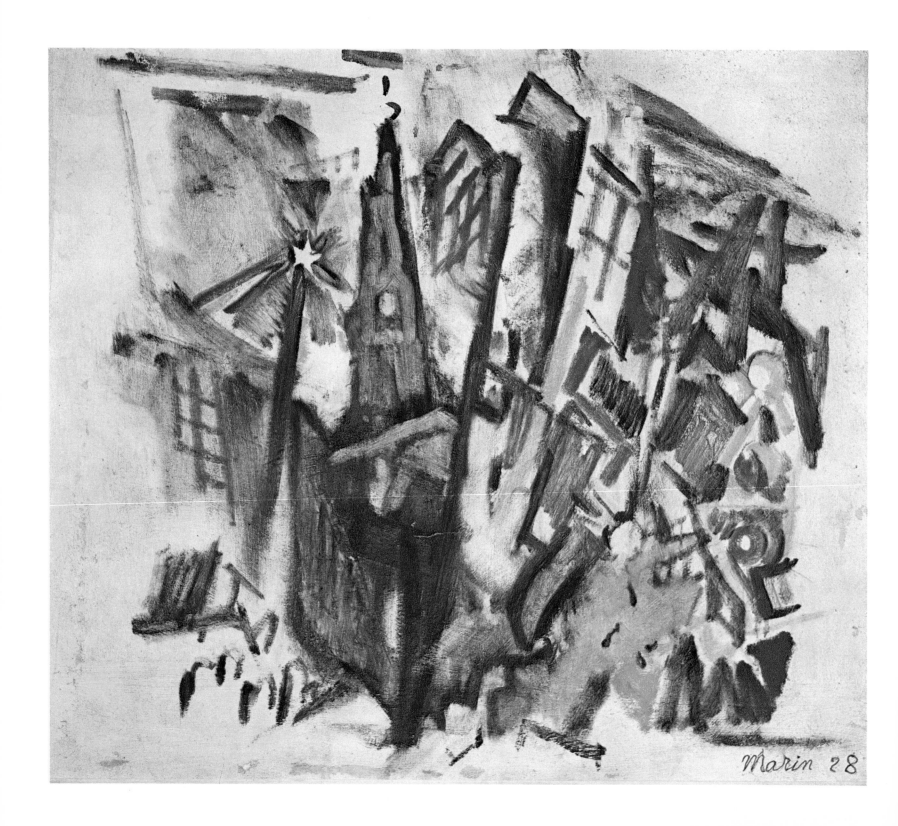

Shall we consider the life of a great city as confined simply to the people and animals on its streets and in the buildings? Are the buildings themselves dead? We have been told somewhere that a work of art is a thing alive. You cannot create a work of art unless the things you behold respond to something within you. Therefore if these buildings move me they too must have life. Thus the whole city is alive—buildings, people, all are alive—and the more they move me the more I feel them to be alive.

It is this moving of me that I try to express so that I may recall the spell I have been under and behold the expression of the different emotions that have been called into being. How am I to express what I feel so that its expression will bring me back under the spells? Shall I copy facts photographically?

I see great forces at work—great movements—the large buildings and the small buildings—the warring of the great and the small— influences of one mass on another greater or smaller mass. Feelings are aroused which give me the desire to express the reaction of these pull forces—those influences which play with one another—great masses pulling smaller masses—each subject in some degree to the other's power.

In life all things come under the magnetic influence of other things— the bigger assert themselves strongly—the smaller not so much but they still assert themselves and though hidden they strive to be seen and in so doing change their bent and direction.

While these powers are at work pushing, pulling, sideways, downwards, upwards, I can hear the sound of their strife and there is great music being played.

Related to St. Paul's, New York, oil, 1928.
Private collection

Never go back of the canvas—in other words never build back—build up—

The concept is of seemingly to be able to lift the painting off the canvas
 the canvas being the great flat the great symbol which must not be destroyed for it nourishes all things on it.

Speaking of destruction—again—I feel that I am not to destroy this flat working surface (that focus plan of expression) that exists for all workers in all mediums. That on my flat plane I can superimpose—build onto—can poke holes into—
 By George I am not to convey the feel that it's bent out of its own individual flatness.

He—be he working on a flat surface reforms his seeings on this surface to a seeing of his own choosing so that which he chooses shall live of its own right on this flat—
 The flat—the symbol of the soil and upon this soil—upright—the plant a growing and living.

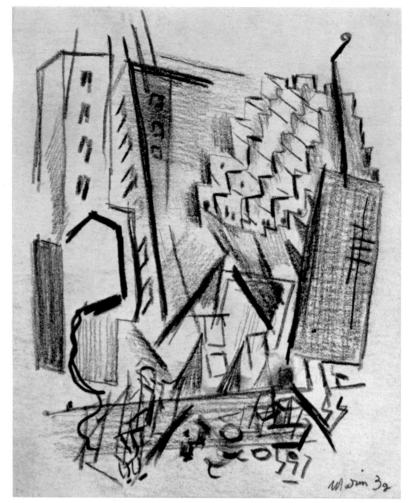

Mid-Manhattan, pencil, 1932. The Downtown Gallery, N.Y.

As I see the right picture it has only 3 dimensions
Canvas length canvas breadth and paint thickness
As I see the right picture
there is no distance
that is—that to the painter a <u>star</u> is as near as a tree in front of you—
so that the size is substituted for distance—that to show anything on canvas as if it were an object is criminal.

One of the greatest helps in art is the <u>blank</u> <u>wall</u> constantly look at the blank wall to get your bearings.

A picture should look as well as a blank wall
A picture is painted on the blank wall of its canvas—and in the painting of this picture as I see it the blank wall of its canvas should never be lost sight of—for the picture exists—is embedded within it—
 I am coming to the belief that all pictures should be wall pictures—and when is the picture the true wall picture? When it jumps back and forth with the walls with the whole architecture of the room.

In my pictures objects appear within the paint flow—are backed up by the paint flow

Let one assume that the Earth is flat—the ancients had it so—and from a certain concept it is flat—above and below that flatness we have mountains hills—below the rivers and valleys the waters the waves above & below that flatness.

With objects occuring so on that canvas—the concept of its levelness and the paint flow—a flowing above and below a carrying its objects on this flow.

There you have my concept of painting the picture and it seems to me a very easy and logical concept—and laterly when I have come a cropper is when I have strayed from this steadfast concept.

Again the picture
The parts playing back and forth never one particle away off lonesome by itself—it would start shrieking out.

This I say—such a picture can—like the running stream—be looked at without tiredness—

Look at the sea some waves high—some low—all a moving above below—below above—the constant line of flatness that's the way the—The Musician—arranges it above below below above—the Eternal flatness—

Which brings us to another great concept of the thirds—which has to do with the above the below the flat—on the face of it that brings us to the thirds—

sky	Earth	water
up	level	below
—soft	loud	
heat	tepid	cold
little	medium	big
yellow	blue	red

the three dominant chords in music in any key

Nature reveals herself in sets of three things—there is land between sky and water—grey between black and white—luke warm between hot and cold—the diagonal between the upright and the prone.

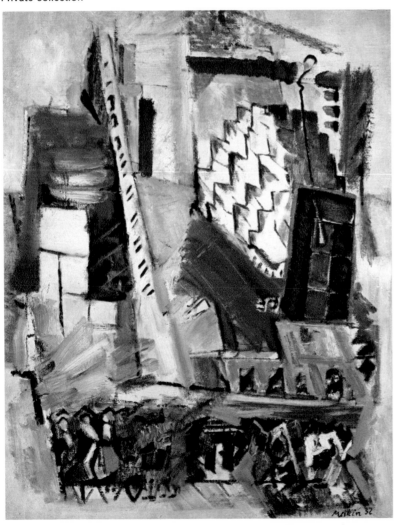

Mid-Manhattan No. II, oil, 1932.
Private collection

Every picture is based on the objects within it

When the objects take on their sufficient weights—your job is finished—and not before—

When these objects take on their sufficiency—they drag their backgrounds along with them

The background is the home of the object—where it lives

All that we can see in pictures are objects and those things which we call backgrounds and it is that playing of objects & backgrounds that concept which is universal and which is susceptible to infinite variety.

As is a dwelling constructed to hold together in all its parts—with the right strengths here and there—in each part—So must the picture be—constructed with the same structural attention as is given to the dwelling.

The leans—the thrusts—weights—spacing weights—paint color weights—All these in the making of the picture— decision movements—suspended movements—the play of part to part.

All to be gotten by—at the very start—the placing of the backbones as it were—for the different paint movements to do their playing about them—the whole a piece of music written with line & paint— paint to look like and never lose its paint feel—not to try to reproduce anything—paint to form its own jewels—for paint can be made to be beautiful of its own paint right . . .

With it all there must be an order—there—is—an order

from the years of seeings and observings

The swirl of movements obey the laws of motion— people do not—unless in panic—run helter skelter on Streets— too— buildings obey their laws of Construction—granted— but there creep in another set of laws—a seeming —wayward—set of laws—The law of the Spirit—the law of Life—The law of the Seeings—which grip the sensitive—grips him in all his being—He with the traveling Eye—He with the Eye that takes in—Step by Step—

Then of a verity—buildings—streets—people—become a Solid mass of moving aliveness—nothing is dead—

with a kind of order to it all played on a few—Key Strings—

It's just scandalous how a work of art has to obey the law How a piece of music has to obey the law—How a piece of writing has to obey the law—the story telling law

If these things have not the story written right into them—well they are—failures—

Because all things—derive—therefore this deriving must have lived—must have had taste must have had smell—must have had that which compelled the fine attention of all sensitive people in their various occupations.

As for the message—as for story—The very doing—the very way it is done—the very what is being done by—they the parts—lead to this message—to this story—in fact is the message—is the story.

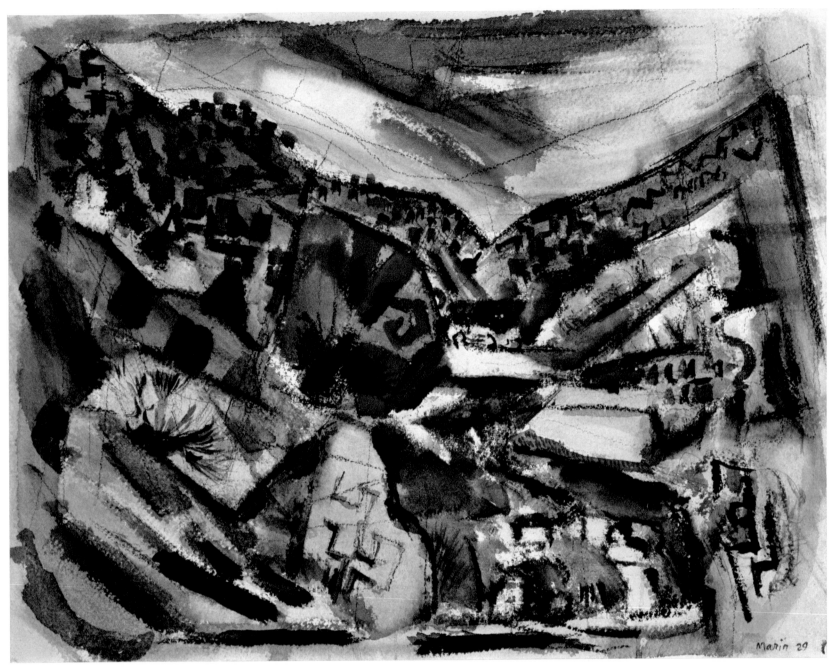

Taos Canyon, New Mexico, No. 2, watercolor, 1929. The Kennedy Galleries N.Y.

Horizontal and Perpendicular

The art of dancing is to keep the top of the head level to the horizontal it can move along this horizontal—the movement taking place in the conscious swaying of the body on both sides of the perpendicular with the legs and arms balancing about this swaying—and for God's sake take that grin off your faces and put it into the dance—the head has enough to do to control the dance without grimaces.

A wonderful example of this—I would say—would be the Eastern women who carry things a top the head.

This leaping into the air—throwing the arms and legs—well that can be a natural leaping and throwing too—but more often it has the appearance of a stunt in that somebody will come along who will leap higher than you do—will beat you at this game at your leaping and throwing.

Same way with playing the piano
for the art of playing the piano to me is how you sit at that instrument.

The mountain was formed by weights pushing and pulling and it's as it were as if these weights were still pulling pushing—that the mountain is still fighting and being fought against—becoming conscious of all this

In your build up of mountain you have got to do just these things.

As my body exerts a downward pressure on the floor the floor in turn exerts an upward pressure on my body.

Too the pressure of the air against my body—my body against the air—all this I have to recognize when building a picture.

You try to see your objects in their movement—positions—you seek for (back bones) of those swaying objects—these you must hold to for all you are worth.

All good writing—All good music—All good painting—obeys this principle

for—as the back bones bend—the whole structure bends

and I would conceive the picture—the writing—the music—as structures related—bending—a swaying on their back bones

Think of the wonderful balance of squirrels—they scratch themselves without losing their balance.

When I have put down enough things to cover the surface I like my pictures to have that kind of balance. I stand them up on their end—turn them upside down—until I see that like the squirrels they have got balance in every direction.

Now then—if I were not so this that and the other thing I'd climb up the tallest ladder and from there would shout "Balance—my boy—your picture must have balance—and even when next you place the address on the envelope see to it that it has balance."

I don't know any big musical words—all I know about music I have learned myself—but I think that Haydn and Bach and those fellows before Haydn's time—those English fellow like Purcell and Orlando Gibbons—gave their music real action.

I try to make the parts of my picture move the same way—only I always try to make them move back and forth from the center of the paper or canvas—like notes leaving and going back to middle C on the keyboard.

Untitled (Figures, Downtown N.Y.C.), pencil, 1932.
Marlborough-Gerson Gallery, N.Y.

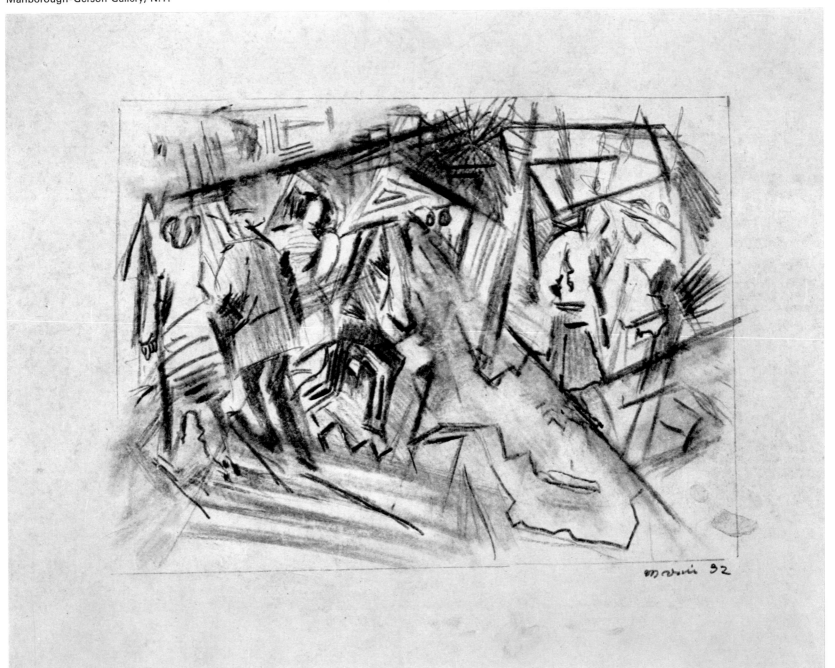

Distortion

in Early Early Spring
black crops up

A painting made want
be so that you feel
you can lift the
parts off

1939 New pictures

(Paint weight —
the glorification
of paint

other side

The pictures I
painted are yet
too American

You showing up the greater intelligence
tree holds the picture two painters

To the artist
every picture is
an adventure
a new adventure

thoughts on pictures should be forced
The observer of the pictures should do the same labor as the one the painter of
it go through the

For most persons it is
as if it were almost
indecent to look at
a work of art.

One has no excuse
for trying to duplicate
the object — he
must make his own
object

Arrogance

all my ancestors breathe
I am tired and sick
of breathing
all my ancestors worked
from the seeing
I refuse —

The picture should be so painted that all the weights should be released at the boundaries of the picture.

Good things start—good things finish—they don't hesistate—they start—
 too—they don't carry on to a something that weakens what is within
 when the edge is reached—the story is told—complete—satisfying—
 —enough said—

Why pictures—
there must be an answer. They are spots in that room that wonder room
 and that is why pictures
Therefore the whole room should be a wonder picture
finally the picture occupies the whole room.

Your painting should be a room—if a man is out in the wilderness—
if he loves that wilderness—that wilderness becomes his room.

A picture is complete when it is the completion of your seeing

Completion—what? Well we know what we mean by Completion
 A chair is complete for its purpose—The picture is a playing of its
parts—when it ceases to play they say it is complete
 So I guess we'll have to pitch overboard the word
Complete
 Why did you do this
 Why did you do that
 and I'll answer them with the old doggerel—
 For fun and for fancy
 To please my Aunt Nancy—

Repetitions within the picture play a great role
they are the brothers and sisters a nodding at one another.

My picture worries me
Those we love—worry us

If one says A complete picture they should mean a complete picture that at the four edges of the canvas the story is completely told.

That all punches are pulled to stop at these Edges that if the force of the paint strokes are not stopped at these Edges one has a perfect right to say where is the rest of your picture. Most pictures I imagine transgress in this one thing—one might just as well just as logically paint a six by eight canvas then cut it down to a four by six—what is left is a fragment of a concept—one can have honest fragments or cutoffs within the canvas but to cut off the completion with possible continuation I would say was criminal for your work of art is to be a complete world in itself all said when the Edge of the canvas has been reached.

What you do must have a base. You have to play above and below it. There are the vertical and the horizontal aspects of what you do and then there are the rhythms in between. The stops—The swift passages and the slow . . .

When a picture's edge is reached the story is told. One must build one's picture from a basic axis. One dare not burst one's frame—there must be no extraneous fringes. Art cannot be forced anymore than life can be forced or overblown.

There is a life line within a work of art just as there is in an object in nature.

Blue Mountain, New Mexico, watercolor, 1929. Marlborough-Gerson Gallery, N.Y.

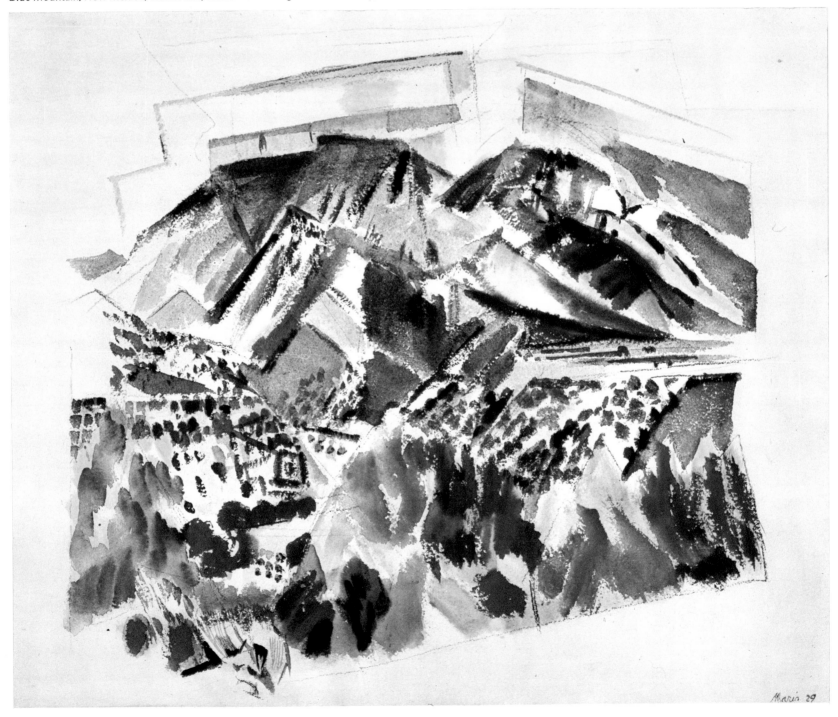

Marin 29

THE ARTIST AND THE WORK OF ART

And now the pictures painted are here—just gestures—
and to me art is no more than that—
these made by that Curious Creature we call an Artist—

Movement No.1, oil, 1947. Marlborough-Gerson Gallery, N.Y.

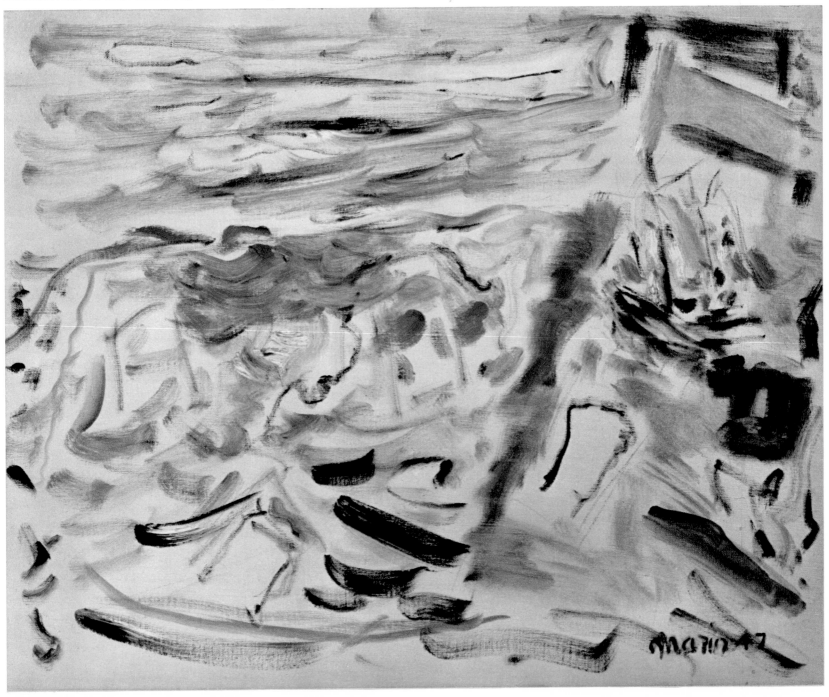

Now then as put down here you will find a set of—cocksure—warranted—guaranteed—sure fire—RULES—

as a guide in our search for that culprit we designate (Artist) and although I and others dislike this word (Artist) intensely—it being the dogondest most characterless most sissified sort of word—we will not let that interfere with our hunting as we with the aid of our guide cannot go wrong.

First of all I'd say he'd have to have two arms & two legs—quite important that he have hands with a couple of feet thrown in. A body with a few things therein—

They speak of big heart—of a certain—kidney—full lunged—and oh yes "guts"

As for the head

well eyes ears nose mouth and I believe something they call brain located somewhere inside the head though some purists persist that this stuff is oft found in the feet of human mud walkers

But as most of these things are found in most human critters as well as in most animal critters we will be forced to consult our guide for this special critter—this bug—or anyway—this he who has the bug.

BODY—well formed (embracing all parts) carefully formed—neatly formed with a well ordered strength not too much—just right—with muscles and rhythmed—free and easy and flexible.

HEAD—broad at line of eyes not too high not too low above eyes—lower head not dominating upper—Each balancing the other—EYES—in their sockets—not bulging—not close together—alert—penetrating—giving the feeling of an inner vision as well as an outer—eyes that can focus—eyes that are thoroughly active seeing that are thoroughly quiet reflecting. Eyes good to look at but not beautiful in the sense of deerlike doelike—eyes not too large just large enough. Eyes that have that soulful expression—pitch them out

" " are steely " " "
" " " serious expression " " "

MOUTH—Quiet yet very changeful upon desire for change—lips never thin yet not so thick as to be termed sensuous. With it all a mouth that like the eyes can kindle. A mouth that in common with eyes hands and in fact every part of the body's moving parts can grip EARS—rather generous—not thin nor too close to head.
NOSE—rather generous too—and well hung.

and now we come to those two fellows that do the work the HANDS—medium sized—well formed with plenty of apparent nervous strength—fingers plenty long enough the ends of which when placed together form an arch never appearing to have that sawed off on a limb appearance.

Hands that have the look of fine tools always in use.

And this critter if you find him will have the ability to laugh at himself have the ability of introspection and self criticism but withall a grand courage a grand confidence. and with the above taken a good generous pinch of Salt and plenty of luck . . .

I would now speak of —our affair—
This—a work of Art—

A consummate sense of Construction based on those vital lines about which the parts move. A consummate draughtsmanship. A consummate awareness of color weights—of balance—of rhythm. Not that you have painted a violin but that you have the rhyhtmic flow shows that you have music aboard.

Yes I would have it that the painter who has not music—is not for me—

Who has not the rhythmic flow as had Mozart as had Bach is not for me—

No work of Art is ordinary for Art is not ordinary—

So that it follows that in a man's seeming lesser works—Seemingly approaching the ordinary approach—that will be discovered—whether or no he's an Artist

for if there you see the inescapable Straight line of a birthright a Shining—maybe feebly—but there it is—then is he in the right of it.

This man all along throughout his life will make his discoveries—will make of his seeings—will build up on this and that—will discard this and that—will have penetrations—God knows will have his problems all the way through but if he is basically right it won't be the love of the problem that stirs him—love of problem solving is not his goal.

They have to be gone through to be solved—to get to his
—life long love visions—

Those whose problem solving is their love will appeal only—to a public of their kind—and not to a public who have hunger for those appealing things we call—Works of Art—

Those who have themselves to think about—those who on looking into the mirror—and a something out of their control tells them—not quite all right—must needs ever after put on that—false—front which kept up becomes a reality to them and they Straight way proceed to write Symphonies or their Equivalents

but with all their boundings their gyrations their flights they Spell False from False Take Offs

all these are not to be mentioned in the same breath with the first breathings of the little Mozart—

We have them here with us

and they are a flocking from abroad to our Shores.

Hail thou a lesser Mozart a lesser Bach

that you are—

real—that you say but little

That you have a bit of Old Mother Earth a clinging to you

That that—Mother Earth—there a clinging stays with you all through your life

The straight course throughout—Your Message—your Seeings

giving to those others—those few—your message—your seeings—

and one must not think for a moment that our Mother Earth has Exhausted herself—She will stir at any time at any place give birth to one of those shining lights—as of yore—and they will have the same Countenance—the Same Step—the Same Stride—the Same Nervousness—the Same Calm—

The which having said—leaves still with that to say for, these utterances of mine seem—in my ever changing mood—in shapes that don't satisfy—

They seem to spell a Hero in sight or somewhere about

Have I been tempted into Hero painting

Now to be quite honest Isn't there Sneaked in—in Hero painting— a being—bearing quite a resemblance to—ones self—as onse Sees oneself—or at least—think they see oneself or at least—would one-self to be—

and all—how wonderful—How wonderful to sit there in one's Easy Chair—and Slay the dragons of the Earth—

How wonderful to lie there quite snug in bed and swim the Turbulent Seas—

I build up but I find that most of my building has to be partly torn down and rebuilt which means that there was another Side to this building that had been neglected.

So I would now say that there was many a Dragon Slain just a sitting there in your Easy Chair

that there's many a Sea swimmed just a lying there in one's bed

So that if one should ask you sometime when you are a sitting there in your Easy Chair—"What are you doing?"—You can answer— "I am a slaying a Dragon"—

Back to our—Hero—The one I have brought to Visibility He— Struts and Strides quite a bit

Has a noble bearing

A halo of virtues is not far away

Now

If he would Strut and Stride less

would discard about ninety percent of his—noble bearing—

would Smother the halo with its—pendant Virtues

was quite a bit more whimsical—would play quite a bit more— would Cut up monkey shines quite a bit more—would have much of a recognition of the—Wild—and its Moments—its seeming Care free—moments—

all of these—possessing a flavor of all of these—would give me a Hero—more of my choosing and Since he's rather a difficult rather an impossible Hero the best we can say is that he find himself among a very indulgent folk.

but just one final stab at him

He must have a side to show to those who would become— too familiar—a side—where—Honest to Goodness—ANGER Flares Forth

again—alas—we cannot paint him complete—he evades us— we're getting him too many sided—there are areas of underpainting— many of overpainting—much (no paint visible)

let's quit

let him—he lets himself take over the never completed task of completing himself

Some would say

"Why not pitch him Overboard Entirely—and—go take a Snooze"

That we won't do

"Come along Hero Old Top"

I got some canvas—it became my canvas on its stretcher
I liked it

 I got some blue paint I squeezed it on the canvas out of the tube
I moulded it I liked it I got some green paint I squeezed it on the
canvas I moulded it I liked it I got some yellow paint I squeezed it
out of the tube I moulded it I liked it I got some red paint I squeezed
it out of the tube onto the canvas I moulded it I liked it and some
black paint and some white paint these I also squeezed out of the
tube I moulded them and too I liked them and that's all I did and it
all gave me delight

Seeing color on an object and seeing color on canvas are two
different things. If you are sensitive to color you will place pigment on
canvas until it shows itself as color—and if pigment is happily placed
on canvas it can ignore the color of all objects—it asserts its own
color—let objects assert theirs.

Sometimes I like to paint a red ocean with light red—maybe between
Venetian and Indian red or maybe spectrum red—red is more
exciting than gray—it is not the color that makes a painted ocean
look like a real ocean—What makes the painted ocean look real is a
suggestion of the motion of water—a red ocean with motion will
look more like the sea than a patch of gray paint without movement.

Blue Sky with traveling clouds
 Green & Red sea
red—a smokey red
more felt than seen
more FELT

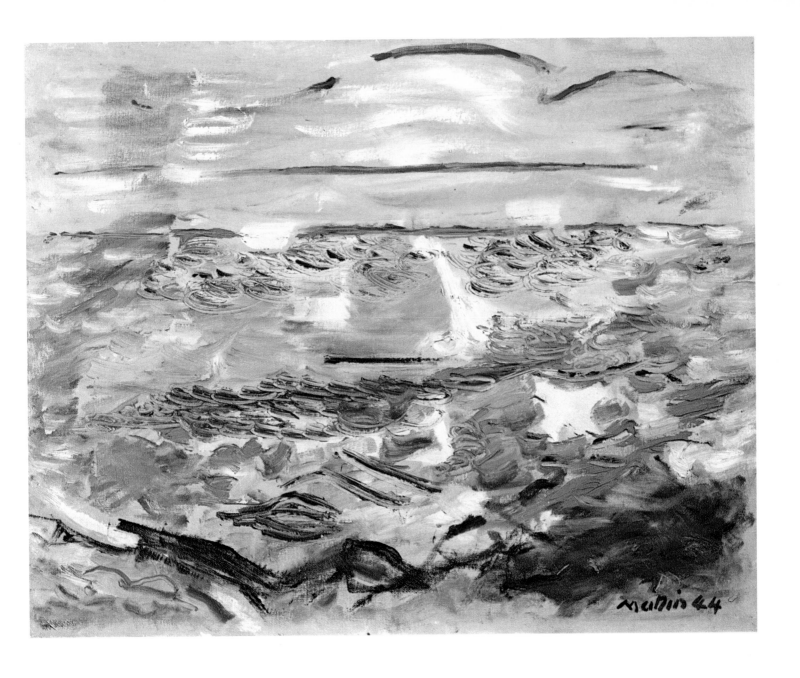

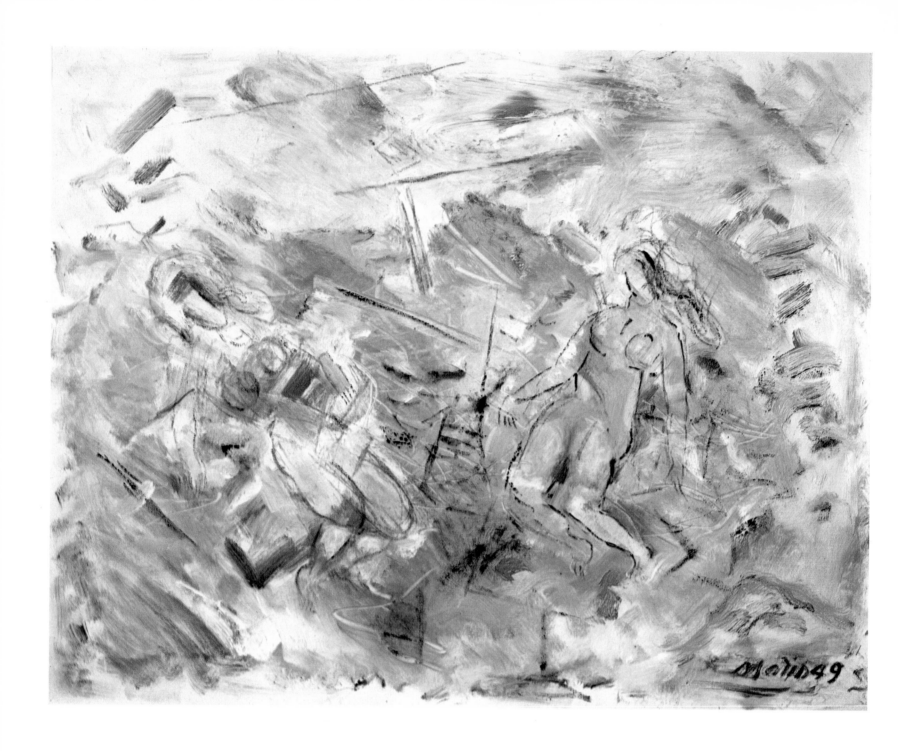

Sea Dance with Figures, oil, 1949.

A nude woman in the prime of life—well formed—is so beautiful that it would seem—that nothing should touch her no thing should spoil her

there you have the work of Art

That art has no mission but to move to delight in its being in its well balanced rightness—
and to do that the colors must delight the eye—the shape of the canvas must delight the eye—the lines and spaces delight the eye—and all those little delights taking their proper places give the big delight—not a damn thing else.

All great artists are in love with subject matter—the world.

Therefore the subject matter which appears in their pictures is a delight.

Abstractionists give forth no such delight—for they get no such delight in looking at the world.

Art is just a series of natural gestures.

For God's sake don't try to be artistic—
All wild animals walk the same way

Art is not so Easy—it takes all a man's got—it takes all a man's got to make it—to have the look of Easiness.

This ideal this work of art so unattainable that one suffers much when one is baffled—when one is stopped—when that [is] not yet seen which would go with what one has which would make the whole to sing—a complete singing—

Art is made by that creature who is half animal half human—he's taken on the human without losing the animal there you get the perfect balance—animal & human

When a great man builds a form the form was there before he started.

Painting is founded on the heart controlled by the head.
 Since instinct is—lost—how a one has to use one's head to get back to instinct.
 The head planning instinct does not work
 The head planning to give instinct a chance that's different—it resolves to a sympathetic loving approach to all things
 The head is apt to remove obstacles—the instinct is apt to go around obstacles

To the gifted there's a—that within—which is ever present—a that which cannot be defined—a that which impels—a that which becomes more and more articulate—a that which becomes more and more intimate. So that there is formed an ever more and more aware-ness of its presence. Then does the gifted one go forth more and more—less afraid—with a courage—with the sense of introspection more and more developed—then is that good machine the body made use of—then can the player play on his instrument the body —it obeying.

A work of art is full of perhapses & maybe sos
Science is factual until it's found to have a perhaps.
Where the perhapses are found something has to be done about it and since art deals in the perhapses & maybe sos why not call it the consummate science—which gets its perfection from seeming imperfection.

In art the great word is perhaps—I will has nothing to do with art
Art loves perhaps
art shies from I will
perhaps is full of humor
I will is destitute of humor

Science reveals, art conceals—science revels in the revealing of the concealed—art revels in the concealing of the revealed. The object of science is to make easy for the many, the object of art to make hard for the many—science is vulgar, art is exalted.

Most of my things are a kind of Supposition.

Untitled (Trees and Houses), pencil, *c.*1950's sketchbook.
John Marin Archives

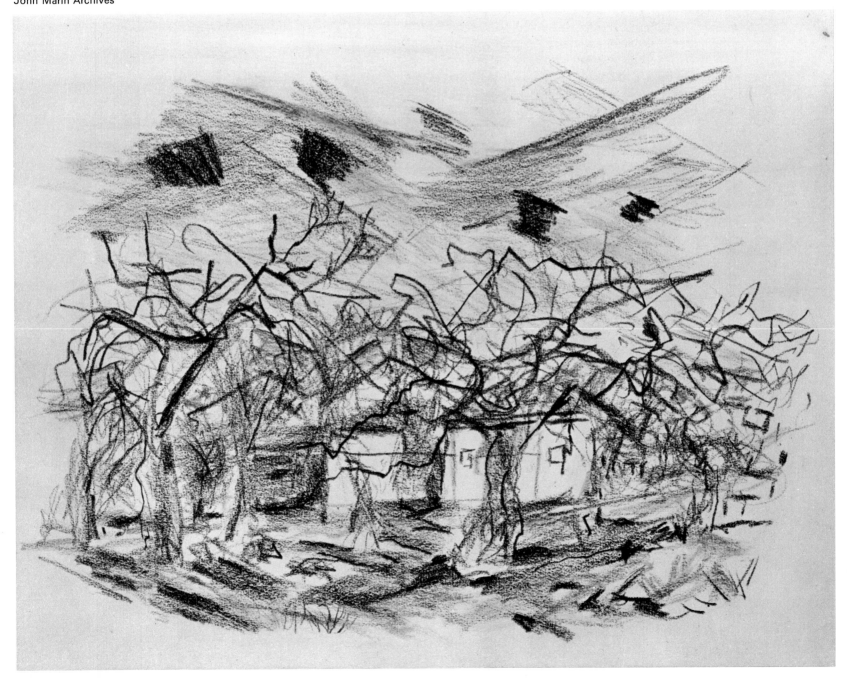

We are of an era where old ways, old terms, old definitions are being reformed to meet the broadening, to meet the coming in.

What is art anyway?

What's the definition?

Has it to do with life?

The Man's an Artist. Has it to do with his eating his breakfast, has it to do with his calls, his speeches, his everything, his walkings around, his prowlings about, toting his canvas, paint and brushes, toting his camera, toting his Musical Instrument?

There you have it—his Musical Instrument.

and as to whether that Musical Instrument be brush, camera, spade, saw, or fiddle—matters not—provided that it gives out the SING of this life. And the record of that SING mayby that which we will term Art in the future.

There you have the artist—he being the one who puts forth that which has its own right of existence—its own beauty.

One cannot create that which one sees—it's already been created—he can create from that which he has seen.

The effort of the one—the artist—to make an object—his picture—irrespective of any other object—he alone recognizes and has respect for other objects.

The one striving after the impossible—the other striving after the possible.

Is not a work of art the most tantalizing—here—there—where—yes and no—sort of thing on Earth—the most vital, yet to all a mystery—to not too many a mysterious reality—it cannot be understood, it can be felt.

. . . this individual—the artist—releasing the different folds of his seeings at periods of his many livings.

—The beautiful lonesomeness—
of
a work of art
and
it is only the lonesome ones who can feel it

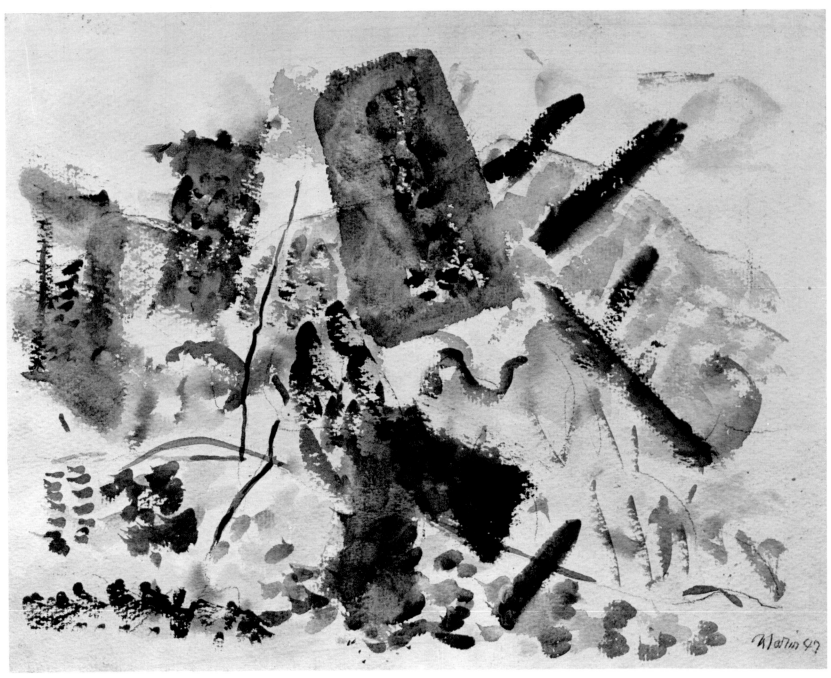

Untitled (Landscape), watercolor, 1947. Private collection

To the public

It is Said—we are becoming—Art Conscious—therefore let there be an—Art Week—focused on work done in—of and by America—

That out of it all will blossom forth—that—worth looking at—

This is the hope—produce the artist and—presto—realization—

—not so fast—

Know you that the artist is not—too common—and that produced he must have Encouragement—though courageous himself—he must have—like others about him—a good living to do good work—this the art Conscious public must help to bring about by purchasing that which they profess to love.

For the public to know—to discern the artist—the one who is—from the one who professes to be

—isn't too easy

One says—"I live here—I use the objects of my locality as subject matter"—it gets him nowhere—if he is not an artist for one living in Australia may be better than he of our Soil—

It is a legitimate hope though that Our Soil will produce the artist.

The people must gradually learn to discern the fine things.

—those sensitive to beauty can

—those not sensitive cannot—

Those sensitive will want and if the want is great enough be sure the artist will appear to supply that want and I repeat he's to be helped —to withold that is to disobey the law of human relationship.

and rest assured that he being an artist gives as much as he gets —he gives abundantly.

This worker—this artist is to be found in his—workshop—there seek him—Expect him not to play the game social or of self advertisement

it would appear in his work and the sensitive ones will have none of it

beware the ambitious one and the one who works all the time— he hasn't time to think.

Go to him whose Every Effort is the good job—to him who delights in his living—to him who takes not himself too seriously and who can at times look and make faces at himself.

Dont rave over bad paintings

Dont rave over good paintings

Dont everlastingly read messages into paintings—

there's the—Daisy—You dont rave over or read messages into it—

You just look at that Bully little Flower—isn't that Enough—

When we grow potatoes in this country we use American soil and when we paint pictures I guess we use something like it

We Americans (other people not here considered) are great braggers.

We'll brag over anything and everything.

The hope is that we'll awaken somehow and find a few things worth while looking at—cherish them

Hopeless—no—there are signs appearing

Apple Trees in Blossom, watercolor, 1948. Collection Mrs. Duncan Phillips

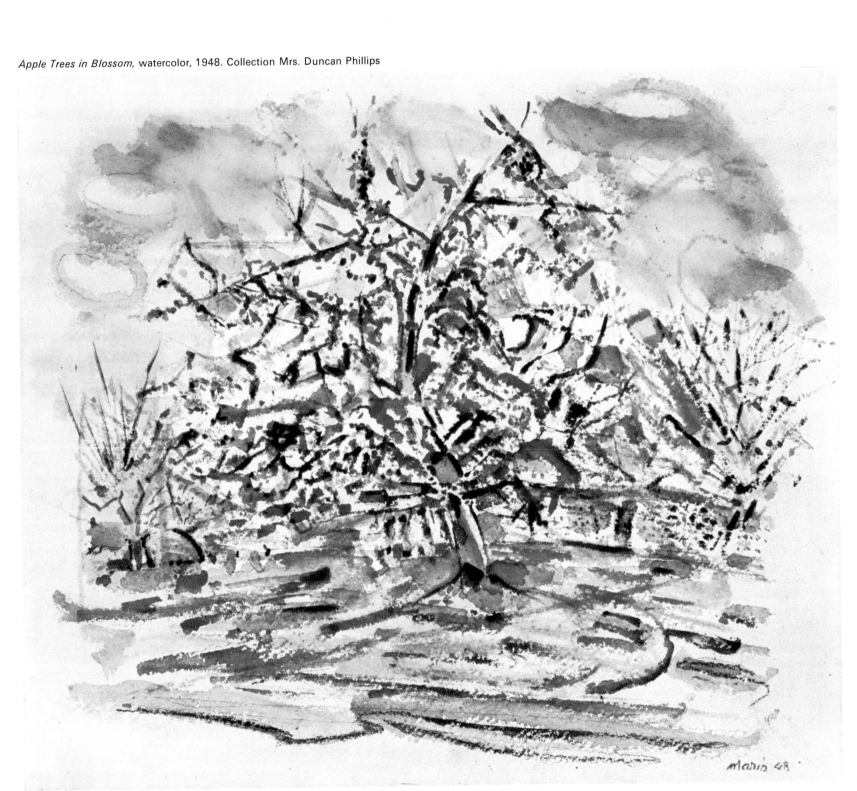

When reproduction is the goal—the feel of movement becomes less and less—but when the basic idea is a symbolic one then the interchangeabilities—produce what we call the life of the picture

Movement is never perfect if it were it would not be movement it would be static—the only perfection Known to man is the Horizontal and the Perpendicular they are the two statics all things revolve about them—they are anchors—
If these two were not motionless then we'd have no gage of motion we couldn't have the concept of motion.

There was a boy in my class who could transfer a Greek torso to paper and make it look nice and real—as real as the plaster cast that he copied. But I thought to myself—what's it for? A man paints a boat so it looks like a boat but what's he got—the boat doesn't <u>do</u> anything—it doesn't move in the water—it is blown by no tempest— That copy boat might sell boats but it cannot be art. Art must show what goes on in the world.

To say something—What? Well first let's get rid of all—labels— Abstraction—nonobjectivism—all the whole stack of isms—

For are we not seeking the—work of art—which in every instance must obey its laws—

To define this—work of art—to make a stab at it—A certain man makes a drawing of a horse—Yes they say "that is a recognizable drawing of a horse"—but to be a work of art the sensitive will have to eventually say—"what a fine drawing" "how well it places itself on the paper it's drawn on"—

"Why the paper and drawing are one"—"how it balances"— "how it has all over it a feeling of flowing movement" "and with it all how—Horsey—it looks"

and all drawing and all painting—whether of—mind seeing objects—or eye seeing objects—have to be recreated to live—of their own right—on this paper or canvas—not killing this great flat— this symbol of rest—whereon they have their movements.

Killing this flat—with the copyings of—mind as well as nature objects—has brought about the decadence of art in the different periods.

Many—so called—works of art come under the head of—Advertisements (and poor advertisements at that) and can be seen—in their all—immediately—that's their business.

A true work of art can stand many seeings—revealing anew at each seeing.

Sea in Red (Version II), oil, 1948. Marlborough-Gerson Gallery, N.Y.

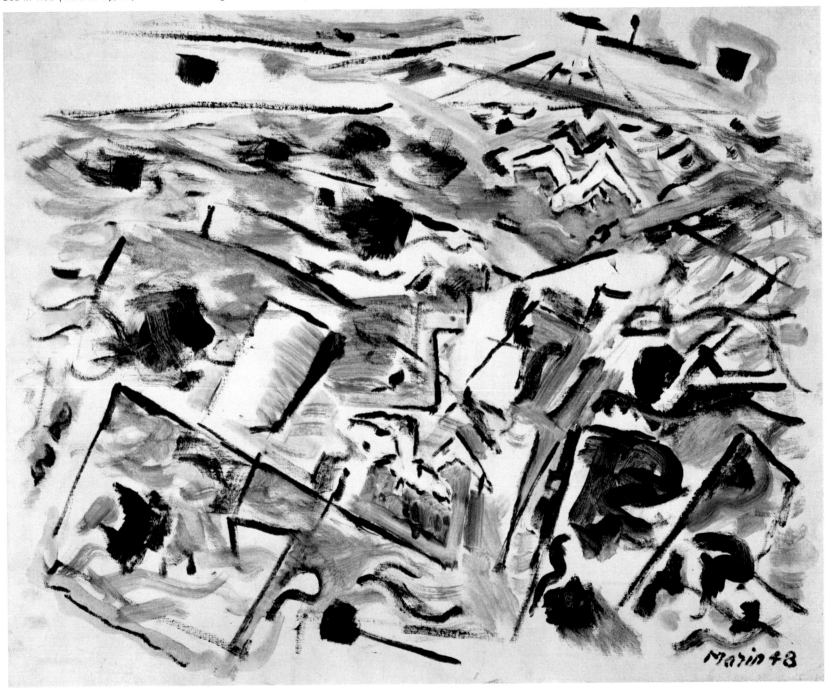

There is nothing but realism

This is the only (ist or ism) left to the artist—for if the work is not real what is it what are you? if you are not real

What is a horse if it is not a horse—

The imaginative story teller has given you nothing unless he gives you a real picture of his imaginings. The unrealist gives you <u>sawdust</u> for bread.

You cannot ride the Copy of a horse but the artist having seen horse gives you something to ride on for he has created his own horse—A copied sea is not real—The artist having seen the sea—gives us his own seas which are real.

And these symbols of his creation give him in their own right even a greater pleasure (being of his particular seeings) than the object seen—he reforms them he rearranges he focuses to his own satisfied inner seeings & longings.

In other words his work is based on his seeings—it seems that a deliberate throwing over board of all these basic (nature love) Seeings whether it be sea—landscape mountain or valley—Or living things Birds fishes animals or humans—again with this great love—would be like a man with a heart soul and flesh & blood left out—

Nature will see to it that the—Symbol—persists.

A good man works all his life you will always hear from him—Some men do seemingly wonderful things—and you never hear of them again so that—those seeming wonder things are oft a fraud are oft fakes.

Great works seem to have a great rest a great calm—painted mostly by a maturity where the balances become beautifully adjusted—but you can bet your life there'll be a stray hair or something wayward somewhere—the artist again will take care that there is.

When you flounder—that little spirit who is with you has STEPPED OUT
there are evil spirits
there are good spirits
art is just a tantalizing little spirit a running about leaving curious marks that have their own behaviour. For the self annointed ones he dont give a damn—
For the sympathetic these marks possess a great strange beauty

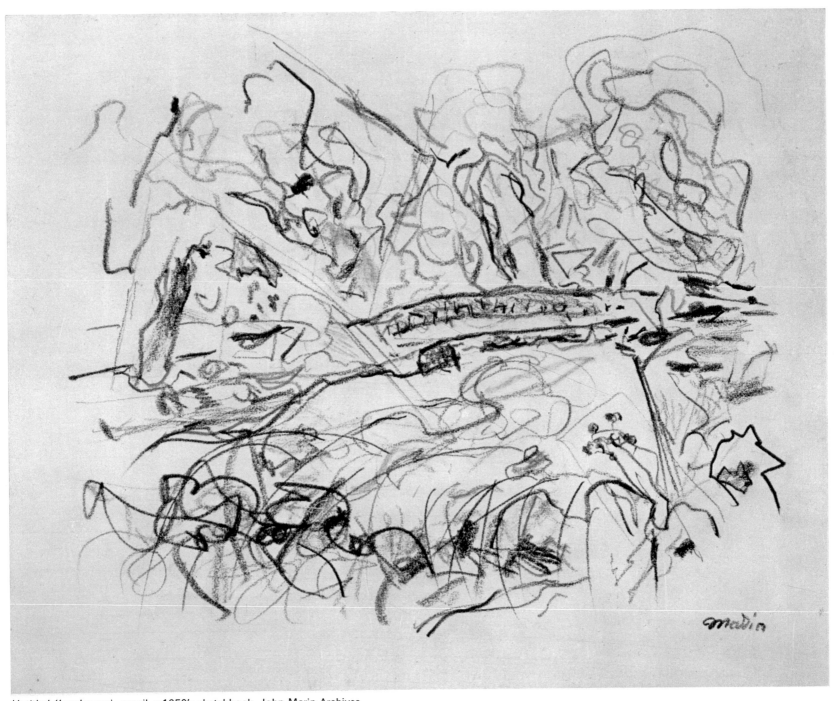

Untitled (Landscape), pencil, *c*.1950's sketchbook. John Marin Archives

When one deals in influence one is oft times misled.

You see one can sense that a one individual who lived five hundred or a thousand years ago and another individual living today may each have been born with a strong physical resemblance or a mental resemblance—related ways related outlook and the one now living may never have seen or heard of the work of the other—the work of the two would bear a strong relationship.

and this is a point oft lost sight of or ignored.

Many go about gunning for influences. They find them growing on every brush stroke and line—

But of course for one to say that he has escaped all influences would be more than CHILDISH—though to one of my temperament and my—living ways—peculiar to myself—would have taken on the least—may be—to my detriment—I have been So wrapped up in my own affair and trying to invent ways for breaking through that the ways of other men haven't troubled or helped me too much.

What do you mean by periods? Writers are always saying you belong to this or that—they always put you somewhere—you belong here they say or you belong there—I never thought of periods or schools—Painters don't care a wrap about those things.

Of late years I don't look much at my contemporaries—I think so much of this man who has been here for so long—and of the wonder of these things.

That the surface plane of the canvas shall never be destroyed that it always has a way of coming back and asserting itself so that the artist now is making Canvas Plane Concepts—before he even touches the canvas in paint—and if one would question this they might look at a Tintoretto and I think it would be discovered that the canvas surface concept was never really destroyed—he couldn't—he had it in him not to destroy—You must be made to see that artist's scene and not nature's scene and if he be an artist he will take care of that—that it is a canvas & paint seeing

All intelligent people used nature but in their art work were not used by it

and that seems to have been the Eastern Concept as opposed to much of the Western when subject matter began to use them—in the first we have the well balanced picture—in the second we have more [or] less the copy of the thing seen—which brings it that the thing seen in the second case was never seen in its own creative sense. When the Greeks began copyings of the human figure their work as art matter began its down grade—when individual figures became greater than concepted creation.

and strange as it may seem though rightly so—the great seeing the piercing seeing of the object begets an intelligent understanding so that one is equipped to the making of creative forms which have an equivalent balance to nature forms—therefore become nature forms in themselves created by that natural—the artist

and I would assume that the definition would be—the Great placement of things in an ordered Sequence.

About the only Frenchman's work I have a profound respect for is a fellow who worked very differently from the way I work and that chap was Boudin—he knew his boats—Hartley has a profound respect for him too—he told me so—I saw a painting of a boat by Manet in I think the Metropolitan—to me it was a joke—to me Manet didn't know boats—didn't know the Sea.

Boudin is very much underrated—he is a fine painter he has so much affection for boats and the beach. He put in all the lines— that's what people did in those days—but he never spoiled the essence of boat.

Jones Beach, oil, 1931. Marlborough-Gerson Gallery, N.Y.

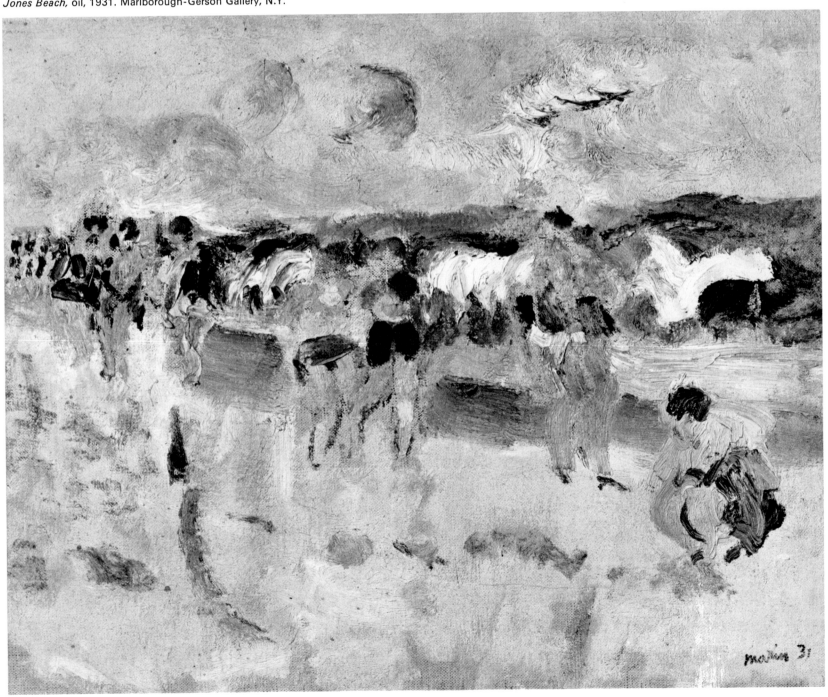

NOTES

When I was a Youngster Rosa Bonheur's Horse Fair was tops to me or Washington Crossing the Delaware and so forth.

after that the then moderns began to creep in so that Manet got to be tops to me

why—because I was told it was tops

Italian Renaissance

where we have a Series of pictures of the Rich man and his living.

A rich man's heaven—all the saints were well clothed all with beautiful hands that did not work

so that the hands and these people got from similar habits and ways of living to look alike so that one hand was about like another so that once one became learned [in] the art it wasn't too difficult for the apprentice to paint in and not go too far astray.

Don't think that some of their paintings didn't portray wonderful imagination that there was no rhythm but their concept was real people real landscape real interiors—which they carried out as near as they could.

Peradventure since these people belonged to the rich man's heaven therefore they had to be presentable.

In the renaissance all hands are beautiful & well kept

Keeping things symbolic tended to what we call the universal

Of course their idea—To recreate on Canvas the kind of people they associated with

In the earlier epochs the idea seemed to be to create beauty of line form and gesture—their idea seemed to be to put down that which was the dominant gesture rather than all the intricate detail which <u>ran along with</u> the gesture

Old Masters

the hands and feet got to be of a pattern—beautiful hands and feet I grant you but hands that never worked.

But it seems they had the idea Now's our chance—this medium gives us a chance to make an almost reproduction of the Objects we see—and they got so that they painted with the idea of making on canvas as near as is possible human flesh jewels gowns trees interiors—they had imagination and an idea of composition—they got to know a lot—took to it and they got to be so familiar with it—and too it gave them a glorious chance to paint well—just glorious pictures with a sumptuousness and richness indescribable

and they got it down to a set of formulas—ways of putting on. One man painted differently than another man he being a different individual but the formulas remained pretty constant. Michel Angelo put in all the muscles—he maybe added a few—so what—

When I was in Washington and visited you [Mr Duncan Phillips] I saw your Giorgionne it left an impression. Now that you were so kind as to send me a copy—I can look at it intimately from time to time.

Giorgionne I was faintly aware of—I hadn't really been introduced but the very name Giorgionne has a flavor—and what is this flavor of the man—I would say magical and loveliness which is so rare in the arts. And when Titian worked on those Giorgionne commencements he put his great robustness there but I am afraid that much of that same magic that same loveliness was lost

As I grow older I find that I cannot accept—without a doubting most of the old masters.

I would rather base—on those archaic peoples and our own American Indians in their concept of what an art work must possess which is mostly an imprinting of their concepts on flat surfaces which surface they do not kill.

I would go farther and say kill not the medium.

Nature is so beautiful so wonderful—that to make that which is based on an imitation almost seems a Crime and that's what I am beginning to think the old masters did—or many young masters and I am afraid I'll have to—in part—include myself.

When we obey that which living things must obey—our instincts—then when we work in various mediums we'll have so great a respect for the mediums and not try to force them to give so much of their life that they are dead. You have your door painted white by your first class house painter but he's killed the medium of all its wonder so that you don't think of painting but of just a white door—so in the wonderful painted imitations of faces of jewels of laces of wrinkles of clothes painted by the old masters—you somehow cease to wonder at the splendor of paint itself. In that sense the paint itself becomes almost as dead as the dead white door

That Goya still haunts me

It is not that it is just a good picture—there are many in the world—but it has all through it that which I find so lacking—that which I am striving so after—rhythm—and that to me hooks a picture right up with—music—

As for Cézanne—when in this country I saw Cézannes I said to myself "There's a painter" not much else—from my point of view that you and the others have given Cézanne too much space—helped on by those Frenchmen.

The Picassos—very first quick impression on looking into—before entering the room—that here were a bunch of big portraits painted by one of those terrible unutterable rotten portrait painters—On entering & staying a while this impression—though one felt Picasso—was never fully pushed away.

In the next room a most wonderful Toulouse Lautrec.

In an issue of the Sunday Times there were reproduced some abstractions Picasso Duchamp & some others—which has given me some fodder for my Saturday Evening tirades.

Am I getting to be a Cranky old Duffer—?

...a photo of Mondrian—a man with a fine intellectual head who has some fine things to say—<u>but</u>—<u>but</u>—<u>but</u> the answer is that in his stripping—he comes pretty close to—blank walls—he's gotten the thing down to perpendiculars and horizontals—which is unassailable for how can one criticize a perpendicular—how a horizontal—how a spotless garment—how a blank wall. You reduce and reduce and reduce until you come to (reductioadabsurdum) you who know your Latin can correct this—he has even neutralized his color—doesn't the man come pretty close to neutralizing himself—Curious isn't it—there's a man with an exceptionally fine head—a making of series of fine uprights & horizontals—as supports for things to grow—Yet nothing grows thereon.

a formalized decadence
after roaming about [The Museum of Modern Art]—suddenly much of this was made clear by looking at eyes. Eyes of Picasso—portrait by Man Ray. Miró—portrait by Balthus. Eyes in Picasso's people Man Ray's eyes

apologetic eyes
—doleful—
all their painted heads are doleful forlorn—they haven't a chance.

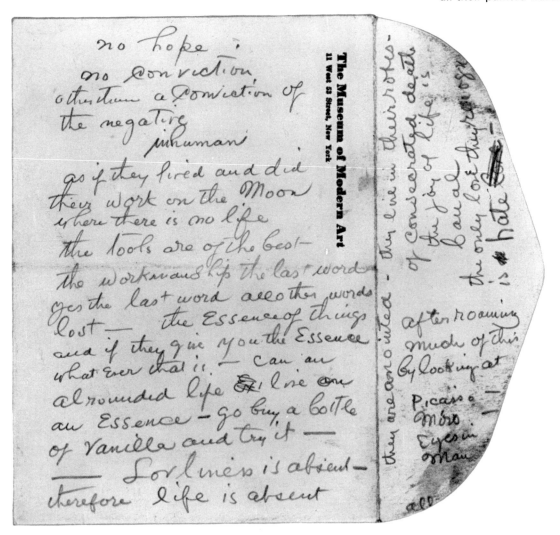

That's the first time I've used rose madder—squeezed it right out of the tube. I like the feel of paint—the drag of the brush across the tooth of the canvas. A painting is something made of paint P-A-I-N-T paint oozing over the canvas—there's painting and then there's paint-ing.

Huge carpetings of color cover the Hills.

It's as if you went to bed with the quietness of green and wakened up to the blaze of yellows and reds.

The Jersey Hills, oil, 1949. Private collection

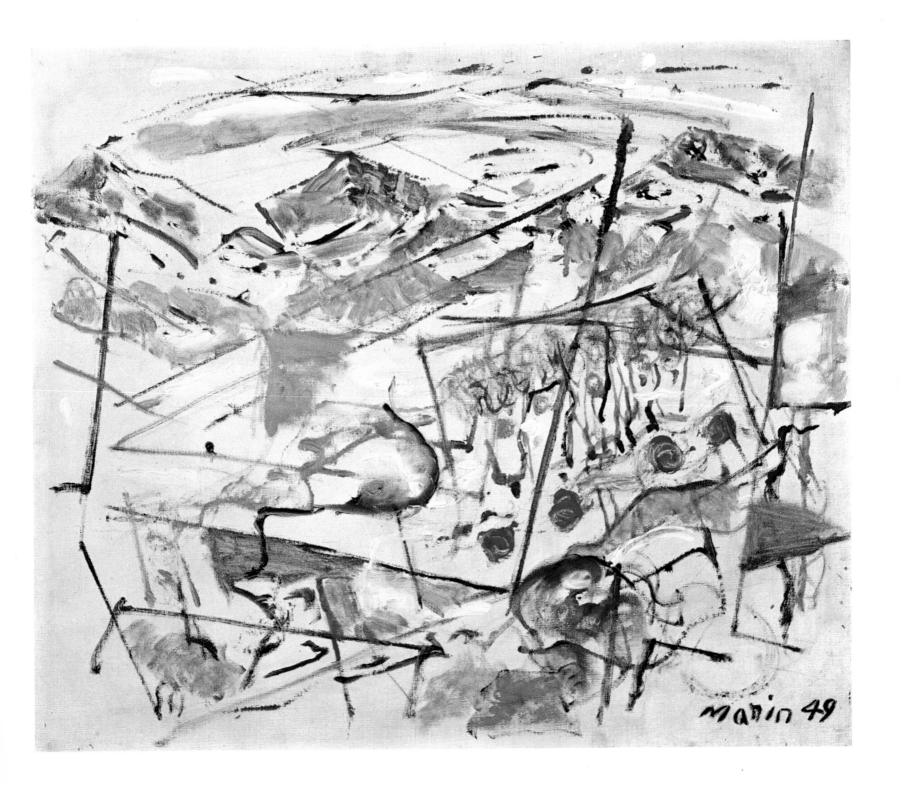

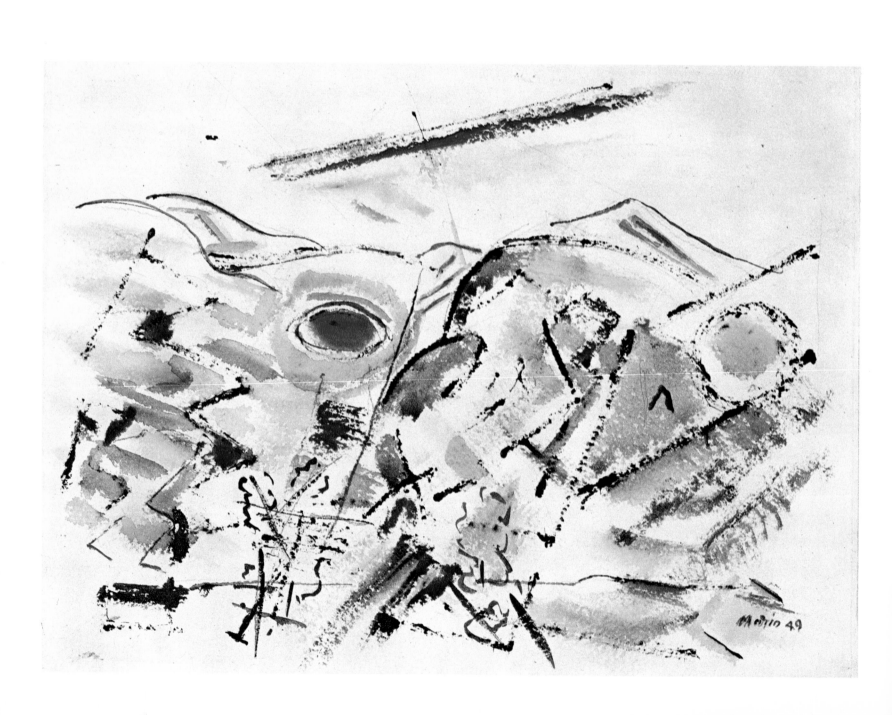

See that blue spot out there? That's a <u>Light</u> color—you can't put it on paper—you can't even get it with mixtures of color—viridian cerulean French blue chromium oxide green or what have you. So you just put down a color that the paper will like a color that looks all right in itself. If the paper likes it it doesn't matter if it's not a transcript from nature.

There will be the big quiet forms—there will be all sorts of movements and rhythm beats—one two three—two two three—three one one—all sorts—all seen and expressed in color weights. For color is life—the life sun a shining on our world revealing in color light all things—
in the seeing of this
in the interest of this
in the doing of this—terms—abstracts—concrete—third or fourth dimension—
bah—Don't bother me.

Tunk Mountain Series No. 3, watercolor, 1949.
The Downtown Gallery, N.Y.

There's the—so called—abstractionist—the so called—non objective approach

quite too often—a diseased approach

or from another point of view—streamlined of all humanity where an old fashioned human embrace is quickly nullified by divorce

Or where nudity of the Object is blatantly shown for the specific purpose of making it the supreme—Commondenominator—

where nudity is shown to rob it—itself—of its appeal—yes of its—old fashion—sex appeal

that sensitive people have.

The going out of one's way to be different always a questionable refuge—when one has—nought to say

Cannot the artist be or better than he be—a well balanced healthy individual

Of course—there have been those—will be those who with their diseases have given to the world—and will give Something Vital

They are not those I speak against

but that—deadly—humorlacking—

that deadly—fun and play lacking—

Those who would Start Symphonies early in life—

those who would startle the world whose—ideal—is the advertisement—

is the noise.

Just suppose we look at man—he hasn't changed much in his physical appearance in the last Two thousand Years—

How Come—he's now so different

How Come—he now has this hatred of all things Seen—

And taking its place a diseased mental seeing

How Come—A pleasure in torture

an Exaltation in torture

Has it a great moral lesson—?

and what the Hell have moral lessons or any other lessons to do with Art

The Creative one has his seeings and his own way of putting them down—

If he's healthy mankind will find it out

If he's diseased mankind will find that out too

 —anyway—

The birds are still singing

 —out there—

Most art(?) today is to me just so much advertisement—it's strong only in a seeing strength—and it is not worth much more than a cigarette advertisement—yes I feel that that art(?) of today is most of it on a wrong base—thus those in the forefront are a borrowing from the past epochs—without the spirit—without the love—without the <u>having</u> to <u>do</u> that those have had—the happiness of life—the sorrows of life—neither of these appear in their work.

There is something of tenderness—of loveliness in happiness—in sorrow—to repeat—neither of these appear in their work—Just a strength of seeing—of seeing WHAT???

To be locked in a room with one of these—and have to look for a period of time—I cannot conceive of a greater torture—

The modern—art works—too oft seem to have to fall back on a <u>pose</u>—the profound—or—I am traveling on a high plane—

You Surrealists—You moderns? do you like my painting?—as one voice they answer—NO—What do you like—we like what comes from within say they—Oh I know that say I—but you mistake—Since your upper story Cannot give out what isn't there what comes from you is quite different—I would guess that it comes from lower down and what's more it has not even a healthy wholesome Stench to it that which is your output.

And there was once the Abstract man who fashioned of this fashioning a form gotten from nowhere but from out of his great head. It resembled no other form but itself and it was exhibited and he stood by to challenge comment—and there appeared a little boy and his father and the little boy looking at the great work said to his father "Oh Popa look at the Nanny Goat"

and the great man nearly had a thousand fits but there was nothing to do

the Kid had spoken.

The sea that I paint may not be *the* sea but it is *a* sea—not an abstraction.

There have been periods of art virility

Many of these modern sculptors seem to have the notion that ugliness is a sign of Virility

and that applies to the drawings and paintings of many modern painters who willfully seek ugliness to give one that impression of Virility

in painting the line drawn between ugliness and beauty is subtle.

Many modern sculptors using primitive man as an object base get something that is decidedly ugly—when you think of the primitive sculptor one cannot—I would say—use the term <u>ugly</u>.

So many workers in the arts—if it's ugliness you want we'll give it to you but it will slap back to you the worker—for you made it.

a Drama in One Act
Curtain rises on two painter fellows seated on a park bench
—x—a man of no consequence
—y—a man of great consequence

x—Do you see that tree up against that light

y—I don't have to look at the tree up against the light—
I see my own object against my own light

x—You do—then you have no use for your eyes—other than to
avoid tumbling into things and except to see to paint your own
objects and their lights

y—That's right

x—Then seeing objects—that is—nature's objects—would tend to
throw you off the track

y—That's right

x—Are you afraid that the looking at these nature objects would give
you pleasure

y—Oh no they wouldn't

x—How about all the artists before you who got a great pleasure
from looking at things

y—I am different—all my seeing is an inner seeing

x—Have you trained yourself to see different

y—In my early years I may possibly have been led astray but know I
know that I am in this way of seeing and that really I always saw
this way and that those things you speak of never in fact did
interest me

x—Then would you say the artists of old who went forth and used
their eyes for seeing were doing wrong

y—That's right

x—But—some things that they did were—just based on those
things seen were they not—would they—everyone—being so
based—be wrong

y—That's right

x—Then let's wipe all of these off the slate and start from your time

y—Right

x—But my dear fellow you are altogether too modest—let's start
with you

y—Well if you put it that way

x—So that it could be—You are the only one

y—Well why not—my shoulders are broad are infinitely broad

x—Now then since we have come to the inevitable sure conclusion
that you are—it—Why paint you these pictures with your inner
reversed eye—why bore yourself with painting when this
untrained outer eye which you have no use for and which there-
fore cannot register your beauty—surely that outer eye of yours
cannot give pleasure—haven't you already gotten the great
pleasure in looking at your inner pictures with your inner eye

y—Good Lord You're right—what a relief—Now I don't have to
bother with that damned paint

x—Why of course
now you are absolved

144 now you have truly Entered your own legitimate Kingdom you

are now truly noble for you have made the great step—Of course
no one will know about you no one will have heard of you.
Therefore there will be no one to acclaim you—to build monu-
ments to you—but what do you care—

y—Hold up—Hold up there
I MUST HAVE MONUMENTS

x—Ah then you must paint—for the people cannot see your inner
things—You have proven your Outer Eye worthless. Therefore
those things painted with the Outer Eye are worthless and to
repeat—Since the people cannot See Your inner Eye Stuff—
hence no monuments

y—Hell—you would kill me

x—Why no—it's not necessary for in shutting out the world about
You—you have Killed yourself—you have consecrated yourself
to an everlasting praising of yourself and You (a being of all
sensibilities) Couldn't stand the awful boredom of everlasting
self praise

Yes it looks as if you have killed yourself

Maybe you were born dead

Adirondacks at Lower Ausable Lake, watercolor, 1947.
The Phillips Collection, Washington

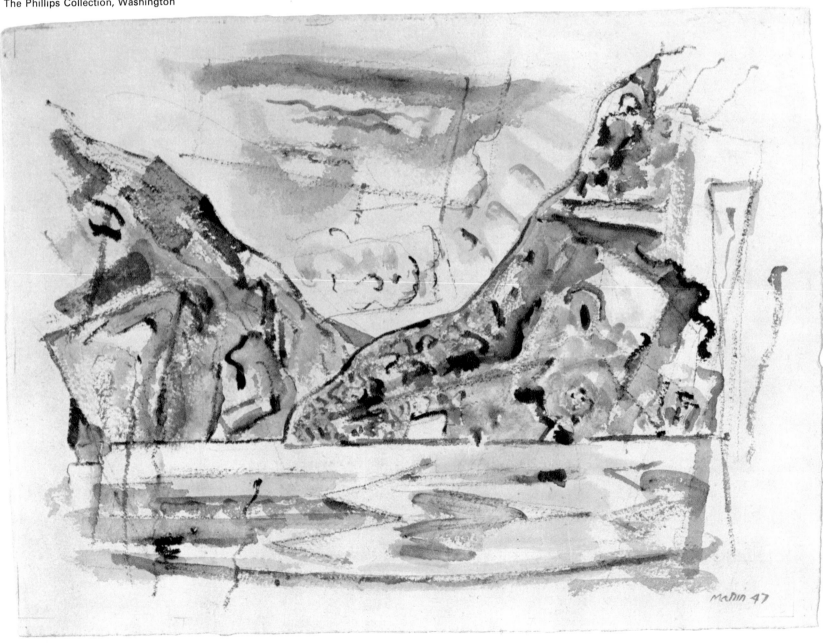

It is strange how the intellectuals run along with the artists—they get to the artists and they say—how does your pulse beat—why did it beat that way—could it not have beaten some other way—and if some other way what would happen—they are interested but never hungry.

Or if they are hungry it's never satisfied therefore they take it out in unnatural satisfactions—they read books and get a hodge podge philosophy of others which they deal out to confound their world contacts—those without the Circle—and they go about with always their door at hand marked—EXIT—which they use when a decided no or yes is called for.

The intellectuals too have taken our music
 And do not most of our composers
 " " " orchestra leaders lean mighty
heavily with the intellectuals.

I am inclined to think that these—the intellectuals—have in their make up a form of Nazism—for the lack of wholesome emotion they put to their (mighty brain)? art—God almighty . . .

For the most part did you ever tell your audience about the picture—what were the artist's aims as revealed in the picture—of course you always tell your audience which is the best picture—which of course—you being the expert—they expect—it proves your expertness.

There you have him

Your art critic

Your music critic

Your baseball—Your racetrack—and your hunting and fishing critic.

Don't they in their stupidity tell you how to look—where to look—and looking where to see—how to interpret—what to read into
 Supposing you were out for a walk—oh—in the woods—along the streams—over the hills
 and—at every step on the way there were signs a telling you how to walk—where to walk—when to stop—how fast to walk—what to see and—how to see it
 say—would you have enjoyed your walk?

All the props—all the propaganda—all the explanations—all the things plastered on to it won't help a tinker's damn—for it has to be—Art—

Art has value to the historian—the tree has value to the lumberman.

The Audacity of one to question when the artist—speaks—
Such a one says—That picture is very strong—
beware—so is a bonehead—

One looks at one's picture and thinks of all sorts of ways to make that picture better
The Critic comes along and Knows nothing of those ways

If the critic should be right and the man who painted the pictures wrong
 God help the [artist]
If the man who painted these be right and the Critic wrong
 Then what—

How vaporish the comments of most commentators

Remember this that those tales of the artist not receiving recognition in his own time are all nonsense—he's always had his following—To believe different were to say there were no sensitive people in his time.

The truth of the matter—that these artists of the past were written up by the Critics of their time—and that these writings have come down to us. The sensitive ones who followed him along—well they for the most part didn't write. And they [the Critics] never wrote an interesting article in their lives they never told anyone of a wonderful day in the woods there is no rhythm or action in their reportings only their stupid notion of Humor humor humor

and He of the horse track—did they ever tell You how the the horses looked—did they ever paint a word picture of that race.

Did your baseball Critic ever paint a picture in words of the look of the diamond of the feel of that particular day

There is only one thing necessary—that the born artist derives delight with his good eyes his sensitive paws. How possible to beat that combination

it cannot be done

Rave you intellectuals—by him you are not heard—only as disagreeable noise.

Hold forth you stupids—he will throw you in the same basket with the intellectuals.

The intellectuals look for the big things???? missing the little things which go to make up the big thing.

Your stupid looks for the little things???? but cannot see the big thing make up of little things.

The big guns from abroad—I know this much they've just gotten our Critics on this side of the water just plain buffaloed

but they the poor creatures who are they going to write about—there are precious few.

The political painters—there is—too—no fun in their work they get the acclaim of the certain powers that be—but the acclaim that they hungrily desire—that is not theirs—some of their work is on a huge scale—the hugeness of Vulgarity—they are ambitious not to do good work but to get their petty renown. You must sit by the stream by the mountain by the tree—in the room where there are people and watch the movement of all these how they balance themselves how they—alive—live themselves. They [the Critics] would if they could cut off the heads of the worthwhile men—they are dangerous to those who do not know.

It seems that Art and Music in our present time lean heavily to (intellectualizing) made for their cultural intellectual Enjoyment— in other words they are trying their best to kill the artist—the terms they use—profundities—In other words they would as their close relations the (Nazis) destroy all that is delightful—lovely—intimate—precious—sweet—dear—

And the awful joke is that they would have it that they are opposed to that very Nazism to which they inescapably belong.

There was a man who said—Art is dead—then he started immediately to Embrace dead art.

Entertained people foster dishonesty—

for is not dishonesty oft times bred by the fear of being held stupid

Let others tell themselves how—

Give yourself the liberty of telling yourself how.

I would suggest (as an exercise) that sometime you take your two eyes along with you—and leave your intillect—and your friends' intillects at home—you might—without these handicaps—begin to see things that would surprise you.

Music—Art

The queer notes in Bach
The beautiful repetitions
The off key notes that somehow belong—"That is not the right note"—
yes it is because the fingers belong there—"You are talking nonsense"
—no somehow it is so—there is a lot in seeming nonsense that makes
for beautiful strange sense.

Bach is finger patterns finger juxtapositions—as the fingers look well
in their different positions they make the music sound well. To play
this music takes an unbelievable concentration and absorbing.
In playing the piano one's head should be lowered one's eyes intent
on fingers and at the same time a looking right into the piano—
sometimes as it were crouched right on the instrument. The music
should course right down through the tips of the fingers right into the
instrument.

When the time arrives You will find that you almost unconsciously
have the fingers in their right positions so that all the fingering that
the professors have given you is so much dross.

That time with me—vague glimpses—I feel that I am on the
threshold of a something relating to it—how to hook up music with
art.

If you substitute Ears for Eyes you will perceive that in Bach the
fingers take logically recognizable positions based on the seeing of
things—

that is that when so placed (these fingers) substituting positions
for shapes—take on logically recognizable shapes

and that even a blind man could know these shapes—he could
feel them.

Music and Art

based on the up and down—the right and left—they both get their
depth through pressure of the fingers—some day I hope to write an
essay on fingers.
Music and Art—they are both based on a very few simples

These simples—discovered recognized and used—make for all
music all art

There are a few born who use the simples instinctively— immedi-
ately—

As they grow they become aware of the logic of it all that is what
we may call used intelligence

This intelligence is found in all living things to swerve from
danger—but here I contradict myself in making the statement that
it's not intelligence—it's a GIFT—where gotten—nobody knows—
So that not knowing—we fashion our God and say God gave it to us.

Music is founded on sounds heard and rhythms seen.

Bach—Haydn—Mozart—Beethoven—Brahms—Chopin comes in a
throwing whole clusters of pearls and jewels at one.

It would seem to be very difficult to write original music for the
musician's whole musical education is against [it] they get to know
too much music—it must take quite a man—a man who has something
strongly to survive that education.

In music objectivity is the tune.

I imagine if we were familiar with their [Eastern and American Indian]
music and had not been fed up with German and Italian music of the
Romantic period and even after—and heard some of the Eastern
music—we'd get a kick—and feel a basic rightness. Why we get
(though we hate to confess it) a kick out of JAZZ and I am sure that
has some of the Eastern flavor but cheer up all our eyes and ears
have been opened a peep or two. Even for myself my preaching
don't amount to too much preaching my practive don't come up to
my counsel—but it's all meant in good humor and faith and tomorrow
is another day again.

I'll listen to the instruments—they are good instruments and they are played by those who are intimate with their instruments I'll look at the players

Too—I'll look at the instruments—

I cease to be bored—I had a bully time.

It almost got to the point where it was not the beautiful music—but the instrument a talking to one another. So with art—not the beautiful piece alone but where all the parts are a talking to one another—where they don't give a damn for you unless you are perceptive

—Some such kind of a Concept—

You sense that intimacy of the parts

That's what I want to see

 " " " " " feel

 " " " " " hear

—That warms me—

Beauty can leave one Cold but where all the parts are a humming one is never Cold

Music is no more abstract than painting. Man hears voices about him the voices of his own kind—of living things of the winds of the waters—the artist has got beautiful instruments his paints chisels his what nots—the musician his beautiful instruments his fiddles his wind instruments his pianos his drums—the artist (and the musician) sees or hears these and his nature equivalents appear. Man gone wrong uses these things seen and heard and proceeds to imitate or express his own groanings and the groanings of mankind.

We revolt from lifelessness—in painting as in music
We have strayed from the life line
When one gets back to the life line we call him revolutionary

Becoming academic
Becoming decadent
There have been periods of art virility—that's where the academician rests.

Art is not great
Music is not great
It's just that they tickle us
When one steadfastly refuses greatness—then one is in the position [to] destroy its own inherent beauty—then and then only can that wonderful thing we call art be created.

To do something—OH GREAT—with a chuckle
 leave out the chuckle—you have no music no art.
That's the trouble with the personal God in all the religions. They have made him without a chuckle.

 and I can imagine a personal God—a fellow comes along—tells him to go Hell—makes faces at him—and for Him to burst out laughing and saying Ah—there's one fellow after my Own heart—I am so tired and sick of these fellows a bowing to me—and their interpretations.

If the moon were to say something to the Earth and the Earth laughed—more people could be killed than in all the wars put together.

Don't <u>try</u> to be great
Don't <u>try</u> to be important
Taken from my own experience—I remember a certain day—looking at my paintings—my head began to swell—it swelled enormously—came near killing me—

 A kid of six was the antidote—with its little painting in colors in a book—

 The cure was as bad as the disease—my own head went down so fast—it again—came near killing me—

One would think that from all this I have written that I am the disciple of—a posing—as of that one is to wash and annoint oneself—I would answer that I do continue with—unlimited seriousness—against those—very same serious creatures—whose work shows that diabolical seriousness whose work shows that diabolical importance whose work is dull & dead.

 When art and music are just a bit of fun made by an honest to goodness funny man who has a way.

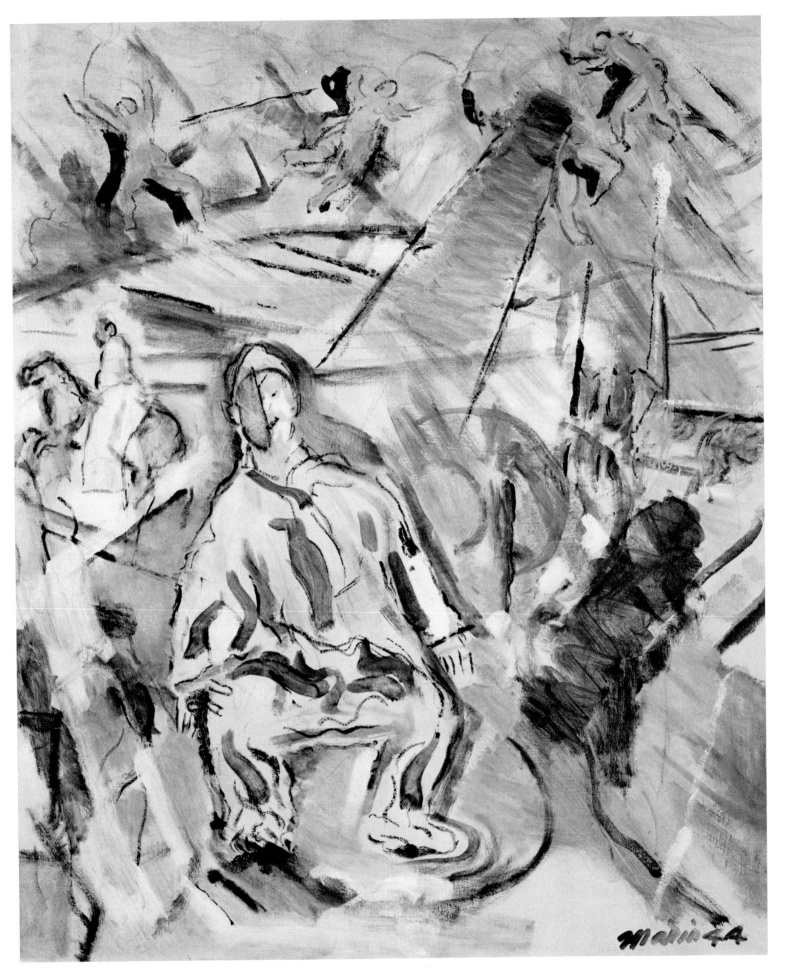

151

Circus, oil, 1944. Marlborough-Gerson Gallery, N.Y.

To those of you—boys and girls who must paint—those of you who have it in you to paint—To those I would say who are you—are you of those who have the European painting style in your System—no use you have there a handicap—are you of those who still go to the galleries where foreign work is being shown—there to learn—that which you will surely have to unlearn—are you to go to the schools in this country there to be taught by incompetents—that which will give you nothing worth while.

Are you to paint that inner vision thereby robbing your eyes of the beautiful all about you . . . indulge yourselves with that inner vision nonsense to an extent then will your eyes be eyes to see no longer then will they become weakened—just things—

Yes you must be Americans that and nothing else and if you are not just that—that is if you are still close to Europe—well let's hope your children may.

Now then are you ready—I am ready to lead you by the hand.

When I speak—that is if I spoke—I would like to speak to the Young in years—since as some do say that I myself remain young in Spirit—therein it would seem we have an affinity to start with—You the young can come under influence of elders and these elders too oft have Set up doctrines that are not in obeyance with basic laws which must be obeyed to keep alive—all laws of motion—of equilibrium—of balance—of Construction—all these—otherwise Chaos—Those who would tell you—to—do this thus and so—belong to such and such an order—I would say are mostly wrong—Those positive ones whose positiveness is based on fallacies—They tell you now we have freedom—their set of freedoms—basic destructive freedoms—They sort of—priests—leading astray a leading you away from your basic instincts and impulses with their "thou Shalt nots"—

Those "thou Shalt nots" who say "Pitch overboard all Seeing of the Object World—Sit down and get it from that wonderful head of yours"—are just as bad as those "thou Shalt nots"—who would have you follow prescribed paths which they themselves Know little about.

—I say do as your instincts would have you do—obeying to the best of your make up the law that makes it possible for you to live—breathe and do—Under bad leadership you can get yourself in a terrible mess.

Yes—and if you have the desire to paint from looking at the cat on the back yard fence—do it—don't let anybody stop you—
and while we are at—DON'TS—
don't solemnize your art
don't propagandize your art
don't stress on the downfall of the human race
be—a bit playful
to balance the serious—
the comedy—the tragedy
—Who is to show you the way—
Are the camps of the abstractionists the non objectives—etc etc—or the academicians to show you it—how about setting up your own little camp—if a song or two stems from it—all hale—but above all don't be ridiculous like—say the man who buys a place and has assembled thereon everything for the building of a house—and a one comes up and asks him "When are you going to build"—Our man draws himself up with great dignity and pointing to the stuff scattered about answers "My house is built there it is"—
—yes the house must be built—
—all must be built—
and it takes a bit of doing
Granted you have what it takes—then not only your joys but the joys of the sensitive people of the world who too see—who are everlastingly looking for those Commonplaces Elevated to the—beautiful—which is—Art—

Art remains that light giving forth—indestructible—by speech of man.

Sea Piece, oil, 1951. Marlborough-Gerson Gallery, N.Y.

A BLESSED EQUILIBRIUM

How to paint the Landscape
First you make your bow to the Landscape—
Then you wait and if and when the Landscape bows to
 you then and not until then Can you paint the
 Landscape

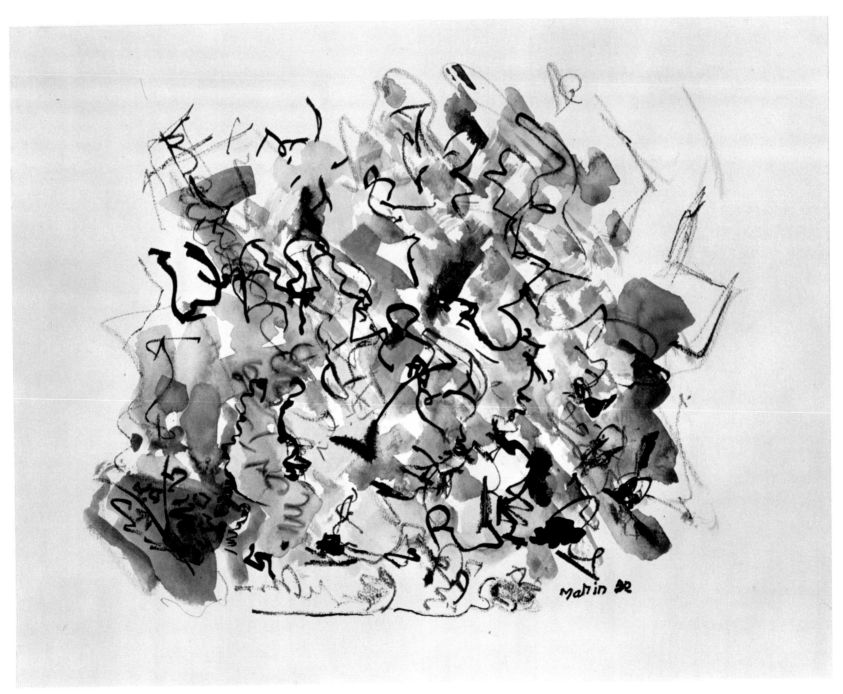

Untitled (Autumn Foliage), watercolor, 1952 sketchbook.
John Marin Archives

I hate lines drawn with a brush [in oil paint]—they are not strong enough. In a watercolor lines are easy—you draw your lines with a pencil. Do you know how I sometimes make lines with oil paint? I fill up a glass ear syringe with diluted oil paint—usually black paint—and while I press on the plunger I draw—It's like using a pencil—you can put down a definite line.

As for subject matter—I go places intimate to me and in those intimate places I start to paint my painting and in those places I look for happening about me that I know that happening about me that I not only see the big happening but realize that the big is made up of all little happenings and that I working must have little happenings in the work otherwise the big happening will not occur. Those who work with great seriousness they miss out for they never see the little happenings which make up into the big.

To get to my picture or to come back I must for myself insist that when it is finished that when all the parts are in place and are working that now it has become an object and will therefore have its boundaries as definite as that of the prow, the stern, the sides and bottom of a boat.

And that this picture must not make one feel that it burst its boundaries—The framing cannot remedy—that would be a delusion and I would have it that nothing can cut my picture off from its finalities—And—too—I am not to be destructive within I can have things that clash I can have a jolly good fight going on. There must always be a fight going on where there are living things. But I must be able to control this fight at will with a Blessed Equilibrium.

Ramapo River, New Jersey, oil, 1952.
The Downtown Gallery, N.Y.

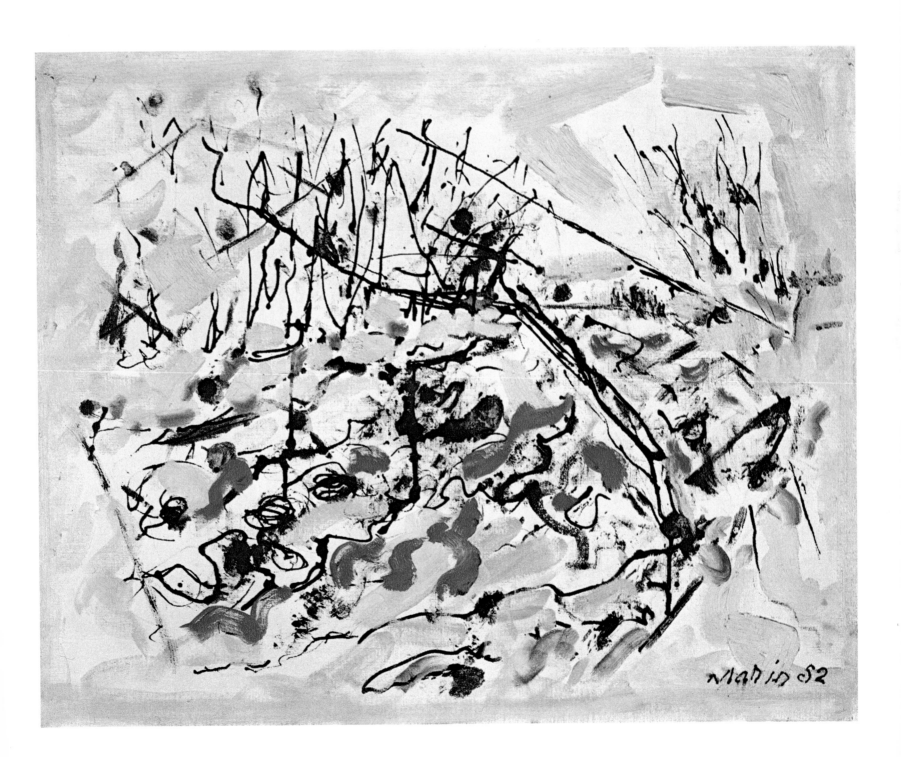

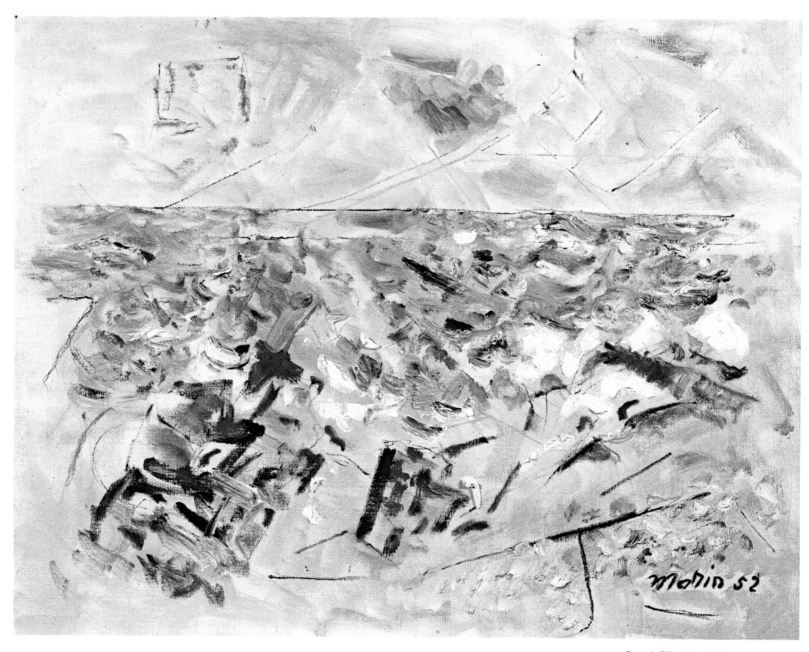

Beach Flint Island, Maine, oil, 1952.
Marlborough-Gerson Gallery, N.Y.

Detail of Beach Flint Island, Maine

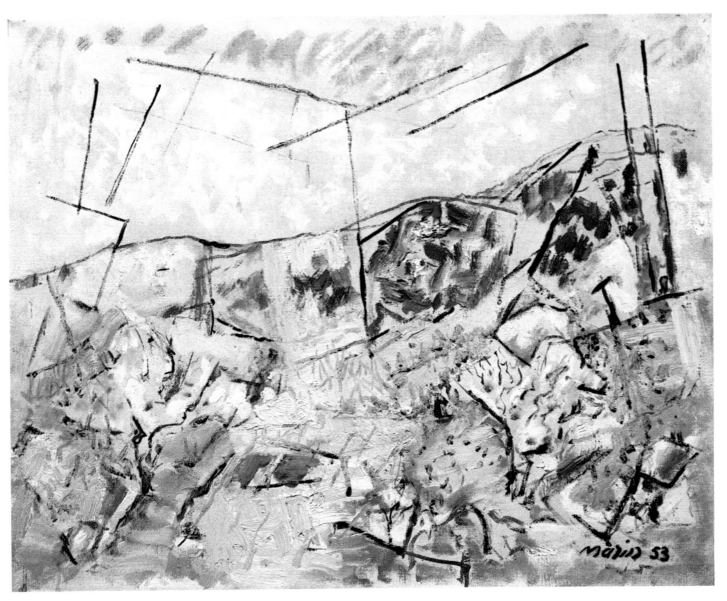

Spring No. 1, oil, 1953.
The Phillips Collection, Washington

It's a wet day two days ago it was a brilliant day—all was washed clean—and after this and other wet days there will be those brilliant days to come when everything sparkles—when the skies are lovely—blue skies with hanging clouds—and it's then I'll play truant and get out and wander to those lovable spots I have discovered not so far away—where the Earth has a sweet smell and a bearing its weight of all growing things—forests—fruit trees—plant life and flowers—and those beautiful streams—made—all made by those wet days.

All life made beautiful by those wet days—that balance—that finely adjusted balance

Sun and rain

then is life worth the living—then do things worth while come to existence

then does the creator create—and a great joy is given to the World.　159

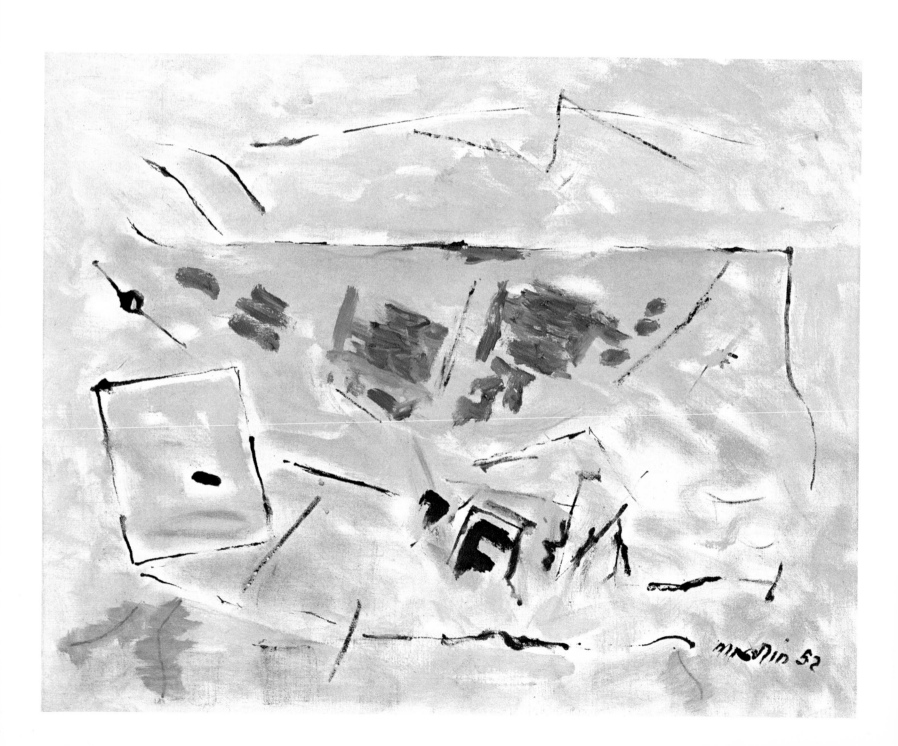

Fewer strokes—still fewer strokes—fewer strokes must count—
A full mellow ring to each stroke.

Seems to me the true artist must perforce go from time to time to the elemental big forms—Sky Sea Mountain Plain—and those things pertaining thereto—to sort of retrue himself up to recharge the battery. For these big forms have everything. But to express these you have to love these to be a part of these in sympathy. One doesn't get very far without this love this love to enfold too the relatively little things that grow on the mountain's back. Which if you don't recognize you don't recognize the mountain.

Freedom what is it—let's disobey the law—
 To first find out—to recognize—the Elemental the big laws then the one must perforce disobey the fool laws—to keep the big law—but so many seek to break the big law—Well, nature has something to Say about this.

My purpose is freedom of motion
Intelligent horse sense motion that becomes aware when the lean goes so far over that it takes a tumble.

A blessed balance not kept becomes a freedom that is unbalanced—destructive—and now you say what's all this to do with painting—with me a painter—It's this —I the worker in paint—the picture maker as long as I can remember—had—as had others—to contend with —currents against—currents of orthodoxy opposed to what they termed a playboy life—but—beside me unseen a seeming spirit moved and existence giving a lift—sustaining spirit & giving me lifts along the way—of liberty—so that I a lover of nature could go about and see how the mountains uplifted themselves nay talked to each other as it were.

As I see it life consists of the tendency [for] succeding recoveries of the out of balance.

Movement, Gray and Blue, oil, 1952.
Marlborough-Gerson Gallery, N.Y.

Music (rhythm—beat—balance—timing—the life flow—life's dancing —separations—coming togethers—with its in be tweenings)

To insist on intimacy.

Bigness with Emptiness is awful

To be able to go into the picture and live

That that you show must be seen—irrespective of subject matter—

To lose the subject—only then can one love the showing of it—
only then does the showing become wonderful so that the showing
is based on the love of the Object. You play with the object for the
showing—how can one play with that which one does not love—

Playing with or on the loved object begets creation—

The painting passing back and forth to the edge of the canvas and these
objects a cropping up on and within the paint lines on and within
the paint—that divide the paint in magnificent forms.

These objects a revealing themselves so that—"here I am"—"here
we are"—the painting—the ocean—the objects like the objects on
the waters—coming up out of the waters—the whole a traveling
back and forth

a full created thing

each part taking its place

Each part dependent on the part it meets.

The other night I saw the full moon a rising
Suspended over Our City
 —the Thrill—
also the time I saw the picture
—the time I heard the music
—the time I put my nose into the water lily
 —the Thrill—
now thou O commentator
—Give thou me—A thrill—

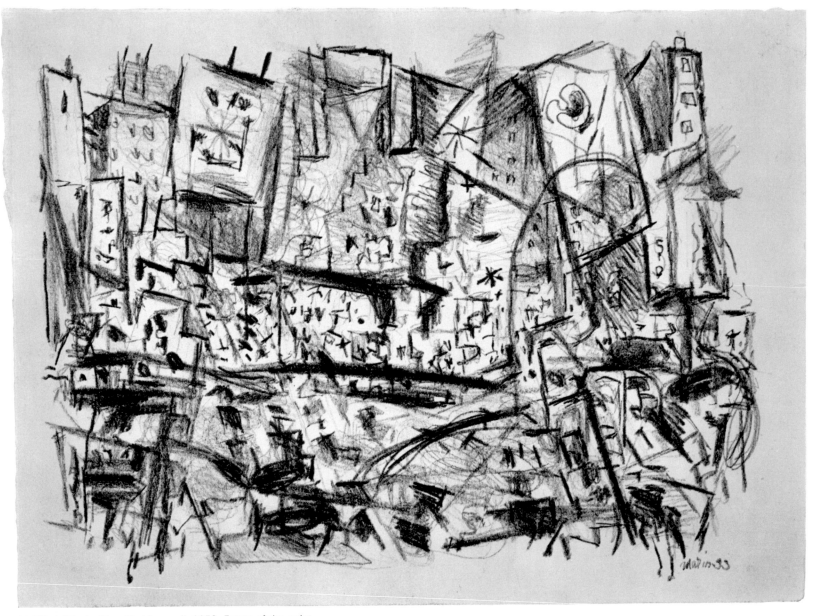

Untitled (Study, New York), pencil, 1953. Estate of the artist

There has come a distinct change in the weather—fall is upon us and I was thinking of painting s summer picture with real angels in it—females in their altogether—as God or someone else made them— so that now that fall is here—there haint no ladies with nothing on.

My clothesless ladies are so camouflaged with the landscape or seascape—that before found by the—Society of Angels—they can put their clothes on.

Though I really doubt that they can ever discover— my dear naked ladies.

In the old masters the landscape & figures are making love to each other.

This wind up here is no respecter of persons it lashes out— with gale force—I painted three pictures up in the pasture— let one not picture other pastures for this one is on a hillside and is full of stumps, mounds & hollows.

The lower end of this pasture—I term my Studio—for with the trees it shelters one from the winds and it is here that I have Cooked up most of my—Seascapes—The sea on the other side of the trees— can't talk back & if it does—my Ears don't hear—

And if these things of mine don't exist—well then they are at least beyond Criticism—for who in Hell can Criticize that which doesn't exist—

There is only one excuse for making a picture that being to kill distance
only one excuse for making music—to kill distance
only one excuse for writing—to kill distance
only one excuse for living—to kill distance
the loaf of bread distant from you does you no good—
Those unconscious things that affect You have become close to You without Your Knowing it.

Sea Fantasy, oil, 1952. Private collection

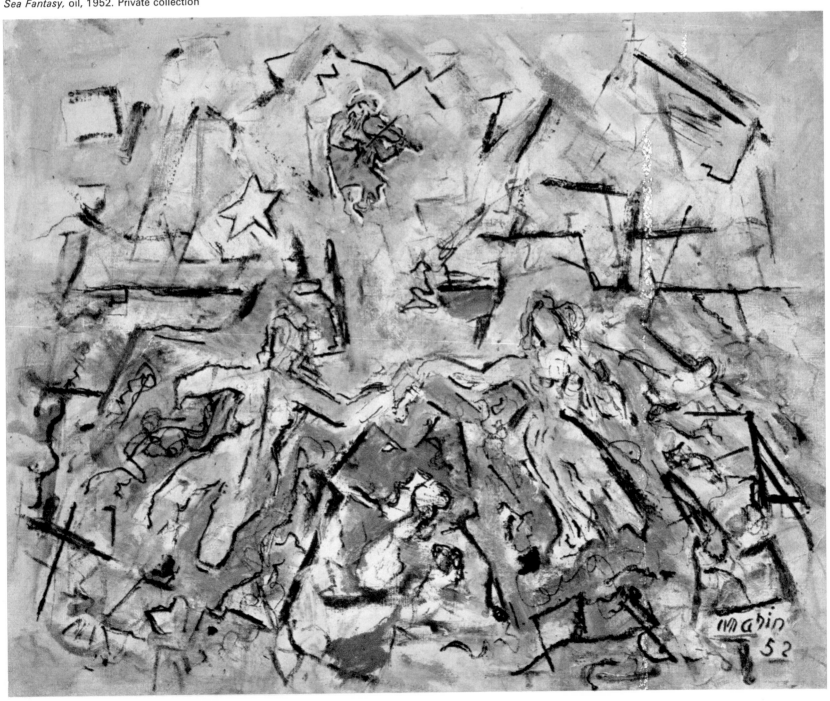

Sea Piece, watercolor, 1951. Private collection

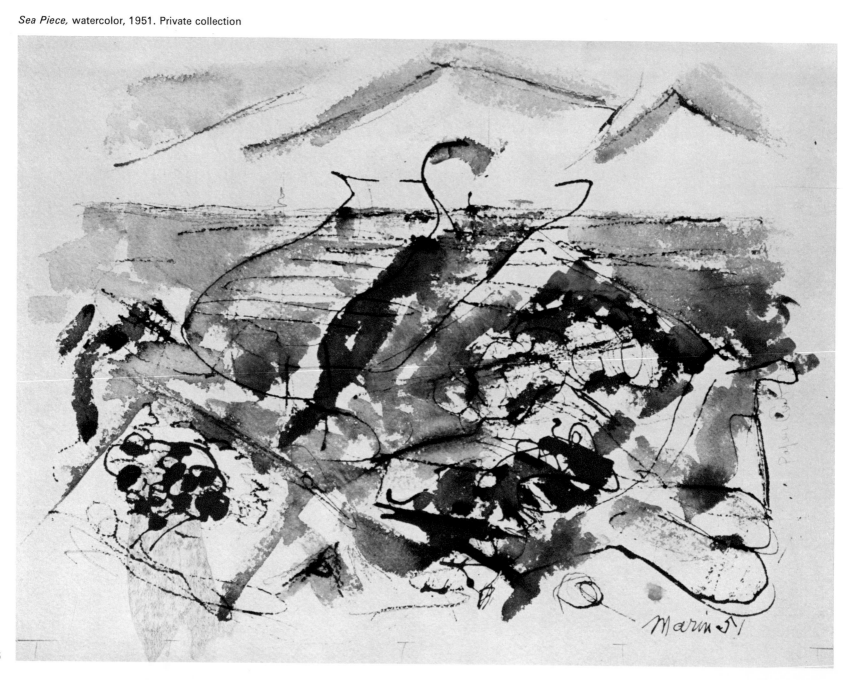

Sea Fantasy, oil, 1952. Private collection

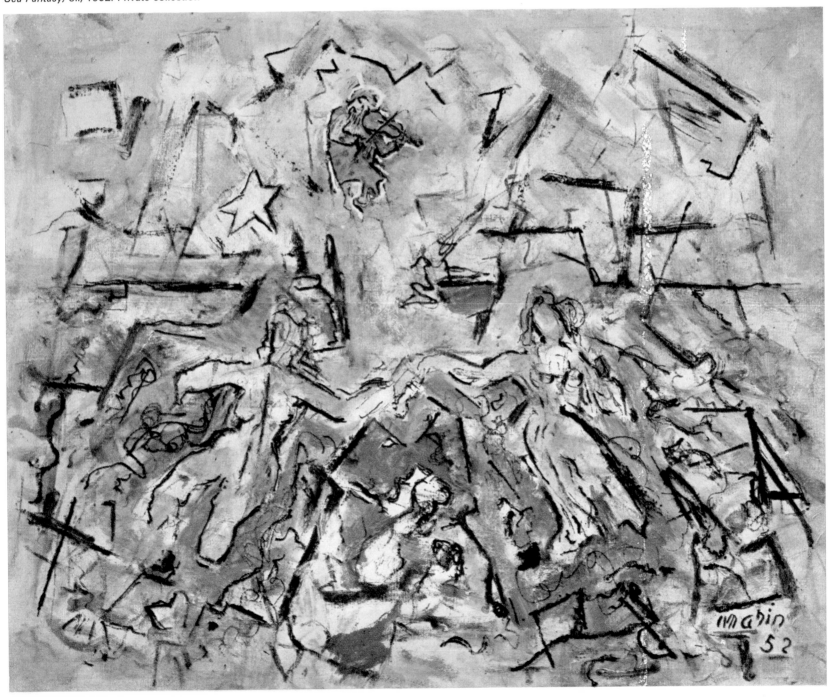

Sea Piece, watercolor, 1951. Private collection

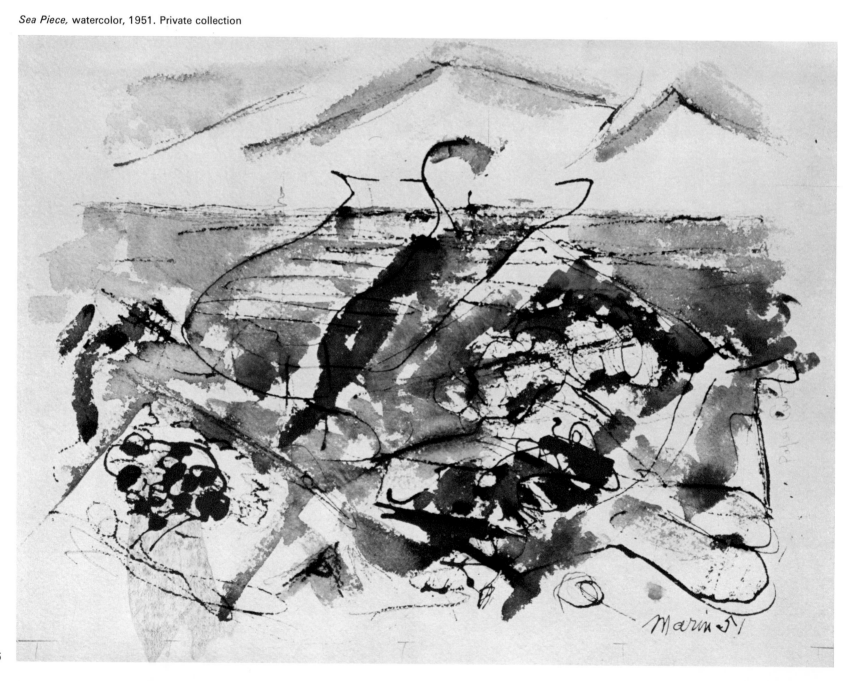

I—have to paint pictures—Oh yes I have to—Some cuss inside me
forces me to paint—those things they call pictures—The thing to do
is to paint the perfect picture then you are through—you don't have
to paint—more—
 One would be a damn fool to do so—
 —but—
the startling things that can occur on a canvas
 —the adventures—
Come with me—just look out of this door—Holy Moses—look out
of that door—Holy Holy Moses—
Now come and look out of this other door—Holy Holy Moses—
 —and there be other doors—many many more—
 —Hundreds of canvases—many many paint pots—a great stack
of brushes and—an extended extened—life—

As for painting—I've given that up—I just tie a brush to my fingers and let that old Silly brush do the painting.

Outdoor painting as such is just a <u>Job</u> to get down what's ahead of you. Water you paint the way water is and moves—Rocks and soil you paint the way they were worked for their formation—Trees you paint the way trees grow.

If you are more or less successful these paintings will look pretty well indoors for they have a certain rugged Strength which will carry them off in a room—but they bear no relationship to the room.

In <u>indoors</u> painting as such things should bear a close relationship to the room.

and I find that now I am hovering close to a Statement that in using the term <u>indoors</u> I am approaching a supposition of <u>inward traveling</u> which throws us back on our haunches again

 But

I would like to sound myself to those would like to roar at those

 Those critics

 Those feeble painters

 Those who gasp out "Interpret myself"

 Those—

 Art literature creatures

 Those—

 Art Exponents

That painting after all <u>is</u> <u>painting</u> just that and that if you paint and paint and when you get through your paint builds itself up moulds itself piles itself up as does that rock this vary set of things why then you might call yourself a painter—you might have one or two of the Old Boys could they come back—give you a deserved pat on the back

Yes I'll have it that painting is a <u>Job</u>—a <u>Job</u> in paint—

and I'm afraid that in the crazed desire to be modern

to have ideas to be original—to belong to the tribe intelligencia—we

have gotten away from the paint job which is a <u>lusty</u> <u>thing</u>

and I almost feel like saying "what you have to say don't amount to so much" but the <u>lusty</u> desire to splash about Submerge oneself in a medium.

You might come up to the surface with something worth while Oh there will be phases and phases and Still more but at present

I Sing to the LUSTY

The Written Sea, oil, 1952. Private collection

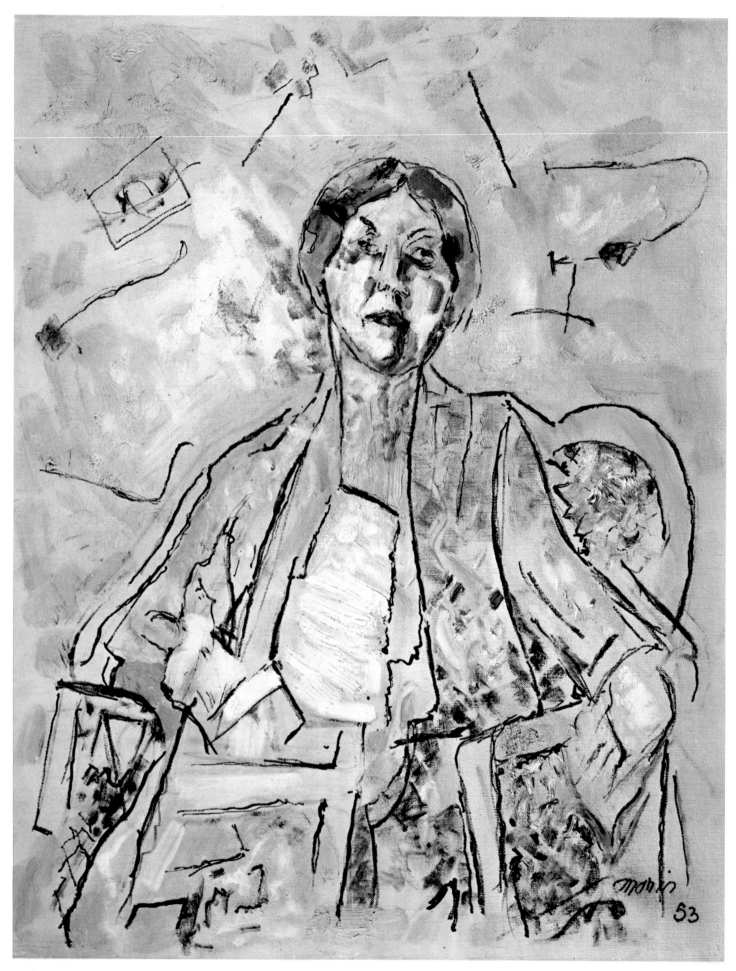

Portrait of Mrs. John Marin, oil, 1953. Private collection

How one has to wage mightily to preserve beauty—

Those sensing and feeling beauty—love The evil minded don't know the meaning of love—they never have—and never will experience love—Curious—the lover can hate—but the hater cannot love—

Consider the wealth of that to love the lover possesses—in nature forms—

Mountains—hills plains and vales—Oceans—seas lakes rivers—streams and the living forms what have movement thereon—

Those loving these forms and having ability—make use in expressing—those ignoring fall back on what they term their inner seeings unrelated to the world about them—

One loving—having the feeling of belonging—expressing—Supplying a want—not loving—where is the belonging—personally—myself speaking—I've no place for—no want for—what is termed the Abstract—the nonobjective—no not one—

A little book now I possess—the Complete Angler of Izaak Walton written over 300 years ago profusely illustrated little drawings by unknowns—but oh—they had real love for their streams and what grew thereon—so that for me they possess a real value—I love to look at them—

(Should the artist portray the lovable—would not his very nature demand it—yes—but—How about the depiction of suffering as in the Crucifixion—for just one example—well are not all the doctors of the world out to bring about health—not disease—decidedly against suffering—would you hang on your wall depicted suffering—by anyone? I doubt it—)

Find a good honest farmer—a good honest man in any walk of life—they are still to be found here and there—but Oh—the Johnnies of the world—they who must be great—Real Vision they possess not—nor kindness—nor love—Didn't Hamlet show them up—

Personally again—there be but one story for me to read—The love story—Highbrow reading—not for me—

Ah—the lover—He can love a woman and bring her close—He can love the Evening Star and bring it close—He can love the flower of the meadow—and bring it close—Is that the approach of the Student?—I doubt it much—

Those the top notchers of France—your Picasso—your Bracque—Miró—Léger—Matisse—Their ability I recognize—but for me they everlastingly lack love—The painted portrait has held for a few thousand years—I feel it will have value in the years to come—that mankind will eventually—is now beginning to get tired and sick of the abstract the nonobjective—that old subject object forms will come forth again.

(As for music I feel the same holds—Debussy and your Strawinski and family I feel will too go by the board—for in their outputs the instruments themselves are to my thinking tortured out of their natural selves—)

There was a man Orlando Gibbons—15th Century—in his music I hear the bells of Heaven a ringing up there aloft...

music—modern music—most of it not for me—Jazz—much I can accept—for there the instruments are on a real honest drunk are having fun...

Yes I realize the Greatness of Beethoven and Mozart and Bach but there was a man not much played—he was a lover too—led quite a happy life—I'll say again and again not fully appreciated—dear Haydn sheer music

So that for myself I could have only two—I'd take Gibbons and Haydn now to wind up—the woman goes to the store to get some food brings it home cooks it the family are all seated—partake of the food—and feel good—happy—and content.

———Oh—no—no—no—not in much of the writings of today not in most poetry—feature writings—plays—essays—and writings of the intellectuals—

That woman isn't going to be let off that easy—was she going to the store—was she out to meet someone—she must become involved and if she reached home isn't it quite possible that the husband will bash her one—and chuck her out—Dostoevsky and Chekhov—don't they show you in their writings that—no the Gal isn't going to get off so easy nor is anyone else they all become involved

No—me—I want the uplift

In music in writing in painting—founded on love—the relatively happy life founded on love—there be quite a few left— Don't you see that—The woman went to the store no that's definite they will have it—the woman went to the———that gives their wonderful abstract thinking a chance

I went to the Peach Orchard in bloom I painted—my object—that that painting has the feel of peach orchard in bloom and nothing else—

The evil minded would over power healthy love—where they do destruction

blessed be love

And one might go on—talk of art in its different forms As to whether in the tearing up the making of new paths As to how much new road real road will be made or as to whether we are just finding out ways and means.

I want an answer to the question? a real answer—a true answer—the only answer—Who can give it—

As for my work

many ups and downs fighting out problems making deductions and then being pulled up on afterthought—and aftersight—but if you do get a little something you like why that's about all you're entitled to in this life.

Many seem to remember their—bad dreams
I'll try to remember my good dreams.

So there now

this is how I try to paint a picture using to the best of my ability colors and lines in their identity places—and there is the fellow up there in the sky who
laughs
—he who sheds tears and
the fellow who shouts at the top of his lungs
Courage
he the loudest of all
Damn it—I'll say so

Eighty-three years is a long time. I have had a long life and a very happy one—retained all my faculties and want to go with them. Why stay?

It's been a beautiful world
it is a beautiful world
it's the only world we've Known
Our work was done in this world
Our friends have been in this world
and we have fared moderately well and we have enjoyed the living moderately well with some Swell moments.

The Circus, oil, 1953. Marlborough-Gerson Gallery

NOTES TO THE TEXT

Editor's note: The reader can identify the provenance of the text used by referring to the pages in this book on which text appears. When more than one text occurs on a page, the order of identification starts at the top of the column at the left. Abbreviations in the Notes have the following meanings:

AS = Alfred Stieglitz

Benson = *John Marin* by E. M. Benson, American Federation of Arts, Washington, 1935.

Helm = *John Marin* by MacKinley Helm; Pellegrini & Cudahy, N.Y. 1949.

Ms = Miscellaneous manuscripts written by John Marin in the John Marin Archives, almost all unpublished.

N = *The Selected Writings of John Marin* edited by Dorothy Norman; Pellegrini & Cudahy, N.Y., 1949.

Princeton Notes = taken during an evening in Princeton, N.J. with Marin, James E. Davis, the editor and others.

S = *Letters of John Marin* edited by Herbert J. Seligmann, An American Place, N.Y. 1931 unpaged.

Yale = Alfred Stieglitz Archive, Beinecke Library, Yale University Collection of American Literature. When reference is made to Yale followed by a number, the number designates the numerical allocation of the given letter in the Stieglitz Archive.

Page **5** Ms to Mr. Lane 11/6/40; 2 ink versions, Lane unknown.

FOREWORD

1. To James E. Davis, 4/1/40; unpub. This and the following quotations of Marin during his visit to Princeton University on 5/2/40, come from the notebooks of James E. Davis; originals in the Firestone Library, Princeton. Davis was friend of Marin, a teacher at Princeton University and is a painter and film maker.
2. To James E. Davis, 5/24/40; unpub.
3. Ms to Duncan & Marjorie Phillips, pencil draft; unpub.
4. Telegram from Lee Simonson, 9/13/28; original in Marin Archives; Simonson was stage designer and the editor of *Creative Art* magazine.
5. To Lee Simonson, 9/13/28; draft; typed carbon in Marin Archives; Yale; S; N 122.
6. Carl Zigrosser, *The Complete Etchings of John Marin*, catalogue by Philadelphia Museum of Art, Philadelphia, 1969.

JOHN MARIN BY JOHN MARIN

Page **15** To AS 9/11/21; Yale #43; S; N 72-3.

EVENTS IN A LIFE

Page **16** Ms 8/26/28; typed copy. pub. "John Marin by Himself" in *Creative Art*, Oct. 1928; Yale; S; N 124-7

18-19 Ms undated; several pgs. pencil draft; unpub.
* John Cheri Marin, III—Dec. 23, 1870—Oct. 1, 1953.
** Marin's maternal grandparents, Currey, lived in Weehawken, N.J.; their two spinster daughters, Jenny and Lelia, brought up the boy.

20 *Manuscripts Number Two*, N.Y. March, 1922; Yale; S; N 77-8.
* Studied under Thomas P. Anschutz & Hugh Breckenridge.
** Studied under Frank Vincent Dumond.
*** *The Mills at Meaux*, oil, 1906.

21 Ms to Egmont Arens, Managing Editor, *Creative Art* 8/26/28; draft; typed copy in Marin Archives; Yale; S; N 121-2.
* Alfred Stieglitz first showed Marin's watercolors at his gallery "291" in March 1909 as a result of the interest of his associate in the gallery, Edward Steichen. Steichen had shipped from Paris a small selection of Marin watercolors. In Feb. 1910 Stieglitz gave Marin his first one-man exhibition.
** N. E. Montross of the Montross Gallery and Charles Daniel of the Daniel Gallery, both in New York City, exhibited Marin's work with the cooperation of Stieglitz while Stieglitz's gallery was closed from 1917-25. In 1925 Stieglitz reopened his gallery under the name "Intimate Gallery" which became in 1929 his famous "An American Place."
*** Alfred Stieglitz's collection was donated to several museums after his death by his wife Georgia O'Keeffe, the renowned painter. The largest number of Marin works went to New York's Metropolitan Museum. Letters and other literary items by and about Marin collected by Stieglitz were given by Miss O'Keeffe to Yale University.
**** The Ferdinand Howald Collection was presented in 1913 to the Columbus Gallery of Fine Arts, Columbus, Ohio.
***** The Phillips Collection, Washington, D.C.
****** The Phillip Goodwin Collection was bequeathed principally to The Museum of Modern Art, N.Y.C.
******* The Albert Gallatin Collection was bequeathed to The Brooklyn Museum, N.Y.C.
Facsimile, To AS 5/18/10; Yale #1; unpub.
Ms undated; Yale miscellaneous file; unpub.

23 Ms to Ernest Haskell undated; Haskell was the son of John Marin's friend, the artist Ernest Haskell; N 205 3/26/43.
* Marie Jane Hughes married John Marin Dec. 1912.
To AS 8/1/12; Yale #5; unpub.
To AS 9/6/16; Yale #13; S; N 30.
** John C. Marin, IV, an only child, born Nov. 22. 1914.
To AS 7/31/17; Yale #16; S; N 35.
To AS 11/23/19; Yale #31; S; N 53.

24 To AS 8/28/32; Yale #94; S; N 146-7.
* Marin bought Marin Island, opposite Small Point, Maine, in the summer of 1915. The island had no water and he was unable to build on it as planned. To AS 8/10/34; Yale #99; N 159-60.
** In Addison, Maine, on Pleasant Bay.
*** The Wass family, neighbors in Addison and close friends.
**** Herbert J. Seligmann, poet, critic and associate of Stieglitz was, with his wife Lilias, a summer neighbor and close friend of Marin.
To AS 8/18/35; Yale #103; N 167.
Map and plan unpub. part of letter to AS 8/10/34; Yale #99.

26 To AS 10/3/45; Yale #123; unpub.
27 Ms undated; pencil notes; unpub.
28 Ms undated; 4 pg. letter in ink; unpub.
29 To James Davis 5/4/45; unpub.
Ms undated; unpub.
* Marin was elected to the National Institute of Arts and Letters in 1942; in 1943 he was elected to the American Academy of Arts and Letters and occupied chair 22.

THE ANCIENT MARINER

Page **30** To AS 7/12/39; Yale #112; N 192.
32 To AS 8/15/19; Yale #27; S; N 46-7; Helm 44-5.
To AS 8/28/39; unpub. Yale #114.
To AS 8/21/27; Yale #74; S; N 115.
To AS 9/28/16; Yale #14; S; N 31.
To AS 8/13/22; Yale #46; S; N 82.
33 Ms undated; pencil draft; unpub.
Catalogue University of California John Marin Memorial Exhibit, 1955; quotation dated 1942. Yale
35 To AS 8/8/16; Yale #12; S; N 28.
Ms to The Editor of *The New Yorker* 4/11/30; 6 pg. letter in ink; Marin wrote evidently objecting to what had appeared in the magazine which, he thought, contained inaccurate facts and misguided humor about himself; unpub.
To AS 9/6/16; Yale #13; S; N 29.
To AS 11/23/19; Yale #31; S; N 55.
To AS 10/22/21; Yale #44; S; N 74.
To AS 10/3/17; unpub. Yale #17.
To AS 9/28/16; Yale #14; S; N 31-2.
To AS 9/16/14; Yale #9; S; N 18.
36 Ms to AS 7/—/35; pencil draft; Yale #102; dif. version N 163.

Ms to AS undated; page 5 of multi-page draft in ink; dif. version Yale #108; N 176-7.
Ms to AS undated; multi-page pencil draft; dif. version Yale #102 dated 7/8/35; N 164.
To AS 7/31/21; Yale #41; S; N 66-7 (misdated).
To AS 7/9/27; Yale #73; S; N 113-4; Helm 42.
To AS 10/5/18; Yale #20; S; N 38 (typo. error for Rowe, Mass.)
To AS 7/22/13; Yale #6; S; N 7.

38 To AS 9/10/13; Letter refers to his neighbors in Castorland, N.Y. where he spent summer of 1913. Yale #7; S; N 9-12.
To AS 11/23/19 Yale #31; S; N 55.
40 To AS 8/28/32; Yale #94; N 147-8.
To AS 8/21/27; Yale #74; S; N 115.
To Stieglitz and O'Keffee 7/18/38; The Thompson family, close friends and neighbors in Addison, Maine. Yale #109; S; N 181.
Ms to Shelton Pitney undated; 3 pg. ink draft. Pitney (unknown) obviously had requested a donation to a World War II cause; unpub.
41 Ms undated; pencil notes; unpub.
Ms undated; pencil notes; unpub.
Ms undated; pencil notes; unpub.
Ms undated; 2 pg. pencil notes; unpub.
43 Ms to Duncan & Marjorie (Phillips) undated; multi-page pencil draft *c.* 1950.
Ms to John (Marin, Jr.) 5/18/39; 4 pg. ink draft; dif. version N 190.

THE SEEING EYE

Page **44** Ms undated; 1 pg. pencil notes; unpub.
46 To AS 8/26/24; Yale #57; S; N 96-7.
47 To AS 8/28/32; Yale #94; N 144.
To AS 7/31/17; Yale #16; S; N 34.
To AS 7/31/17; Yale #16; S; N 35.
To AS 8/28/32; Yale #94; N 145.
Twice A Year #2, Spring-Summer 1939; N 185.
Princeton notes; 5/2/40; unpub.
To AS 8/18/35; Yale #103; N 167-8.
48 To AS 10/3/17; Yale #17; unpub.
To AS 9/6/14; Yale #9; S; N 19.
To AS 9/15/44; Yale #121; N 212.
51 Ms undated; pencil notes; unpub.
Ms undated; pencil notes; unpub.
Ms undated; pencil notes; unpub.
Ms undated; pencil notes; unpub.
Ms undated; multi-page pencil draft; unpub.
53 Ms undated; pencil notes; unpub.
Ms undated; pencil notes; unpub.
Ms undated; multi-page pencil draft; unpub.
54 Ms undated; multi-page pencil draft; unpub.
Ms undated; multi-page pencil draft; unpub.
Ms undated; multi-page pencil draft; unpub.
Ms undated; pencil notes; unpub.
56 To Strand 9/20/30; Paul Strand, eminent photographer, close friend of Marin and Stieglitz. S; N 137
To Zoler 8/25/29; E. C. Zoler associated with Stieglitz and Marin at "291" and "An American Place". S; N 132.
To AS 7/21/29; Yale #83; S; N 130.
57 To Strand 6/22-25/29; S; N 128.
58 To Zoler 8/25/29; S; N 132.
To AS 8/4-14/30; Yale #87; S; N 135.
61 Ms to AS undated; multi-page pencil draft. dif. version Yale #115; 8/31/40; N 195.
Ms to Duncan "late Sept. Early Oct. '48"; Charles Duncan, sign painter, good friend of Marin in N.J. multi-page ink letter; unpub.
To AS 7/31/21; Yale #41; S; N 66 (misdated).
To AS 9/8/42; Yale #118; N 203.
"A Day with John Marin" by Beaumont Newhall, *Art in America* Sept.-Oct., 1953.
To AS 8/28/32; Yale #94; N 144-5.
To AS 9/15/44; Yale #121; N 214.
62 To AS 9/1/38; The Wass family, close friends and neighbors in Addison, Maine; Yale #110; unpub.
64 To AS 9/14/20; Yale #36; S; N 59.
66 To AS 9/11/21; Yale #43; S; N 70-71.
To AS 9/16/14; Yale #9; S; N 17.

The Circus, oil, 1953. Marlborough-Gerson Gallery

NOTES TO THE TEXT

Editor's note: The reader can identify the provenance of the text used by referring to the pages in this book on which text appears. When more than one text occurs on a page, the order of identification starts at the top of the column at the left. Abbreviations in the Notes have the following meanings:

AS = Alfred Stieglitz

Benson = *John Marin* by E. M. Benson, American Federation of Arts, Washington, 1935.

Helm = *John Marin* by MacKinley Helm; Pellegrini & Cudahy, N.Y. 1949.

Ms = Miscellaneous manuscripts written by John Marin in the John Marin Archives, almost all unpublished.

N = *The Selected Writings of John Marin* edited by Dorothy Norman; Pellegrini & Cudahy, N.Y., 1949.

Princeton Notes = taken during an evening in Princeton, N.J. with Marin, James E. Davis, the editor and others.

S = *Letters of John Marin* edited by Herbert J. Seligmann, An American Place, N.Y. 1931 unpaged.

Yale = Alfred Stieglitz Archive, Beinecke Library, Yale University Collection of American Literature. When reference is made to Yale followed by a number, the number designates the numerical allocation of the given letter in the Stieglitz Archive.

Page **5** Ms to Mr. Lane 11/6/40; 2 ink versions, Lane unknown.

FOREWORD

1. To James E. Davis, 4/1/40; unpub. This and the following quotations of Marin during his visit to Princeton University on 5/2/40, come from the notebooks of James E. Davis; originals in the Firestone Library, Princeton. Davis was friend of Marin, a teacher at Princeton University and is a painter and film maker.
2. To James E. Davis, 5/24/40; unpub.
3. Ms to Duncan & Marjorie Phillips, pencil draft; unpub.
4. Telegram from Lee Simonson, 9/13/28; original in Marin Archives; Simonson was stage designer and the editor of *Creative Art* magazine.
5. To Lee Simonson, 9/13/28; draft; typed carbon in Marin Archives; Yale; S; N 122.
6. Carl Zigrosser, *The Complete Etchings of John Marin*, catalogue by Philadelphia Museum of Art, Philadelphia, 1969.

JOHN MARIN BY JOHN MARIN

Page **15** To AS 9/11/21; Yale #43; S; N 72-3.

EVENTS IN A LIFE

Page **16** Ms 8/26/28; typed copy. pub. "John Marin by Himself" in *Creative Art*, Oct. 1928; Yale; S; N 124-7
18-19 Ms undated; several pgs. pencil draft; unpub.
 * John Cheri Marin, III—Dec. 23, 1870-Oct. 1, 1953.
 ** Marin's maternal grandparents, Currey, lived in Weehawken, N.J.; their two spinster daughters, Jenny and Lelia, brought up the boy.
20 *Manuscripts Number Two*, N.Y. March, 1922; Yale; S; N 77-8.
 * Studied under Thomas P. Anschutz & Hugh Breckenridge.
 ** Studied under Frank Vincent Dumond.
 *** *The Mills at Meaux*, oil, 1906.
21 Ms to Egmont Arens, Managing Editor, *Creative Art* 8/26/28; draft; typed copy in Marin Archives; Yale; S; N 121-2.
 * Alfred Stieglitz first showed Marin's watercolors at his gallery "291" in March 1909 as a result of the interest of his associate in the gallery, Edward Steichen. Steichen had shipped from Paris a small selection of Marin watercolors. In Feb. 1910 Stieglitz gave Marin his first one-man exhibition.
 ** N. E. Montross of the Montross Gallery and Charles Daniel of the Daniel Gallery, both in New York City, exhibited Marin's work with the cooperation of Stieglitz while Stieglitz's gallery was closed from 1917-25. In 1925 Stieglitz reopened his gallery under the name "Intimate Gallery" which became in 1929 his famous "An American Place."
 *** Alfred Stieglitz's collection was donated to several museums after his death by his wife Georgia O'Keeffe, the renowned painter. The largest number of Marin works went to New York's Metropolitan Museum. Letters and other literary items by and about Marin collected by Stieglitz were given by Miss O'Keeffe to Yale University.
 **** The Ferdinand Howald Collection was presented in 1913 to the Columbus Gallery of Fine Arts, Columbus, Ohio.
 ***** The Phillips Collection, Washington, D.C.
 ****** The Phillip Goodwin Collection was bequeathed principally to The Museum of Modern Art, N.Y.C.
 ******* The Albert Gallatin Collection was bequeathed to The Brooklyn Museum, N.Y.C.
Facsimile, To AS 5/18/10; Yale #1; unpub.
Ms undated; Yale miscellaneous file; unpub.
23 Ms to Ernest Haskell undated; Haskell was the son of John Marin's friend, the artist Ernest Haskell; N 205 3/26/43.
 * Marie Jane Hughes married John Marin Dec. 1912.
To AS 8/1/12; Yale #5; unpub.
To AS 9/6/16; Yale #13; S; N 30.
 ** John C. Marin, IV, an only child, born Nov. 22. 1914.
To AS 7/31/17; Yale #16; S; N 35.
To AS 11/23/19; Yale #31; S; N 53.
24 To AS 8/28/32; Yale #94; S; N 146-7.
 * Marin bought Marin Island, opposite Small Point, Maine, in the summer of 1915. The island had no water and he was unable to build on it as planned. To AS 8/10/34; Yale #99; N 159-60.
 ** In Addison, Maine, on Pleasant Bay.
 *** The Wass family, neighbors in Addison and close friends.
 **** Herbert J. Seligmann, poet, critic and associate of Stieglitz was, with his wife Lilias, a summer neighbor and close friend of Marin.
To AS 8/18/35; Yale #103; N 167.
Map and plan unpub. part of letter to AS 8/10/34; Yale #99.
26 To AS 10/3/45; Yale #123; unpub.
27 Ms undated; pencil notes; unpub.
28 Ms undated; 4 pg. letter in ink; unpub.
29 To James Davis 5/4/45; unpub.
Ms undated; unpub.
 * Marin was elected to the National Institute of Arts and Letters in 1942; in 1943 he was elected to the American Academy of Arts and Letters and occupied chair 22.

THE ANCIENT MARINER

Page **30** To AS 7/12/39; Yale #112; N 192.
32 To AS 8/15/19; Yale #27; S; N 46-7; Helm 44-5.
To AS 8/28/32; unpub. Yale #114.
To AS 8/21/27; Yale #74; S; N 115.
To AS 9/28/16; Yale #14; S; N 31.
To AS 8/13/22; Yale #46; S; N 82.
33 Ms undated; pencil draft; unpub.
Catalogue University of California John Marin Memorial Exhibit, 1955; quotation dated 1942. Yale
35 To AS 8/8/16; Yale #12; S; N 28.
Ms to The Editor of *The New Yorker* 4/11/30; 6 pg. letter in ink; Marin wrote evidently objecting to what had appeared in the magazine which, he thought, contained inaccurate facts and misguided humor about himself; unpub.
To AS 9/6/16; Yale #13; S; N 29.
To AS 11/23/19; Yale #31; S; N 55.
To AS 10/22/21; Yale #44; S; N 74.
To AS 10/3/17; unpub. Yale #17.
To AS 9/28/16; Yale #14; S; N 31-2.
To AS 9/16/14; Yale #9; S; N 18.
36 Ms to AS 7/-/35; pencil draft; Yale #102; dif. version N 163.

Ms to AS undated; page 5 of multi-page draft in ink; dif. version Yale #108; N 176-7.
Ms to AS undated; multi-page pencil draft; dif. version Yale #102 dated 7/8/35; N 164.
To AS 7/31/21; Yale #41; S; N 66-7 (misdated).
To AS 7/9/27; Yale #73; S; N 113-4; Helm 42.
To AS 10/5/18; Yale #20; S; N 38 (typo. error for Rowe, Mass.)
To AS 7/22/13; Yale #6; S; N 7.
38 To AS 9/10/13; Letter refers to his neighbors in Castorland, N.Y. where he spent summer of 1913. Yale #7; S; N 9-12.
To AS 11/23/19 Yale #31; S; N 55.
40 To AS 8/28/32; Yale #94; N 147-8.
To AS 8/21/27; Yale #74; S; N 115.
To Stieglitz and O'Keeffe 7/18/38; The Thompson family, close friends and neighbors in Addison, Maine. Yale #109; S; N 181.
Ms to Shelton Pitney undated; 3 pg. ink draft. Pitney (unknown) obviously had requested a donation to a World War II cause; unpub.
41 Ms undated; pencil notes; unpub.
Ms undated; pencil notes; unpub.
Ms undated; pencil notes; unpub.
Ms undated; 2 pg. pencil notes; unpub.
43 Ms to Duncan & Marjorie (Phillips) undated; multi-page pencil draft *c*. 1950; unpub.
Ms to John (Marin, Jr.) 5/18/39; 4 pg. ink draft; dif. version N 190.

THE SEEING EYE

Page **44** Ms undated; 1 pg. pencil notes; unpub.
46 To AS 8/26/24; Yale #57; S; N 96-7.
47 To AS 8/28/32; Yale #94; N 144.
To AS 7/31/17; Yale #16; S; N 34.
To AS 7/31/17; Yale #16; S; N 35.
To AS 8/28/32; Yale #94; N 145.
Twice A Year #2, Spring-Summer 1939; N 185.
Princeton notes; 5/2/40; unpub.
To AS 8/18/35; Yale #103; N 167-8.
48 To AS 10/3/17; Yale #17; unpub.
To AS 9/6/14; Yale #9; S; N 19.
To AS 9/15/44; Yale #121; N 212.
51 Ms undated; pencil notes; unpub.
Ms undated; pencil notes; unpub.
Ms undated; pencil notes; unpub.
Ms undated; pencil notes; unpub.
Ms undated; pencil notes; unpub.
Ms undated; multi-page pencil draft; unpub.
Ms undated; pencil notes; unpub.
53 Ms undated; pencil notes; unpub.
Ms undated; pencil notes; unpub.
Ms undated; pencil notes; unpub.
54 Ms undated; multi-page pencil draft; unpub.
Ms undated; multi-page pencil draft; unpub.
Ms undated; multi-page pencil draft; unpub.
Ms undated; multi-page pencil draft; unpub.
Ms undated; pencil notes; unpub.
56 To Strand 9/20/30; Paul Strand, eminent photographer, close friend of Marin and Stieglitz. S; N 137
To Zoler 8/25/29; E. C. Zoler associated with Stieglitz and Marin at "291" and "An American Place". S; N 132.
To AS 7/21/29; Yale #83; S; N 130.
57 To Strand 6/22-25/29; S; N 128.
58 To Zoler 8/25/29; S; N 132.
To AS 8/4-14/30; Yale #87; S; N 135.
61 Ms to AS undated; multi-page pencil draft. dif. version Yale #115; 8/31/40; N 195.
Ms to Duncan "late Sept. Early Oct. '48"; Charles Duncan, sign painter, good friend of Marin in N.J. multi-page ink letter; unpub.
To AS 7/31/21; Yale #41; S; N 66 (misdated).
To AS 9/8/42; Yale #118; N 203.
"A Day with John Marin" by Beaumont Newhall, *Art in America* Sept.-Oct., 1953.
To AS 8/28/32; Yale #94; N 144-5.
To AS 9/15/44; Yale #121; N 214.
62 To AS 9/1/38; The Wass family, close friends and neighbors in Addison, Maine; Yale #110; unpub.
64 To AS 9/14/20; Yale #36; S; N 59.
66 To AS 9/11/21; Yale #43; S; N 70-71.
To AS 9/16/14; Yale #9; S; N 17.

69 Ms to AS undated; multi-page, pencil draft; unpub.
Ms undated; pencil notes on envelope postmarked 1942.
Ms undated; pencil notes; unpub.
To AS 9/21/38; Yale #111; N 184.

THE SOUND OF INSTRUMENTS

Page 70 Ms undated; 1 pg. ink notes; unpub.
72–79 Ms undated; 7 pg. ink manuscript intended for facsimile reproduction; possibly an early version of facsimile reproduced in *John Marin Drawings and Water Colors,* The Twin Editions, N.Y. 1950; unpub.
80 Ms undated; ink notes; unpub.
Ms undated; ink draft; early version of Twin Editions publication noted on pp. 72–9; unpub.
83 Ms undated; pencil notes; unpub.
Ms undated; pencil notes; unpub.
To Duncan & Marjorie (Phillips) 7/12/48; multi-page pencil draft; dif. version N 227.
Ms 8/26/28; see Notes ref. pg. 16.
84 Ms undated; pencil notes for Twin Editions publication; see Notes ref. pg. 72–9.
To AS 10/[9]/19; Yale #30; S; N 52; Benson 101–2.
John Marin Drawings and Water Colors, The Twin Editions, N.Y. 1950.
87 Ms to John (Marin, Jr.) undated; 4 pg. pencil letter. A similar description of *The Circus* is found in the Archives in a draft of a letter to Marin's friend Harry Wass, c.1943; unpub.
88 Ms undated; pencil notes; unpub.
Ms undated; pencil notes; unpub.
Ms undated; pencil notes; unpub.
90 To AS undated; Yale #3 Stieglitz notes this was written in 1911. S; N 3–4.
To E. A. Taylor *International Studio,* August 1911; quoted by Carl Zigrosser, *The Complete Etchings of John Marin,* Philadelphia Museum of Art, 1969.
92 Ms undated; pencil notes; unpub.
To Mr. Lustberg 4/24/33; Joseph Lustberg, New York, wrote Marin for painting instruction. N 149.
Ms undated; pencil notes; unpub.
Ms undated; pencil notes; unpub.
To AS 8/31/40; multi-page pencil draft. dif. version Yale #115; N 194.
To AS 7/12/39; Yale #112; N 192.
To AS 8/28/32; Yale #94; N 146.
To AS 7/12/39; Yale #112; N 192.
94 Ms undated; pencil notes; unpub.
Ms to AS undated; multi-page ink draft; dif. version Yale #115 8/31/40; N 194–5.
Ms undated; pencil notes; unpub.
Ms undated; multi-page pencil draft; unpub.
96 To AS 9/1/38; ink; Yale #110; part pub. Helm 80; unpub.
Princeton notes 5/2/40; unpub.
Ms undated; pencil notes; unpub.
Helm 101.
To AS 9/19–26/15; Yale #11; S; N 25.
Helm 101.
Ms undated; pencil notes; unpub.
Ms undated; pencil notes; unpub.
98 Ms undated; pencil notes; unpub.
Ms to AS undated; multi-page pencil draft; dif. version Yale #115 8/31/40; N 194
Ms undated; pencil notes; unpub.
Ms undated; pencil notes; unpub.

THE PICTURE CONCEPT

Page 100 Original manuscript in Downtown Gallery Archives, undated; enclosed with letter to Mrs. Halpert published in exhibition catalogue *The Artist Speaks,* April 1949.
102 Helm 97.
Ms undated; pencil notes; unpub.
105 Catalogue for Photo-Secession Gallery Marin Exhibit 1913; Yale; S; N 4–5.
106 Ms undated; pencil notes; unpub.
Ms undated; pencil notes; unpub.
Ms 8/26/28; see Notes ref. pg. 16.
Catalogue Institute of Contemporary Art, Marin Exhibit, Boston 1947; Yale; N 219.

Ms undated; pencil notes; unpub.
Ms undated; multi-page pencil notes; unpub.
Ms undated; multi-page pencil notes; unpub.
107 Ms undated; multi-page pencil notes; unpub.
Ms undated; multi-page pencil notes; unpub.
Helm 97.
108 Ms undated; pencil draft; unpub.
Ms undated; pencil draft; unpub.
Catalogue University of Miami, Marin Exhibit, Oct. 1951.
John Marin Drawings and Water Colors, The Twin Editions, N.Y. 1950.
Ms undated; multi-page pencil draft; unpub.
Twice A Year #2, Spring-Summer 1939; N 185.
110 Ms undated; multi-page pencil notes; unpub.
Ms undated; multi-page pencil notes; unpub.
Ms 8/26/28; see Notes ref. pg. 16.
Twice A Year #2, Spring-Summer 1939; N 186–7.
Helm 96.
Catalogue Institute of Contemporary Art, Boston, 1947; N 220.
Helm 95.
113 Ms undated; pencil notes; unpub.
Twice A Year #2, Spring-Summer 1939; N 186–7.
Ms undated; 2 pg. pencil notes; unpub.
Ms undated; pencil notes; unpub.
Ms undated; pencil notes; unpub.
Ms to Duncan 10/6/47; 4 pg. ink letter. *Journal of the Archives of American Art,* Feb. 1961.
Ms undated; pencil notes; unpub.
Ms undated; pencil notes; unpub.
114 Ms to AS undated; multi-page pencil draft; unpub.
Catalogue Montclair Art Museum, Marin Exhibit, March 1964.

THE ARTIST AND THE WORK OF ART

Page 116 Ms to Duncan & Marjorie (Phillips) undated; multi-page ink draft. dif. version N 222 dated 11/18/47.
118 Ms to Miss Axelrod undated; 3 pg. ink letter c.1945; a response to Miss Axelrod (unknown) who apparently had requested a description of the artist; unpub.
118–119 Ms to Duncan & Marjorie (Phillips) undated; multi-page ink and pencil draft c.1950.
120 Ms to AS undated; multi-page pencil drafts in 2 versions; a 3rd version Yale #108 9/23/37; N 175–6.
Ms undated; pencil notes; unpub.
Helm 95.
Ms undated; pencil notes; unpub.
123 Ms undated; pencil notes; unpub.
Ms undated; pencil notes on Museum of Modern Art envelope; unpub.
Ms undated; pencil notes; unpub.
124 Ms undated; pencil notes; unpub.
Ms undated; pencil notes; unpub.
Ms undated; pencil notes; unpub.
Ms undated; pencil notes; unpub.
Ms undated; pencil notes; unpub.
Ms undated; pencil notes; unpub.
Ms undated; pencil notes; unpub.
Ms to Duncan & Marjorie (Phillips) undated; multi-page pencil draft; unpub.
Ms undated; pencil notes; unpub.
Ms undated; pencil notes; unpub.
To AS 7/22/13; Yale #6; S; N 6–7.
To AS 7/20/31; Yale #90; N 138.
126 "Can A Photograph Have The Significance of Art", pub. in *Manuscripts Number Four* N.Y. Dec. 1922; Yale; S; N 88.
Catalogue Princeton University, Marin Exhibit, 1949. N 197–8.
Catalogue Institute of Contemporary Art, Marin Exhibit, Boston 1947. N 218.
To AS 9/19-26/15; Yale #11; S; N 26.
128 Ms undated; multi-page pencil and ink drafts for "Guest Editorial" in *The Palisadian* pub. 11/15/40. final version N 196–7.
New York Herald Tribune art column 10/18/36.
Ms undated; first pencil draft for "Guest Editorial" noted above.
130 Ms undated; pencil notes; unpub.
Ms undated; pencil notes; unpub.

Helm 47.
Downtown Gallery Archives, undated.
132 Ms undated; multi-page pencil notes; unpub.
To AS 8/10/41; Yale +117; N 199.
Ms undated; multi-page, pencil notes; unpub.
Ms undated; multi-page, pencil notes; unpub.
Ms undated; multi-page, pencil notes; unpub.
134 Ms to Mr. Daly undated; 3 pg. ink letter. Mr. Daly unknown; unpub.
The New York Times 11/18/36.
Princeton Notes 5/2/40; unpub.
Ms undated; multi-page pencil and ink draft; unpub.
Ms undated; multi-page ink draft; unpub.
135 To AS 9/10/36; Yale #106; N 171.
Helm 74.
136 Ms undated; multi-page pencil notes on art history; unpub.
Ms to Duncan & Marjorie (Phillips) undated; multi-page ink draft, c.1950. Marin kept a framed, colored postcard reproduction of the Phillips' *Giorgione* in his Cliffside, N.J. studio. unpub.
Ms to Duncan & Marjorie (Phillips) undated; multi-page pencil draft, dif. version N 172; 2/13/37.
Benson 19.
137 To AS 12/1/23; Yale #54; S; N 94–5.
To AS 8/1/37; Yale #107; N 174.
To Kalonyme 7/2/45; Louis Kalonyme, art critic and associate of Stieglitz and Marin. N 216–17.
Ms undated; pencil notes verso of envelope reproduced pg. 123; unpub.
138 "A Day with John Marin" by Beaumont Newhall *Art in America,* Sept.–Oct., 1953.
To AS 10/5/18; Yale #20; S; N 37 (Rowe, Mass.)
141 Helm 95.
Catalogue Contemporary Calligraphers, Contemporary Art Museum, Houston, April–May 1956; dif. version *Creative Arts,* October 1928; N 124.
142 Helm Foreword; N 226.
143 To Duncan & Marjorie (Phillips) 11/18/47; N 222.
Ms undated; pencil notes; unpub.
To AS 7/12/39; Yale #112; N 192.
Ms undated; pencil notes; unpub.
Helm 103.
Ms undated; pencil notes; unpub.
Ms undated; pencil notes; unpub.
Ms undated; pencil notes; unpub.
144 Ms undated; 7 pg. pencil draft, 2 versions; unpub.
146 Ms undated; multi-page pencil notes; unpub.
Ms undated; multi-page pencil notes; unpub.
Ms undated; multi-page pencil notes; unpub.
Twice A Year #2 Spring-Summer 1939; N 188.
Ms to AS undated; multi-page pencil draft. dif. version Yale #115 8/31/40; N 194.
Ms undated; pencil draft; unpub.
Ms undated; pencil draft; unpub.
Ms undated; pencil notes; unpub.
147 Ms undated; pencil notes; unpub.
Ms undated; pencil notes; unpub.
Ms undated; pencil notes; unpub.
Ms undated; pencil notes; unpub.
Ms undated; pencil notes; unpub.
Twice A Year #2 Spring-Summer 1939; N 188.
Twice A Year #2 Spring-Summer 1939; N 187.
148 Ms undated; Examples of multi-page pencil notes on music and art; unpub.
149 *Ibid.*
150 Ms undated; 1 pg. pencil draft; unpub.
To AS 9/19–26/15; Yale 11; S; N 26–7.
Twice A Year #2 Spring-Summer, 1939; N 185.
Ms undated; pencil draft; unpub.
152 Ms undated; multi-page pencil draft; unpub.
Ms undated; multi-page pencil and ink drafts, signed; unpub.
Catalogue Institute of Contemporary Art, Marin Exhibit, Boston, 1947; N 218.

A BLESSED EQUILIBRIUM

Page 154 Ms undated; pencil notes; unpub.
156 Helm 74. With reference to Helm's quotation about a syringe, it is said that after Marin's prostate operation at the New York Hospital in 1951, he

tired of the injections being administered and took the hypodermic away from the nurse. When she left his room, he filled it with ink and, using the needle as a point, made many drawings of the view from his window
Ms to Duncan & Marjorie (Phillips) undated; multi-page pencil draft c.1950; unpub.
Ms 8/26/28; see Notes ref. pg. 16.

159 To Duncan & Marjorie (Phillips); 6/11/45; N 216.

161 To AS 7/3/17; Yale #15; S; N 32.
Ms 8/26/28; see Notes ref. pg. 16.
To AS 7/21/29; Yale #83; S; N 130.
Ms undated; pencil notes; unpub.
Ms undated; pencil notes; unpub.

Ms undated; pencil notes; unpub.
Ms undated; pencil notes; unpub.

162 Ms undated; multi-page pencil draft; unpub.
Original manuscript in Downtown Gallery Archives, undated; ink. Enclosed with letter to Mrs. Halpert published in exhibition catalogue *The Artist Speats*, April 1949.

164 To Zoler 9/14/33; N 155.
Ms undated; pencil notes; unpub.
To AS 9/8/42; Yale #118; N 204.
Ms to Duncan & Marjorie (Phillips) undated; multi-page pencil draft; c.1950; unpub.

167 Ms to Duncan "Late Sept—Early Oct. '48"; multi-page ink letter; unpub.

168 To AS 9/29/43; Yale #119; N 209.
To AS 7/20/31; Yale #90; N 139–40.

171 To Kalonyme 7/7/53; according to John, Jr. this was his father's last letter; unpub.
Ms to Kalonyme undated; 1 complete and 1 partial pencil draft of the above letter; unpub.

172 To AS 7/31/17; Yale #16; S; N 34.
To AS 11/2/18; Yale #21; S; N 40.
To Duncan & Marjorie (Phillips) 7/12/48; N 228.
Manuscripts Number Two N.Y. March, 1922; Yale; S; N 77–8.
Catalogue University of California, John Marin Memorial Exhibit, 1955; Yale.
To AS 7/8/35; Yale #102; N 165.

LIST OF PAINTINGS AND DRAWINGS

Oil

Cerulenm Blue ~~⊘~~ # 5

Cadmium Red — Enough
" Yellow "

Yellow Ocre

Ivory black "

Cobalt Green "

White 2 Titanium White

Cerulenm Blue Enough ?

Ox ide Cromm get 2
otherwise Enough green

Lt Red Enough

Transp Brown get ~~2~~ 2
Brown Ocre get ~~2~~ 4
Raw Umber get ~~6~~ 4
Cobalt Blue ~~Jt 2~~ 1